DUTCH & FLEMISH PAINTING

110 illustrations selected & introduced by Christopher Brown

Phaidon

The author and publishers are grateful to all museum authorities and
private owners who have given permission for works in their possession to be
reproduced. Plates 2, 43, 58 and 62 are reproduced by gracious permission of
Her Majesty the Queen.

Phaidon Press Limited, Littlegate House, St Ebbe's Street, Oxford
Published in the United States of America by E. P. Dutton.

First published 1977
© 1977 Phaidon Press Limited
All rights reserved

ISBN 0 7148 1772 4
Library of Congress Catalog Card Number: 76–62638

Printed in Great Britain by Severn Valley Press, Caerphilly, Glamorgan

Dutch and Flemish painting

In 1555 the Habsburg Emperor Charles V transferred the government of the Netherlands to his eldest son, Philip II, whom he also created King of Spain. At that time representatives of all the seventeen provinces of the Netherlands comprised the assembly of the States General at Brussels, and Charles and Philip appeared together before it on this occasion. During the course of Philip's reign, the whole of the Netherlands rose in revolt, but only the seven provinces to the north of the great rivers which flow into the North Sea succeeded in gaining their independence from Spanish rule. When the Twelve Years' Truce was signed in 1609 the division was clear: the north was to be independent and Protestant, the south remained subservient to Spain and reverted to Catholicism. This arrangement, largely the result of geographical and military factors, was formalized by the Treaty of Münster in 1648 (see Plate 29), and has survived (with a number of territorial changes) until the present day in the nations of the Netherlands and Belgium.

It is of the first importance, therefore, when considering Dutch and Flemish art of the seventeenth century, to remember how recent the political split was, and that both schools of painting, however differently they developed, had common ancestry in the great school of early Netherlandish painting which flourished, principally in the towns of the south, in the fifteenth and sixteenth centuries. Rubens, for example, was born in 1577, only twenty-two years after Philip II's accession, at a time when the outcome of the revolt was very much in doubt.

Much of the fighting during the revolt took place in the south, and particularly in and around Antwerp. The resulting economic and social disruption, as well as the persecution of Protestants, caused many Flemings to seek refuge in the north. Among those emigrants were painters like Gillis van Coninxloo and David Vinckboons, who left Antwerp and finally settled in Amsterdam. Followers of Pieter Bruegel, they imported Flemish landscape and genre styles into Amsterdam, and influenced the younger generation of Dutch painters. For example, the great innovatory landscape artist Hercules Segers was a pupil of Coninxloo, and his more conservative contemporary Hendrick Avercamp (Plate 8) was probably a pupil of Vinckboons.

Both Dutch and Flemish seventeenth-century painting have their roots in early Netherlandish painting. However, it is undeniable that the two schools diverged markedly during the century, and there can be no doubt that this divergence in style and subject-matter was a direct result of the political and religious division between the two countries. In order to illustrate this divergence, the natural temptation is to compare the two leading figures of the century in the two countries: Rubens and Rembrandt. While such a comparison (which is attempted in this volume by a careful juxtaposition of plates) is immensely interesting and suggestive, it is not quite accurate. Rembrandt, one of the few Dutch painters who could equal Rubens in the range of his subject-matter (portraits, landscapes, religious and mythological subjects), is not representative of Dutch painters as a whole. Many Flemish painters, however, did emulate Rubens both in style and subject-matter (Van Dyck, Gaspar de Crayer, Jordaens and Theodor van Thulden, for instance). Dutch artists tended to specialize in a way in which Flemish artists, on the whole, did not: Hals was exclusively a portraitist, de Hoogh a genre painter, Ruisdael a landscapist, Willem van de Velde the Younger a marine painter, and so on. They specialized in what they could do best, and what they knew would satisfy a popular demand, and this question of demand, of patronage, is the crucial difference between the two countries. In Flanders (the south), the traditional sources of patronage for artists remained predominant: the court, the aristocracy and the Catholic Church. Civic institutions and rich merchants also commissioned paintings, but there was no art market such as existed in Holland. This important difference can be best stated in this way: in Flanders, the great majority of paintings were individually commissioned (altarpieces, mythological and historical scenes, portraits, and so on), whereas in Holland the great majority of paintings were produced for the market. Holland had the first modern art market, which, with its apparatus of dealers, exhibitions and contracts, operated in a manner recognizably similar to the contemporary art market. This is not, of course, to say that no paintings were commissioned in Holland: nor, conversely, that a small art market did not exist in Flanders. Portraits are always commissioned by family or friends if not by the sitter himself, and it is no accident that such an enormous number of seventeenth-century Dutch portraits survive. However, the traditional sources of patronage which dominated the production of paintings in Flanders in the seventeenth century no longer did so in Holland. The nearest equivalent to the court of the Archduke Albert and the Archduchess Isabella, the regents of the King of Spain in Flanders, was the court of the Stadholder of Holland, the Prince of Orange, in The Hague. During the lifetime of Prince Frederik Henry and that of his consort Amalia van Solms, the House of Orange commissioned a considerable number of paintings and also painted decorations for the palaces at Rijswijk and Honselaersdijk (both now destroyed), and the Huis ten Bosch at The Hague. For the decoration of the latter (which still stands) with allegories of the House of Orange and the career of Frederik Henry, native artists like Gerard Honthorst and Cesar van Everdingen were employed, but imported Flemings, like Jacob Jordaens, played an important part. The style of these decorations was the international Baroque, a style suited to the glorification of princes, but out of place in the basically democratic Dutch Republic. It is significant that the series of religious paintings which Rembrandt executed for the Prince of Orange in the 1630s shows the artist at his most Baroque. The financial resources of the House of Orange were small compared with the court at Brussels. Unlike the Flemish aristocracy, the Dutch nobles were few, politically impotent and relatively poor. They commissioned portraits, but could not emulate their southern brethren in the elaborate decoration of their houses. Though there were more practising Catholics in the north (including a number of prominent painters, like Steen and Vermeer) than is generally appreciated, the Catholic Church had gone 'underground' and could not commission altarpieces. The Calvinist churches, as can be seen in the church interiors of Saenredam (Plates 46 and 48) and de Witte (Plate 31), were white-washed and decorated only by hatchments.

Although these three traditional sources of patronage had been weakened or had disappeared altogether in the north, certain individuals and institutions did commission paintings other than single portraits. The new town hall in Amsterdam, for example, was decorated with scenes of the Revolt of the Batavians (seen as a prototype of the Revolt of the Netherlands) by leading Amsterdam painters, including Rembrandt. Other civic institutions commissioned paintings, as did the militia companies, regents of charitable foundations, and others. The group portrait of this kind is a uniquely Dutch phenomenon. But, despite these exceptions, most Dutch painters worked most of the time for the market. This had several important consequences. Firstly, paintings were cheap as there were so many of them. Holland in the seventeenth century was a rich country, benefiting from the success of her merchant marine, her merchants and her bankers, and yet this wealth, rather than being siphoned off by a few as happened elsewhere in Europe, does seem to have reached lower levels of society. It has been estimated that fifty per cent of the Dutch had some disposable income, that is to say, income over and above that devoted to necessities. Many ordinary Dutchmen, sailors and farmers, bought paintings, a fact which astonished visitors from England like John Evelyn. The consequence of this popular demand was the production by a huge number of painters of an enormous number of paintings, which were bought and sold cheaply to decorate walls, rather than to be treasured as works of genius. This demand also affected the social status of the painter: rather than being a confidant of princes and nobles, as in the south, he was a craftsman, like a furniture maker or a potter, working for a popular market. A further consequence of this demand was the emergence of many local schools of painting. Every town of any size had its own school: Delft, Dordrecht, Alkmaar, Hoorn, Deventer, Haarlem, and Leiden, for instance.

Holland is, therefore, the great exception in the history of seventeenth-century European painting. While certain stylistic similarities do exist, in terms of subject-matter and scale, Dutch painting differs greatly from the mainstream of the European Baroque, which found one of its greatest exponents in the Fleming, Rubens. Though geographically close neighbours, Dutch and Flemish seventeenth-century painters, both heirs to the same tradition, diverged radically during the course of the century as a direct result of the social, religious and political differences between their two countries.

Ambrosius Bosschaert (1573–1621)
1 A Vase of Flowers

Panel, 25¼ × 18⅛ in. Signed in monogram: AB. About 1620. The Hague, Mauritshuis.

Ambrosius Bosschaert the Elder was the patriarch of a dynasty of flower painters. He had been born in Antwerp, but as a child left the troubled city with his family for Middelburg in the north. He is recorded in Utrecht from 1616 until 1618, and died in The Hague. His style, with its painstaking attention to detail and elaborate arrangement of flowers, is similar to that of the better-known Jan Brueghel, and it has been assumed that Bosschaert was a pupil of Brueghel in Antwerp. This is, however, extremely unlikely (Brueghel was only five years older than Bosschaert), and it is more likely that it was Bosschaert who originated this type of flower-piece. Certainly it was Bosschaert who developed the composition of a vase of flowers placed in a niche or an arched window-frame with a landscape background. The flowers in Bosschaert's paintings are almost all identifiable and are often rare, reminding us of the collector's mania for exotic and unusual flowers, particularly tulips, which reached extraordinary heights in Holland in the early years of the seventeenth century. He also often included rare shells, which were also collected enthusiastically by the Dutch.

Jan Brueghel the Elder (1568–1625)
2 A Flemish Fair

Copper, 18¾ × 27 in. Signed and dated 1600. Royal Collection.

This is an outstanding example of the multi-figured compositions showing a Flemish *kermis* (fair), which were extremely popular among the followers of Pieter Bruegel. They represent an evolution from Pieter Bruegel's own paintings of peasant life, though they are executed on a smaller scale and in a more meticulous style. Imported into Holland by Flemish painters, who emigrated from Antwerp during the war with Spain, they contributed to the development of genre painting.

Hendrick Goltzius (1558–1616)
3 *(left)* Quis Evadet Nemo (Who shall escape it?)

Pen, brown ink, 18¼ × 14 in. Signed with monogram and dated 1614. New York, Pierpont Morgan Library.

The drawing, executed in the manner of an engraving (though the design was not engraved), dates from 1614, two years before the artist's death. It is an allegorical presentation of the subject of human mortality, yet it is far more direct and lacks the heavy-handed allegorical machinery of Jacob de Gheyn's treatment of the subject (Plate 5). The tradition of representing the idea of *vanitas* by a young man holding a skull goes back at least as far as an engraving by Lucas van Leyden of 1516. It is later employed by Frans Hals in a magnificent canvas (Plate 20) painted in about 1626–8.

Rembrandt van Rijn (1606–69)
(right) Sheet of Studies

Pen and wash, red chalk, 8⅛ × 9⅛ in. About 1636. University of Birmingham, Barber Institute of Fine Arts.

Drawn about 1636, this is one of the most fascinating of all Rembrandt's sheets of studies, combining as it does his acute and tender observation of everyday life (in the three sketches of a mother and child) and his love of rich ornament and elaborate dress (in the heads).

Hendrick Goltzius (1558–1617)
4 *(top)* 'The Fat Kitchen'

Pen, brown ink with brown wash, 8 × 13⅛ in. Signed and dated 1603 (on jug on table). Leiden, University Print Room.

This is the preparatory drawing for an engraving by Jacob Matham. The engraving bears the inscription: 'J. Matham fecit et excud.' (Jacob Matham made and executed this), without mentioning Goltzius. The scene glimpsed in the background shows Dives and Lazarus, the rich man at his table with the beggar at the gate, his sores being licked by dogs (Luke 16: 19–21). This kind of composition – a kitchen interior with a recessed Biblical scene – was extremely popular in the Low Countries in the second half of the sixteenth century. There is no doubt that this mannerist device of recession was deliberately employed to present a contrast between the worldly scene in the foreground and the religious background scene. The foregrounds of such scenes gave the artist an opportunity to depict still-life, and they are forerunners of the seventeenth-century Dutch still-life tradition.

Jacob de Gheyn (1562–1629)
(bottom) A Witches' Sabbath

Pen, ink and grey-brown wash, 11 × 16 in. Signed and dated 1600, lower left. Oxford, Ashmolean Museum.

De Gheyn is an enormously important and influential figure in the development of Dutch painting in the early years of the seventeenth century. He was a pupil of Goltzius in Haarlem and later worked with great success in Amsterdam and Leiden (where he moved in university circles), principally as an engraver. He finally settled at The Hague where he was employed at the court. As a draughtsman, he is at his most experimental. Considered as a group his drawings present two distinct aspects: *nae't leven* drawings (that is, from the life), and *uyt den gheest* drawings (from the spirit, or imagination), elaborate allegories (Plate 5), mannerist landscapes and witchcraft scenes. De Gheyn was not unusual amongst his contemporaries in the interest which he took in witchcraft and the supernatural – belief in witches and demonic possession was widespread and the line between science and magic had yet to be drawn. In this dramatic scene, set in a wall-niche with dark shadows thrown against the back wall, three witches are using both human and animal ingredients in the preparation of a spell. De Gheyn's knowledge of anatomy is evident in the drawing of the dissected human corpse, which, as was the practice in anatomy demonstrations, emphasizes the cavity of the stomach and chest. Despite de Gheyn's infinite care in the representation of the details of the preparation, it is difficult to believe that his intention was entirely serious: there is a degree of caricature in the depiction of the hags, and a self-conscious melodrama in the setting and the lighting of the scene.

Jacob de Gheyn (1562–1629)
5 Allegory of Death

Pen, ink, grey and brown wash, 18 × 13¾ in. Signed and dated 1599. London, British Museum.

The overall layout of this complex allegory of the inevitability of death (particularly the arrangement of the figures) derives from late medieval tomb sculpture, though the drawn curtains of the canopy are features of Italian Renaissance tombs. The combination of the living and the dead, of farmer and emperor, orchestrate the theme that death comes to all men, high and low. The texts were composed by the Dutch humanist scholar and lawyer Hugo de Groot (Grotius) – the one on the canopy states the theme: MORS SCEPTRA LIGONIBUS AEQUAT (Death makes the sceptre equal to the hoe). In the upper part de Gheyn places the Old and the New Law: the Old, illustrated by the Fall of Man in the roundel on the left, is in shadow and accompanied by the owl, symbol of night, while the New, represented by the Crucifixion is illuminated by a lamp. The upper central area of the composition shows a representation of the Last Judgement. Just below are a winged hour-glass (fleeting time) and the Homo Bulla (man is a bubble), which illustrates the idea that man's life is as vulnerable as a soap bubble. Similarly, the vase which emits smoke and the vase of flowers are symbols of the transience of human life. This kind of elaborate allegorical conceit, which seems heavy-handed and overblown to modern eyes, was a familiar means of representing such ever-present fears.

Peter Paul Rubens (1577–1640)
6 *(left)* The Entombment of Christ

Pen and ink, washed, over black chalk, 8¾ × 6 in. About 1615. Amsterdam, Rijksmuseum.

This drawing is loosely based on Caravaggio's painting of this subject in the Vatican. Rubens had painted a free copy of the Caravaggio (National Gallery of Canada, Ottawa) probably about 1613/15, soon after his return from Italy. This drawing, usually dated about 1615, shows him once again adapting Caravaggio's composition. It does not seem to have been done with a specific commission in mind.

Peter Paul Rubens (1577–1640)
(right) Venus Lamenting Adonis

Pen and ink, washed, 8¼ × 6 in. About 1608–12. London, British Museum.

A vigorous, economical pen drawing executed about 1608–12. It is the most elaborate of three drawings of the subject from the same period,

probably preparatory to a lost painting. The origin of the composition would seem to be the classical group of Menelaus and Patroclus, of which there were two versions in Florence by about 1570. The one in the Pitti Palace had been restored, and it was the restored group which was used by Rubens as the basis of this composition. Adonis was a beautiful mortal with whom the goddess had fallen in love, and who subsequently died in a hunting accident. In one of the most celebrated poems of antiquity Brion describes the goddess embracing the dying boy and trying with her kisses to suck his breath into her body.

Joachim Wtewael (1566–1638)
7 The Judgement of Paris

Panel, 23½ × 31¼ in. Signed, lower left: Jo wte wael/fecit/A° 1615 (Jo in monogram). London, National Gallery.

Joachim Wtewael was born in Utrecht, and was apprenticed there to the mannerist painter and designer Joos de Beer. He later travelled in France and Italy. Wtewael's style is based on 'Haarlem mannerism' or, more correctly, 'Sprangerism'. Carel van Mander introduced designs by Bartholomeus Spranger (a native of Antwerp, who after a prolonged stay in Italy had become one of Rudolf II's court artists at Prague) into Haarlem in 1583. Spranger's elegant, sophisticated and erotic court art dominated painting in the town for a decade. Wtewael and his contemporary in Utrecht, Abraham Bloemaert, practised their individual interpretations of 'Sprangerism' long after it had been abandoned in Haarlem. In this panel Wtewael depicts the Judgement of Paris in what must have seemed by 1615 a very old-fashioned style. Jupiter permitted Eris, the personification of strife, to attend the wedding of Peleus and Thetis. (This is the scene in the right background.) While there, she caused a quarrel between the goddesses as to who was the fairest. Mercury brought Venus, Juno and Minerva to the shepherd Paris on Mount Ida to judge between them. His choice of Venus led to the outbreak of the Trojan War.

Hendrick Avercamp (1585–1634)
8 A Scene on the Ice near a Town

Panel, 22¾ × 35⅝ in. Signed, on a wooden boarding in the centre foreground: HA (in monogram). About 1615–20. London, National Gallery.

Hendrick Avercamp was baptized in Amsterdam, but his family moved in 1586 to Kampen in the province of Overijssel. Dumb from birth, he was known as 'de stom van Campen'. His style is based on that of the Flemish followers of Pieter Bruegel the Elder. He painted almost exclusively ice scenes, and made a large number of coloured drawings of winter scenes, fishermen and peasants (an important group is in the Royal Collection at Windsor). Judging from the costume of the figures, this panel would seem to have been painted about 1615–20. The town in the background does not seem to be identifiable; it is not Kampen as has been suggested. The building on the right may be a brewery.

Peter Paul Rubens (1577–1640)
and Jan Brueghel (1568–1625)
9 Adam and Eve in the Garden of Eden

Panel, 29⅛ × 44⅞ in. Signed: Petri Pauli Rubens . . . Figr., IBrueghel fec. About 1610–15. The Hague, Mauritshuis.

This is an outstanding example of a familiar phenomenon in both Dutch and Flemish painting of the seventeenth century – collaboration between two specialist painters. In this case Rubens painted the figures and Jan Brueghel the landscape and the animals. There is a beautiful preparatory drawing for the figures of Adam and Eve in the Print Room of the Boymans-van Beuningen Museum, Rotterdam.

Peter Paul Rubens (1577–1640)
10 The Descent from the Cross

Panel, 45 × 30 in. About 1611. London, Courtauld Institute Galleries.

A preliminary study (or 'modello') for the central panel of the great altarpiece The Descent from the Cross, which Rubens painted for Antwerp Cathedral in 1611–14. The Descent is based on a number of Italian versions of the subject which Rubens had seen while he was in Italy. In the finished altarpiece the left wing depicts the Visitation and the right the Presentation in the Temple. The Descent was engraved

in 1620 by Lucas Vorstermann, and there is no doubt that it was this engraving that inspired Rembrandt to his – far less heroic – version of the subject (Plate 11).

Rembrandt van Rijn (1606–69)
11 The Descent from the Cross

Etching, 20⅞ × 16¼ in. 1633.

In the early 1630s Rembrandt received a very important commission – a series of paintings of the Passion for the Stadholder of Holland, Prince Frederik Henry of Orange. This is an etched version of The Descent from the Cross from that series, and it is quite clear from a comparison with Plate 10 that, as the basis for the composition, Rembrandt used the design of Rubens's great altarpiece in the cathedral at Antwerp. Rembrandt has, however, altered Rubens's conception in a number of respects – most importantly, Rubens's Italianate heroization of the event and, in particular, of Christ's body have been replaced by a brutal realism. The dead body of Christ is grotesque and distended, a palpable weight in the arms of the men who are removing it from the Cross. One of these men, balanced on a ladder, his face in shadow and clutching Christ's arm, is a self-portrait of the artist. Rembrandt has brought great drama to the scene not only by the vivid characterization of each figure, but also by the use of a strong fall of light on the figure of Christ and the white sheet which is to be wrapped around his body.

Peter Paul Rubens (1577–1640)
12 A Gentleman in Armour on Horseback
(Study for the Portrait of the Duke of Lerma)

Pen and ink washed over black chalk, 11¾ × 8½ in. 1603. Paris, Louvre.

In 1603 Rubens went to Spain as a representative of his employer, the Duke of Mantua. His principal task was to take gifts to the King of Spain. He also took a number of paintings (copies, not by himself, of famous originals in Rome) for the king's favourite, the Duke of Lerma. A number of these paintings suffered during the journey, and two had to be replaced by Rubens. Soon after the presentation of the paintings to Lerma, Rubens received the enormously important commission for an equestrian portrait of the duke. This was a great opportunity, and in the noble and dramatic composition which he evolved, Rubens certainly justified the choice. He adopted a very low viewpoint so that the form of the horse dominates the composition and leads the spectator's eye upward – along the animal's graceful neck – to the commanding head of Lerma himself. The portrait, now in the Prado Museum, Madrid, was immediately successful. It established the reputation of the young Fleming and the design was soon imitated outside Spain.

Peter Paul Rubens (1577–1640)
13 Portrait of a Lady

Pen and ink, over black chalk, 12⅜ × 7¼ in. 1606. New York, Pierpont Morgan Library.

This drawing was preparatory to a painted portrait of Brigida Spinola-Doria of 1606. In that year Brigida, the daughter of a noble Genoese family, married Giacomo Massimiliano Doria. The painting was executed in Genoa during Rubens's stay in the city. It is now in the National Gallery of Art, Washington, and originally had the same format as the drawing, but has unfortunately been cut down. There is a great difference between the appearance of Brigida Spinola in the painting and the drawing, a difference which would seem to go beyond the convention of flattery in a portrait. It has been recently suggested that one of her ladies-in-waiting was a stand-in for this study, the purpose of which was simply to work out the composition.

Anthony Van Dyck (1599–1641)
14 (left) The Crowning with Thorns

Brush and pen, with brown wash, 9½ × 8¼ in. About 1620. London, Victoria and Albert Museum.

This is a compositional drawing preparatory to a painting, now lost. Whereas in Plate 14 (right) Van Dyck is working on an individual figure in a larger composition, here he is laying out the whole composition, disposing the various elements within it. His strong use of light and shade (and the introduction of a source of light in the form of a lantern) displays his familiarity with the work of Caravaggio and his followers.

Anthony Van Dyck (1599–1641)
(right) A Man on Horseback and Three Horses' Heads

Brush and pen, with brown wash, 10⅜ × 6½ in. Amsterdam, Rijksmuseum.

In the bottom left-hand corner Van Dyck has written colour notes in Flemish. The rider would seem to be St George, or possibly St Martin. A number of paintings by Van Dyck include these saints, but none is close enough to establish the present drawing as preparatory to it. Rather, it shows Van Dyck in a brilliant sketch working out an early idea for a figure which he later altered. The speed of execution and the economy of line is characteristic of the artist.

Peter Paul Rubens (1577–1640)
15 Crocodile Hunt

Canvas, 97¼ × 126⅜ in. About 1615/16. Munich, Alte Pinakothek.

These huge canvases of hunts, of which Rubens and his studio painted a large number, were popular among the contemporary aristocracy, who spent much of their leisure time hunting. In this particular painting, showing a crocodile hunt in North Africa, the landscape is probably by Jan Wildens, a landscape specialist in Rubens's studio. (See also Plate 65 *bottom*.)

Hendrick ter Brugghen (*c*. 1588–1629)
16 The Concert

Canvas, 39 × 46 in. About 1626–7. Private Collection.

Born in the province of Overijssel, Hendrick ter Brugghen's family soon moved to Utrecht where he was a pupil of Abraham Bloemaert. He lived in Rome for about ten years, but was back in Utrecht by 1615, and spent the rest of his life in the town. His style is an individual interpretation of Caravaggio's Roman work, and that of Caravaggio's immediate followers. He was the first important Dutch 'Caravaggist' to return to Holland. His pictures are largely of genre and religious subjects, though there are a few mythological and literary scenes. This particular painting, one of ter Brugghen's masterpieces, displays his delicate, personal idiom. The subtle configurations of the fall of light and the absolute ease with which the paint is applied are aspects of ter Brugghen's mastery.

Rembrandt van Rijn (1606–69)
17 Christ at Emmaus

Paper on panel, 14⅝ × 16¼ in. Signed, lower right, RHL in monogram; about 1628. Paris, Musée Jacquemart-André.

Painted during Rembrandt's Leiden years, this is the first treatment of a subject which fascinated the artist and which he painted many times during his career. It has been pointed out that the composition is based on Adam Elsheimer's *Philemon and Baucis* (Dresden), which Rembrandt would have known from an engraving. Here Christ occupies the position of Elsheimer's Jupiter, on the right of the painting, and it was Elsheimer's example that enabled Rembrandt to dispense with the traditional composition. In tracing the source of the composition, we should not, however, underestimate Rembrandt's originality in rendering Christ's head in silhouette against the brightly lit wall, an extraordinarily effective and dramatic device.

Anthony Van Dyck (1599–1641)
18 Sir Robert Shirley

Canvas, 79 × 52½ in. 1622. Sussex, Petworth House, The National Trust.

19 Lady Shirley

Canvas, 79 × 52½ in. 1622. Sussex, Petworth House, The National Trust.

Robert Shirley (?1581–1628), who called himself Sir Robert or Count Shirley, was an Englishman who served as an envoy for the Shah of Persia and was married to a Circassian noblewoman (Plate 19). In 1608 he went to Europe to negotiate an alliance between Persia and the European princes against the Turks. He was entertained by Sigismund III of Poland, was well received by Pope Paul V, and after visiting Spain he came to England in 1611. He left Persia on a second diplomatic mission in 1615, stayed in Rome 1617–22, and visited Gregory XV at Rome in 1622. In 1624 he was received by James I and

given a residence, but was dismissed on the arrival of another envoy in 1627. He died in disgrace in Persia in 1628. These portraits were painted during Van Dyck's first visit to Rome in 1622. The style of the pictures, the free brushwork and luxuriant treatment of the rich fabrics, displays how little Van Dyck was affected by Roman portraiture. As we might expect from the many drawings in the Italian Sketchbook after Titian and the Venetians, it was Venice that remained the key to his portrait style.

Frans Hals (*c*. 1581/5–1666)
20 Young Man Holding a Skull

Canvas, 36⁵⁄₁₆ × 31¹³⁄₁₆ in. About 1626–8. Private Collection.

In England the painting has become known as Hamlet declaiming over poor Yorick's skull. Hals did occasionally paint theatrical characters, and his contemporaries painted scenes from plays; we also know that an English travelling company was in Holland before this date. However, the identification is quite fanciful as the picture is a *vanitas* (that is, a painting which is intended to convey the idea of the transience of human life) of a well-known type (see the note to Plate 3 *left*). The boy's costume has nothing in common with contemporary dress. It is of the theatrical kind which the Dutch Caravaggists used for their genre and allegorical subjects. The picture was painted in about 1626–8 when Hals was flirting with dramatic, Caravaggesque effects.

Anthony Van Dyck (1599–1641)
21 Francois Langlois as a Savoyard

Canvas, 41⅛ × 33¼ in. 1632–4(?). The Viscount Cowdray.

Francois Langlois (1589–1647), called 'Ciartes' after his birthplace Chartres, was a well-known engraver, publisher of prints and art dealer. He was an agent for Charles I and the Earl of Arundel on the Continent. He is represented here as a 'Savoyard', that is, an itinerant journeyman, shepherd and musician, similar to the gipsy fiddlers who roamed about Europe. This is presumably an allusion to his musical talent: he is holding a kind of bagpipes known as the *musette*, on which he was expert, and which he occasionally played at court. The conceit of being portrayed as a humble peasant musician is a popular one in Netherlandish painting of this date. It is difficult to date the picture by its style. There were a number of occasions on which Van Dyck and Langlois could have met, but the most likely date for the picture is 1632–4, between Van Dyck's arrival in England and Langlois' settling in Paris.

Peter Paul Rubens (1577–1640)
22 Rubens and his Wife, Isabella Brant, in the Honeysuckle Bower

Canvas, 68½ × 52 in. 1609. Munich, Alte Pinakothek.

On 3 October 1609 Rubens married the seventeen-year-old Isabella Brant, and this painting, executed soon after, celebrates their marriage. Isabella died in 1626 and Rubens mourned her in a deeply-felt though characteristically restrained letter: 'Truly I have lost an excellent companion whom one could love – indeed, had to love, with good reason – as having none of the faults of her sex. She had no capricious moods, no feminine weakness, but was all goodness and honesty, and because of her virtues she was loved during her lifetime and mourned by all at her death. Such a loss seems to me worthy of deep feeling.'

Pieter Claesz. Soutman (*c*. 1580–1657)
23 Emerentia van Beresteyn

Panel, 57¼ × 41½ in. About 1628. Buckinghamshire, Waddesdon Manor, The National Trust.

Pieter Soutman is said to have been a pupil of Rubens in Antwerp. By 1628, he was established at Haarlem, where he lived and worked for the rest of his life. He was influenced in his portrait style by Frans Hals. During the nineteenth century, this picture was a much admired work by Hals. However, the attribution was rejected some time ago, and the strong influence of Rubens makes it likely that it is the work of Soutman. The picture was painted soon after Soutman's arrival in Haarlem, when Emerentia was five or six. The clothes she wears look as if they were meant for an adult, but at this time children simply wore smaller versions of adult clothing.

Adriaen Brouwer (*c.* 1606–38)
24 Tavern Scene

Panel, 18⅞ × 29⅞ in. About 1630. London, National Gallery (on loan from a private collection).

Adriaen Brouwer was a brilliant, short-lived painter, who specialized in peasant and low-life scenes. He seems to have moved to Haarlem in about 1623–4 and there entered the studio of Frans Hals. If there had been no documentary evidence for this, the brilliance of Brouwer's brushwork would have suggested a contact with the great Haarlem portraitist. Brouwer was in Antwerp in 1631–2 and died there in 1638. His earliest work displays his great debt to Pieter Bruegel the Elder's peasant scenes, but his Haarlem training is revealed in the individual treatment accorded to each figure, and in the great subtlety of his palette. His work was greatly treasured in his own day, and both Rembrandt and Rubens collected it. Brouwer's delicate use of colour and the sparkling surface of his rare panels can only be appreciated in the original, such as this superb example on generous loan to the National Gallery. As with much genre painting, the subject – brawling and vomiting in a tavern – may come as a surprise as a fit subject for Brouwer's superlative technique.

Jan Steen (1626–79)
25 Twelfth Night ('Le Roi Boit')

Panel, 23 × 22 in. About 1668. The Marquis of Tavistock and the Trustees of the Bedford Estates.

Twelfth Night is one of a number of old Catholic feasts which survived in Holland, if in secularized form, despite the pressure of the Calvinist Church. Steen's domestic representation of the feast contains many of the traditional elements. The King is drinking, while his followers, including the Fool (with an inverted funnel on his head) and the Priest (in black), stand behind him. The figure on the right wears a black hood and a string of egg-shells; he plays a rommel-pot (an earthenware pot half-filled with water with a pig's bladder stretched across its mouth). A maid holds up the three-stemmed *koningskaarsjes* (King's candles). The picture she illuminates shows the kings following the star to Bethlehem. The figure above the King may well be a self-portrait of the artist. He often introduced a self-portrait into scenes of domestic jollity.

Frans Hals (*c.* 1581/5–1666)
26 Portrait of a Man

Canvas mounted on panel, 42⅛ × 33½ in. Inscribed, upper left, AETAT SUAE 36 and upper right AN° 1622. Chatsworth, The Duke of Devonshire and the Trustees of the Chatsworth Settlement.

The sitter has not been satisfactorily identified. The pose is unusual. In no other portrait does Hals present his sitter with crossed arms, a posture emphasized by the richly embroidered pattern of the sleeves. It is difficult to know whether this has a particular significance. Seymour Slive has written: 'Crossed arms can signify defiance, insolent arrogance, impatience or incredulity. To the mannerist art theorist Lomazzo "crossing arms" was a base action and to some of Hals's contemporaries, who were accustomed to regarding arm and even foot placement as part of fully articulated speech, folded arms must have symbolized inexpressiveness.'

Peter Paul Rubens (1577–1640)
27 Portrait of Ludovicus Nonnius

Panel, 48¼ × 39½ in. About 1627. London, National Gallery.

The sitter was a doctor, who published his best-known book, the *Diaeteticon sive re cibaria* in 1627. This portrait may have been painted to commemorate the event. Nonnius was a personal friend of Rubens, a member of the humanist circle in which the painter moved, and is mentioned in a number of his letters. The marble bust represents Hippocrates, the Greek who was thought to be the founder of medicine.

David Teniers the Younger (1610–90)
28 The Gallery of the Archduke Leopold-Wilhelm

Canvas, 50 × 64 in. Signed, lower left: DAVID TENIERS Fe/1651. Sussex, Petworth House, The National Trust.

Archduke Leopold-Wilhelm was one of the greatest collectors of the early seventeenth century. David Teniers had moved to Brussels where the archduke had his court by 1651, and entered his service as an official painter. One of his first tasks was to record the collection of paintings in this view of the archduke's gallery. The archduke himself is the figure in black pointing to a portrait on the floor. His preference for Venetian sixteenth-century paintings is clear and most of them can be identified with extant pictures. For example, the picture in the top row on the left is Giorgione's *Three Philosophers* now in Vienna; on the end of that row is Titian's *Diana and Actaeon*, now in the National Gallery, London. Other paintings by Giorgione, Titian and Veronese can be recognized as well as some by Tintoretto, Sebastiano del Piombo, and by Raphael.

Gerard ter Borch (1617–81)
29 The Swearing of the Oath of Ratification of the Treaty of Münster, 15 May 1648

Copper, 17⅝ × 23 in. Signed, on a tablet hanging on the left hand wall: GTBorch. F. Monasterij. A.1648. (GTB in monogram). London, National Gallery.

The ratification of the Treaty of Münster was an event of great importance in Dutch history. It represented the conclusion of the long war for independence from Spain which had begun in 1568. The Spanish had been forced to recognize the *de facto* independence of the United Provinces in 1609 but the Treaty of Münster brought *de jure* recognition. Spain renounced her claim to sovereignty, recognizing the independence of the United Provinces, and accepting her conquests, including those in the Portuguese colonies. This picture shows the final swearing of the Oath of Ratification in the town hall at Münster on 15 May 1648. A detailed account of the ceremony was published by Johan Cools, who had been present. He tells us that the room was decorated with foliage and flowers. The Conde de Peñeranda was dressed in grey with silver embroidery and the Dutch all in black. They seated themselves at a round table, on which stood two caskets containing the treaty documents. Speeches were made and the treaty read out in Dutch and French. The delegates stood and the Spanish swore by placing their right hands on the Gospels and afterwards kissing a crucifix. The Dutch delegates swore by raising their right hands. Ter Borch's painting agrees closely with Cools's account, but he shows both delegations taking the oath simultaneously. The placing of the figures in a semicircle facing the spectator is also, of course, a pictorial convention. The artist, who had been in Münster since 1646 and painted several of the delegates during his stay, has included a self-portrait on the extreme left of the picture. Ter Borch is said to have asked 6000 guilders for the picture (Rembrandt received 1600 for *The Night Watch*), but, as he was offered less, he kept it, and it does seem to have remained in the possession of his family.

Rembrandt van Rijn (1606–69)
30 The Woman Taken in Adultery

Panel (top corners rounded), 33 × 25¾ in. Signed, lower right: Rembrandt f 1644. London, National Gallery.

This account of Christ's forgiveness of the adulteress (John 8:3) is an outstanding example of Rembrandt's small-scale religious scenes. It reveals his great gifts as a colourist, an aspect of his art often forgotten. The figures are dwarfed by the massive temple, their drama heightened by a fall of light which suffuses the rich colour of the altar and the robes of the priest. In the elaborately decorative treatment of much of the background the picture recalls Rembrandt's style of the early 1630s in a way that is otherwise unparalleled in the 1640s. The freely drawn foreground figures are consistent, however, with his style in the mid 1640s.

Emanuel de Witte (*c.* 1617–*c.* 1692)
31 The Interior of the Old Church, Amsterdam, during a Sermon

Canvas, 31¼ × 24¾ in. Signed, lower right, E de Witte; about 1660. London, National Gallery.

In 1642 de Witte joined the guild at Delft. He was there for about ten years before moving to Amsterdam. He began to concentrate on painting church interiors in the late 1640s, an interest he shared with his Delft contemporaries Gerrit Houckgeest and Hendrick van Vliet. He also painted domestic scenes, harbour views and, after 1660, market scenes in which portraits are sometimes included. Houbraken says that he was 'famed for his knowledge of perspective'. This view, painted in about 1660, is of the nave and south aisle of the Old Church

at Amsterdam. The scene has been altered slightly; for example, the small organ has here been transported from the north to the south aisle.

Jacob Jordaens (1593–1678)
32 The Holy Family and St John the Baptist

Panel, 48¾ × 36⅞ in. About 1620–5. London, National Gallery.

Unlike his great contemporaries, Rubens and Van Dyck, Jordaens remained in Antwerp during his working life. In 1636/7 he was one of the artists chosen to execute the paintings for Philip IV's Torre de la Parada from designs by Rubens. In 1640 he delivered the first of a series of paintings commissioned by Charles I for the Queen's House at Greenwich. After Rubens's death in 1640 Jordaens became 'the prime painter' in Antwerp – in the view of Charles I's agent, Balthasar Gerbier. Jordaens was baptized a Catholic, but he and his family developed Protestant sympathies, which he was able to declare only after the Peace of Münster in 1648. Holy Communion according to the Protestant rite was not celebrated at his house until 1674. His wife, and later himself and his daughter, were buried in the churchyard of the Protestant community at Putte, just over the Dutch border. This picture (impeccably Catholic in sentiment) was probably painted in the first half of the 1620s, perhaps under the influence of Caravaggio's *Madonna of the Rosary*, which had been acquired for the Dominican Church in Antwerp in the early 1620s: the poses of the Virgin and Child derive from a Rubens composition of about 1616.

Peter Paul Rubens (1577–1640)
33 Study for the Figure of Christ on the Cross

Black and white chalk, some bistre wash, on coarse grey paper, 20¾ × 14⅝ in. About 1614–15. London, British Museum.

This study from the nude, which is usually dated about 1614–15, is unusual in Rubens's work for the elaboration of its finish. It has been suggested that the preliminary chalk drawing was done by an assistant and that the extensive work in bodycolour (chiefly lead white) was then laid in by Rubens. It is not a study for any known painting.

Peter Paul Rubens (1577–1640)
34 (top) Studies for Venus and Cupid

Pen and ink, 8 × 11 in. About 1618–20. New York, The Frick Collection.

This sheet seems to have been part of a larger one which also included a sheet of reclining female nudes. Both parts recall Titian's painting of *The Andrians* (Prado Museum, Madrid), which Rubens may have had in mind when drawing these swiftly-executed compositional sketches.

Peter Paul Rubens (1577–1640)
(bottom) 'Night' (La Notte): after Michelangelo

Black chalk, pen, heightened with yellow and white bodycolour, 14⅛ × 19½ in. 1603. Paris, Fondation Custodia (F. Lugt Collection).

This outstanding sheet shows drawings from several angles of Michelangelo's famous sculpture of *Night*. The sheet is made up of two distinct parts, a central sheet laid by the artist into a larger one. The central part shows the figure of *Night*, as it is seen today by a spectator facing the monument. This was drawn by Rubens in Florence in the spring of 1603. The left hand of the statue, which was never completed by Michelangelo, was drawn by Rubens at a later date, when he corrected and completed the central drawing and added the two others. The studies from above and behind cannot have been made from direct observation in the chapel and were presumably made from small versions of the statue in terracotta or bronze. Rubens was an enthusiastic collector and may himself have owned a reduced version of the statue or even a *modello* for it.

Peter Paul Rubens (1577–1640)
35 The Rape of the Daughters of Leucippus

Canvas, 87⅞ × 82½ in. About 1618. Munich, Alte Pinakothek.

Castor and Pollux were the sons of Leda by Zeus. The twins abducted the two sisters Phoebe and Hilaris, and were pursued by Idus and Lynceus, who were betrothed to the girls. Castor died in the ensuing fight and Pollux was permitted to die by Zeus. They were transformed into a constellation, the Gemini. Ruben's account of this rare subject was painted in about 1618. As so often with Rubens, it is possible to point to the sources of individual elements of the composition – the overall composition is from a group of fighting horsemen in Leonardo's *Battle of Anghiari*, while the girl who is off the ground is taken from one of the figures in Luca Cambiaso's *Rape of the Sabines* fresco in Genoa. The composition is carefully balanced: the naked bodies of the two girls forming dramatic diagonals across the picture surface. The flesh colours of the two sexes are deliberately contrasted. Rubens, scholarly antiquarian and classicist that he was, must have been aware that the horses of Castor and Pollux were white. However, here he subordinated accuracy to the colour balance of the picture.

Frans Snyders (1579–1657)
36 Squirrels on a Branch

Panel, 13¼ × 16 in. Private Collection.

A charming study from nature by one of Rubens's major collaborators. Snyders entered the Antwerp guild in 1602, and soon after set out for Italy. He was back in Antwerp by 1609. Among many important patrons, he worked for the City of Antwerp, Philip IV of Spain and the Archduke Leopold-Wilhelm. He worked with Rubens and specialized in the painting of animals, fruit and flowers.

Willem Kalf (1619–93)
37 Still-Life with the Drinking Horn of the St Sebastian Archers' Guild, Lobster and Glasses

Canvas, 34 × 40¼ in. About 1653. Private Collection.

Willem Kalf was born in Rotterdam, and probably studied with the still-life painter François Rijckhals at Dordrecht. He was in Paris in the 1640s, but had settled in Amsterdam by 1653 and remained in the city until his death. His earliest pictures are farm interiors in the manner of Adriaen van Ostade, but he subsequently concentrated on still-life and in particular on *pronkstilleven* (*pronk* means lavish display) of this kind. This is one of the finest of all Kalf's elaborate still-life compositions. The presence in the picture of the horn of the St Sebastian Archers' Guild suggests that it is a particular commission. Of a still-life by Kalf, Goethe wrote that it showed 'in what sense art is superior to nature and what the spirit of man imparts to objects when it views them with creative eyes. There is no question, at least there is none for me, if I had to choose between the golden vessels and the picture, that I would choose the picture.'

Frans Hals (c. 1581/5–1666)
38 A Married Couple in a Garden (Isaac Massa and Beatrix van der Laen?)

Canvas, 55½ × 65½ in. About 1622. Amsterdam, Rijksmuseum.

There was already an established tradition of portraying a married couple in a landscape by the time this portrait was painted. It represented marital fidelity, and was used by Rubens in his portrait of himself and his first wife, Isabella Brant (Alte Pinakothek, Munich; for a later example, see Plate 22). It has been argued with great force that the portrait is a marriage picture representing Isaac Massa and his first wife Beatrix van der Laen. The marriage took place on 25 April 1622, which is quite compatible with the dating of the picture on stylistic grounds.

Peter Paul Rubens (1577–1640)
39 (left) Study of a Naked Woman, Standing, Seen from the Back

Black and red chalk, with white highlights, 20¼ × 10 in. About 1635–40. Paris, Louvre.

This is probably a drawing of a small ivory statuette in Rubens's own collection. He had a number of such statuettes by George Petel, a German sculptor whom he knew well, in his collection. The drawing is also related to *The Three Graces*, now in the Prado Museum.

Rembrandt van Rijn (1606–69)
(right) Female Nude with a Snake

Red chalk, 9⅝ × 5½ in. About 1637. London, Villiers David.

This beautiful red chalk drawing of a woman proffering her breast may represent Cleopatra. She is wearing an Oriental headdress, and a snake is wrapped around her legs and her right arm. The drawing is not related to any known painting by Rembrandt, though there is a similar nude in the Adam and Eve etching of 1638. It is an excellent example of Rembrandt's drawing from the nude model, which, in his finished paintings and etchings, was so criticized by later, more classically-minded critics (see Plate 41, *bottom*). While there are no garter marks on the legs of this model, Rembrandt has not in any way idealized her in her transformation into Cleopatra. Her stomach is distended, her thighs broad and her breasts no longer firm.

Peter Paul Rubens (1577–1640)
40 A Nude Man, Kneeling

Black and white chalk, 20½ × 15¾ in. About 1609. Rotterdam, Boymans-van Beuningen Museum.

An excellent example of the elaborate chalk drawings from the nude which Rubens made for his paintings in the early part of his career. This drawing is preparatory to *The Adoration of the Magi*, now in the Prado Museum, Madrid, which was painted in 1609. Later, as Rubens grew in confidence, chalk drawings from the model are executed more simply, with less modelling in light and shade, and more reliance on line. This sheet of a muscular male model clearly displays Rubens's study of Michelangelo's figure drawing, and also of antique statuary.

Rembrandt van Rijn (1606–69)
41 (top) Diana at the Bath

Black chalk, washed with bistre, 7¼ × 6½ in. About 1631. London, British Museum.

This is a preparatory drawing in reverse for an etching. The lines in the drawing are indented partly with a stylus, partly with hard black chalk, for transfer to the plate. Rembrandt here used a studio drawing of a model to represent a mythological figure. He saw no need to idealize the figure. This uncompromising realism made him a target for criticism (see Plates 41 *bottom* and 39 *right*).

Rembrandt van Rijn (1606–69)
(bottom) Naked Woman Seated on a Mound

Etching, 7 × 6¼ in. 1631.

This etching was executed in 1631, the year in which Rembrandt moved to Amsterdam. Its aggressive realism, in deliberate contrast to idealized Italian nudes, must have surprised contemporaries. A later generation of Dutch artists, imbued with a classical approach to the female nude, condemned Rembrandt's unadorned depiction of models. In 1681 Andries Pels wrote:

> He chose no Greek Venus as his model
> But rather a washerwoman or treader of peat from the barn
> And called this whim 'imitation of nature',
> Everything else to him was idle ornament. Flabby breasts
> Ill-shaped hands, nay, the traces of the lacings
> Of corsets on the stomach, of the garters on the legs
> Must be visible if nature was to get her due
> This is *his* nature which would stand no rules.
> No principle of proportion in the human body.

Jacob de Gheyn
42 (top) Study of a Man on his Deathbed (Carel van Mander?)

Pen, ink and grey wash, 5⅝ × 7 in. About 1606(?). Frankfurt, Städelsches Institut.

Like Plate 95, this is a remarkable example of the *nae't leven* (from the life) aspect of de Gheyn's work. It is a delicate, moving drawing of a man on his deathbed, a man who has been traditionally identified as the Haarlem painter and theorist Carel van Mander. Van Mander's famous *Het Schilder-Boeck* (Book of Painters) contains an enthusiastic account of the life and works of de Gheyn. Although there are portraits of him, it is difficult to be sure that this man, wasted by terminal illness, can be certainly identified as van Mander.

Willem Buytewech the Elder (1591–1624)
(bottom) Interior with a Family by a Fire

Pen and brown wash, 7⅞ × 11¾ in. Signed, lower left: buitewech fecit/Anno 1617.23. Hamburg, Kunsthalle.

This drawing is remarkable not only in the work of this important and influential artist, but also in Dutch art of the period. It is an extremely early example of a scene of everyday life, apparently lacking any symbolic or allegorical content. Willem Buytewech moved to Haarlem and entered the guild in 1612, the same year as Hercules Segers and Esaias van de Velde, both important innovatory artists. Known as *geestige Willem* (witty Willem), he is best known for his development of the so-called 'merry company' scenes and for his illustrations to the work of the Dutch poet Bredero. He is a crucial figure in the evolution of Dutch genre painting in the seventeenth century, though in his drawings he is far more realistic than in his rare paintings. This drawing, perhaps of his own home, shows him in his most realistic mood. It is also extremely interesting as a record of a Dutch interior in the early years of the seventeenth century: note the map (on a west-east rather than north-south axis) used as a form of domestic decoration, and the recessed bed.

Adriaen van Ostade (1610–85)
43 The Interior of a Peasant's Cottage

Panel, 18⅜ × 16⅜ in. Signed, A v Ostade/1668 (Av in monogram). Royal Collection.

Adriaen van Ostade was a pupil in the studio of Frans Hals at the same time as Adriaen Brouwer (see Plate 24). Ostade was born in Haarlem and lived there all his life. He was enormously prolific – there are more than 800 surviving paintings, over 50 etchings and innumerable drawings, mostly peasant scenes, though he also painted a few Biblical subjects and portraits. In *The Interior of a Peasant's Cottage*, which is dated 1668, the fall of light within the dark interior displays Ostade's familiarity with Rembrandt's lively contrasts of light and shadow in the 1630s and 1640s. The sketchy technique has all the immediacy of his watercolour drawings and etchings.

David Teniers the Younger (1610–90)
44 A View of Het Sterckshof near Antwerp

Canvas, 32¼ × 46₁₆/₁₁ in. Signed, D TENIERS F; about 1646. London, National Gallery.

Traditionally the house in the background was thought to be Teniers's own, De Drij Toren, at Perck, which he bought in 1662. This identification has recently been proved to be incorrect: in fact, the view is that of the back of Het Sterckshof at Deurne, near Antwerp. Similarly the figures in the left foreground have been said to be David Teniers, his wife and eldest son. However, the peasant offering the fish is probably paying a seigneurial due and thus it would seem that the lady receiving it is the lady of the house. David Teniers was Adriaen Brouwer's immediate heir in the depiction of peasant scenes in Flanders, but had a far more detached view of his subject. Teniers showed himself as a landowning gentleman visiting a country *kermis* as a spectator rather than as a participant as Brouwer had done. Teniers was enormously prolific and extremely successful. By 1651 he had settled in Brussels in the service of the governor of the Spanish Netherlands, the Archduke Leopold-Wilhelm.

Jan van der Heyden (1637–1712)
45 The Huis ten Bosch at The Hague

Panel, 8½ × 11¼ in. Signed, on a stone, lower left: IVDH. About 1670. London, National Gallery.

Jan van der Heyden trained in Amsterdam as a glass painter, an apprenticeship which can be detected in his meticulous technique, of which Houbraken wrote: 'He painted every brick in his buildings . . . so precisely that one could clearly see the mortar in the joins, and yet his work did not lose in charm or appear hard if one viewed the pictures as a whole from a certain distance.' The Huis ten Bosch (House in the Wood) was built for Amalia van Solms, wife of the Stadholder, Prince Frederik Henry of Orange, in 1645/52. The architect of this fine example of the new Dutch classical style was Pieter Post, pupil of the great Jacob van Campen, who designed the Amsterdam Town Hall. After Frederik Henry's death in 1649, Amalia turned the Huis ten Bosch into a memorial to him, commissioning a number of Dutch and Flemish artists (among them Jacob Jordaens) to decorate the Oranjezaal with allegories of the House of Orange and the career of Frederik Henry. This view of the building, from the back or

garden side, is substantially accurate. The building still stands, but a number of alterations have been made since van der Heyden painted it. An outer staircase has been built on this side, the dome has been changed and wings were added in 1734–7. The statues and obelisks are no longer there.

Pieter Saenredam (1597–1665)
46 The Interior of the Buurkerk at Utrecht

Panel, 23¾ × 19¾ in. Signed; de buerkerck binnen utrecht/aldus geschildert uit iaer 1644/van/Pieter Saenredam. London, National Gallery.

Pieter Saenredam, the son of the engraver, Jan Saenredam, was based in Haarlem, though he travelled widely in Holland. A painter of church interiors and topographical views, he was scrupulously accurate in his drawings, but when he came to turn them into paintings, he modified them for reasons of composition. There is a drawing of the interior of the Buurkerk from the same viewpoint dated 16 August 1636 in the municipal archives at Utrecht. The painting corresponds to the right half of the drawing (there is also a painting which corresponds to the left half). The rough drawing on the pier at the right represents the four sons of Aymon: after a quarrel in which one of the brothers killed Charlemagne's son, he and his brothers escaped on his magic horse Bayard. The story of their adventures was very popular throughout Europe up until the eighteenth century, and in Holland the four brothers frequently appear on pottery, metal-work, textiles and shop signs.

Rembrandt van Rijn (1606–69)
47 The Death of the Virgin

Etching, 16⅛ × 12¾ in. Signed and dated, Rembrandt f. 1639.

Rembrandt's first large etching since the *Christ before Pilate* of four years before, it is, unlike that, an original work in the medium and not a careful reproductive print in the style of the engraver. It represents a culmination of the artist's efforts to compose on a grand scale during the preceding years. While much of the plate is simply sketched in, for example the angels at the top, other parts, like the figures around the bed, are fully elaborated. The result is pictorial though the integrity and individuality of the medium remain. The composition itself is a combination, characteristic of this phase of Rembrandt's career, of a Baroque religious drama with naturalistic representation of the events around the bed.

Pieter Saenredam (1597–1665)
48 The Interior of the Marienkerk in Utrecht

Pen and brown ink over black chalk, 15¼ × 11⅝ in. Inscribed: 'P. Saenre . . .' and 'Ste Marijenkerck binnen Utrecht den 9 Julij 1636.' Edinburgh, National Gallery of Scotland.

This beautiful drawing, which has only recently come to light, and which shows the nave and choir (looking east) of a church which was pulled down in the nineteenth century, was done in July 1636. Four and a half years later, Saenredam made a painting of the same view, which is now in the Rijksmuseum, Amsterdam.

Johannes Vermeer (1632–75)
49 Girl Reading a Letter

Canvas, 32⅛ × 25¾ in. About 1659. Dresden, Staatliche Gemäldegalerie.

This is a painting from early in Vermeer's career. It is the earliest example of a favourite subject: the fall of light from a window on a single figure. Note the characteristic, elaborate still-life in the foreground, which forms a barrier between the subject and the spectator. Vermeer also introduces the illusionistic device of a curtain, on a curtain rail. Pictures were often protected in this way. Letter-writing and letter-reading are favourite subjects with Dutch seventeenth-century painters, and often signify absent love. The inscription accompanying a letter-writing Amor in Otto van Veen's *Amorum Emblemata* (Antwerp, 1608) reads: 'Just as, for lovers, pictures even of absent loved ones are delightful . . . How much more delightful are letters, which convey the true imprints and marks of a lover.'

Anthony Van Dyck (1599–1641)
50 Queen Henrietta Maria

Canvas, 39½ × 33¼ in. About 1636. Private Collection.

In 1632 Van Dyck settled in London, was knighted by Charles I and is described as 'principall paynter in Ordinary to their Majesties at St James'. This portrait of the queen is almost certainly the portrait which was being painted in December 1636, according to a despatch from the papal agent to Cardinal Francesco Barberini. It was probably a gift for the cardinal, to thank him for his help in the negotiations for Bernini's bust of the king and also for the pictures which he sent to the Royal Collection. The gesture of the queen's hands may refer to her pregnancy: Princess Anne was born on 17 March 1637. The great care which Van Dyck lavished on this portrait displays his wish to impress the cardinal, an important patron of the arts, and the Roman *cognoscenti*.

Rembrandt van Rijn (1606–69)
51 Portrait of a Woman with a Fan

Canvas (originally rounded at top), 45 × 38½ in. Signed, extreme right edge of canvas: Rembrandt f/1643. Private Collection.

This is one of a pair of unidentified portraits – the man has a falcon on his wrist. They are among the finest portraits of the early 1640s. It was a period in Rembrandt's career when the hectic rate of portrait painting in the 1630s had slowed down. He concentrated on far fewer, more elaborately composed and more precisely painted portraits. The juxtaposition with Van Dyck's *Queen Henrietta Maria* (Plate 50) points up some telling differences between the two artists' approach to portraiture. It is particularly noticeable how much freer Van Dyck's technique is, not only in the treatment of the satin dress but also in the lightly brushed-in background. Beside Van Dyck, Rembrandt's technique seems almost laboured, his palette dull, and yet how infinitely satisfying is the result of his efforts.

Peter Paul Rubens (1577–1640)
52 'Peace and War' (Minerva Protects Pax from Mars)

Canvas, 80⅛ × 117½ in. 1629–30. London, National Gallery.

This huge canvas was painted in London for Charles I in 1629–30. The painter was involved in diplomatic negotiations to bring about peace between Spain (and her dominion, the Southern Netherlands) and England. The picture sets forth in pictorial terms Rubens's diplomatic aims and the hoped-for fruits of peace. Occupying a central position is the figure of Peace; she is protected by Minerva, Goddess of Wisdom and the Arts, who forces away Mars, the God of War, and behind him, the fury Alecto, while a screaming phantom spitting fire hovers over the scene. War is thus represented as an ever-present threat, always poised to disrupt peace. In the foreground, three children – in fact the children of Balthasar Gerbier, Charles I's agent in the Netherlands and France – are led forward by a winged cupid and the torch-carrying boy-god of marriage, Hymen, for marriage prospers in peacetime. The children are to enjoy the fruits of peace which spill forth from a cornucopia held out by a satyr. On the left a woman brings wealth in the form of precious objects and jewels. Beside her another joyfully shakes a tambourine. Even the leopard is shown to be merely playful, rolling on his back to claw at the vine leaves on the grapes. These were the blessings of peace which Rubens passionately enjoyed and believed in, and which he painted with breathtaking virtuosity.

Rembrandt van Rijn (1606–69)
53 Jacob Blessing the Sons of Joseph

Canvas, 69 × 82¾ in. About 1656. Cassel, Gemäldegalerie.

The picture is falsely signed and dated 1656: however, this signature and date may replace originals. Certainly the date fits in with the style of this impressive picture. Rembrandt may have returned to it in the 1660s to add certain of the more freely painted features. This is one of Rembrandt's greatest religious works painted during the fiercely creative mid 1650s. Joseph tries to guide the hand of his father to the head of his first-born, but Jacob's hand rests on the blond head of the younger child, Ephraim, to whom the Gentiles trace their ancestry. The elder boy, Manasseh, who is small and dark, is blessed with the left hand. The submissive gesture of Ephraim's crossed hands, Joseph's tender regard for his father, Manasseh's intense gaze towards

his brother, all are painted in strong, broad strokes. The unusual presence of Asenath, Joseph's wife, also in an attitude of submission, strengthens and balances the composition.

Rembrandt van Rijn (1606–69)
54 Self-Portrait

Panel, 24⅞ × 19⅞ in. Signed, lower right corner, Rembrandt F/163 . . . Pasadena, California, Norton Simon Museum of Art.

The portrait shows Rembrandt in his early thirties, a successful and prolific portrait painter, well dressed and self-confident. He had come, seven years before, from the provincial town of Leiden, and established himself as one of Amsterdam's leading painters with the *Anatomy Lesson of Dr Tulp*, painted in 1632 (Mauritshuis, The Hague). He married well and bought a large house in the Breestraat. Rembrandt's series of self-portraits, drawn, etched and painted, are one of the most extraordinary phenomena of Western art. No other artist painted his own face so often and so consistently throughout his career. They are thus not only a unique record of his changing appearance, painted with remarkable candour, but also of his developing style in all media.

Anthony Van Dyck (1599–1641)
55 Thomas Wentworth, 1st Earl of Strafford

Canvas, 53½ × 43 in. 1636. Sussex, Petworth House, The National Trust.

Strafford (1593–1641) began his political career in opposition to Charles I, but after his appointment as Lord Deputy in Ireland in 1632 he became one of the king's staunchest and most able supporters. Recalled to conduct the Scottish war, he was impeached by the Commons and executed in 1641. Strafford took great trouble to arrange for Van Dyck to paint his portrait, and to distribute copies of it among his friends. In a letter to his agent Raylton before returning to Ireland, he wrote: 'Take care in packing pictures for Dublin: Of those two last drawn of my being at Eltham; the short one is for lady Carlisle and the other at length for Lord Newcastle: and mind Sir Anthony that he will take good pains upon the perfecting of this picture with his own pencil.'

Pieter de Hoogh (1629–84)
56 A Woman and her Maid in a Courtyard

Canvas, 29 × 24⅜ in. Signed, lower right: P.D.H./166(?). London, National Gallery.

De Hoogh's earliest genre interiors are in the style of the Haarlem and Amsterdam barrack-room painters (like Pieter Codde and Willem Duyster), but there are no dated pictures before 1658. The pictures of that year and those painted immediately before and after are in the new Delft style of the 1650s. Carel Fabritius and (in Dordrecht) Nicolaes Maes were influential in the as yet problematic development of this style, which finds its greatest expression in the work of de Hoogh's Delft period and of Vermeer. After his move to Amsterdam in the 1660s, de Hoogh's style changed. His clientele was richer and so consequently were his interiors: many are over-elaborately decorated and at the same time his technique becomes increasingly coarse. In this Delft scene, the wall at the end of the garden is the old town wall of Delft, although the scene is an imaginary one incorporating a number of real architectural features.

Jan Steen (1625/6–79)
57 'The Burgher of Delft and his Daughter'

Canvas, 32½ × 27 in. Signed, centre, on the lower step: J Steen 1655 (J and S in monogram). Private Collection.

The sitters have not been identified. The canal is the Oude Delft, where Steen himself had a brewery from 1654 to 1657. On the right the Old Church can be seen, and along the canal over the man's right shoulder are the Delflands Huis and the Prinsenhof. Steen came to Delft in 1654, when de Hoogh and Vermeer were not yet active and the most significant figure was Carel Fabritius. Closely associated with the circle of Fabritius was Nicolaes Maes, working in nearby Dordrecht. Both Maes and Fabritius had been pupils of Rembrandt. There is a painting by Maes which probably served as the prototype for this composition. The coat of arms on the bridge is that of Delft. The still-life in the window is probably a *vanitas* symbol. The two

beggars were no doubt included to stress the sitter's contributions to public and private charities, an important aspect of Dutch social life during the seventeenth century.

Anthony Van Dyck (1599–1641)
58 Cupid and Psyche

Canvas, 78½ × 75½ in. About 1639–40. London, Royal Collection.

Cupid finds Psyche in the 'dull lethargy' of sleep into which she had sunk when she opened the box of beauty brought to her from Proserpine at the request of Venus. Painted for Charles I, this is the only one of Van Dyck's subject paintings for the English court to survive. It is very loosely painted, almost sketch-like, and it may be unfinished. It reflects Van Dyck's study of Titian (and, in particular, of the Farnese Bacchanals) in the small scale of the figures and its mood of poetic melancholy. It has been suggested that Margaret Lemon, Van Dyck's beautiful and jealous mistress, was the model for Psyche.

Anthony Van Dyck (1599–1641)
59 The Lords John and Bernard Stuart

Canvas, 93½ × 57½ in. About 1638. Private Collection.

Lord John Stuart (1621–44) and Lord Bernard Stuart (1622–45), were the third and fourth sons of the 3rd Duke of Lennox. Both died fighting for Charles I in the Civil War. Van Dyck settled in England in 1632 as court painter to Charles I on terms exceptional in the history of royal patronage in England. He was consistently patronized by the king, the royal family and the court. Such was his immediate success and his continuing popularity that he created the image of the king and the Caroline court that we immediately recognize today. The king as melancholy knight-warrior was Van Dyck's creation as are Charles's languid, richly-dressed courtiers. The Stuart brothers, one of the finest of all Van Dyck's portraits of the English aristocracy, are the very image of the Cavalier court.

Aelbert Cuyp (1620–91)
60 River Landscape with Horsemen and Peasants

Canvas, 49 × 96¼ in. Signed, A cuyp. About 1655. Private Collection.

The painting has been cut by about ten inches at the top, which has considerably altered the balance of the landscape to the sky. On 18 May 1818, Joseph Farington wrote in his diary: 'I went to the British Institution and there met Mr West and I went round the exhibition with him examining all the pictures. While looking at Lord Bute's picture by Cuyp, he sd that picture was brought to England by the late Captn. Baillie, and was the first picture by that master known in England. Having been seen pictures by Cuyp were eagerly sought for and many were introduced and sold to advantage!' Such was the subsequent enthusiasm for Cuyp in England that many of his best pictures, imported between about 1760 and 1840, are still in this country.

Aelbert Cuyp (1620–91)
61 View of the Maas in Winter

Panel, 25¼ × 35¼ in. Signed, A cuyp. About 1650. Private Collection.

Son of the painter, Jacob Gerritsz Cuyp, Aelbert was born in Dordrecht. His early landscape style reflects study of Jan van Goyen's work of the late 1630s, but he radically changed his style in the mid 1640s under the influence of the second generation of 'Italianizing' landscape painters of Utrecht, particularly Jan Both. Cuyp is not recorded outside Dordrecht and probably did not visit Italy. However, he did travel along the Rhine, the Maas and the Waal, sketchbook in hand. After his marriage in 1658 to a patrician widow, his output diminished and he took on more and more public duties. As well as his landscapes, the chronology of which is by no means clear, he painted a number of portraits in his father's manner, and a few farmyard scenes. The ruins on the right are those of the Huis te Merwede, built in the thirteenth century and ruined early in the fifteenth, which lie about a mile to the east of Dordrecht. They stand, in much the same state as they were in the seventeenth century, on land which has now been reclaimed.

Anthony Van Dyck (1599–1641)
62 Three Heads of Charles I

Canvas 33¼ × 39¼ in. About 1636. Royal Collection.

This painting was commissioned from Van Dyck to enable the Roman sculptor Bernini to execute a bust of the king. The marble bust was ordered by the queen, Henrietta Maria. Pope Urban VIII and his nephew Cardinal Francesco Barberini authorized Bernini (who was under exclusive contract to the Papacy) to accept the commission, and Van Dyck's painting was despatched to Rome soon after March 1636. That Van Dyck took great pains with the portrait was no doubt because of his desire to impress the Romans who would see it. Bernini's bust was enthusiastically received by the king and queen at Oatlands on 17 July 1637, being admired 'nott only for the exquisiteness of the worke but the likenesse and nere resemblance it had to the king's countenance.' The bust was destroyed in the fire at Whitehall Palace in 1698.

Unknown Artist
63 Allegory of the Martyrdom of Charles I

Canvas, 22 × 32 in. Sussex, Petworth House, The National Trust.

In the background on the right, London, dominated by the profile of Old St Paul's, is burning, presumably in the great fire of 1666. In the right foreground is a painting of the execution of Charles I. The picture is being studied by a number of animals, including a wolf wearing a human mask, a bear and a fox. All represent human vices and wear Latin tags identifying them. Behind the picture is a group of conspirators, presumably the regicides. In the centre foreground an armed man dragging a woman by her hair while a child clings to her is a group taken directly from a painting by Rubens, and represents the evil effects of war. On the left are a collection of devils and weird beasts against a background of ruins. There are numerous other symbols, for example, the abandoned scales of justice, and the skulls and hour-glass, both symbols of mortality. The message is, of course, that the execution of Charles I brought subsequent disasters, particularly war and destruction; that regicide leads inevitably to chaos and violence. Its particular interest is that the artist, presumably a Fleming, used a curious mixture of previous styles: the devils and beasts of Hieronymus Bosch represent evil, and the allegorical language of Rubens represents the horrors of war. The result may not be entirely satisfactory in aesthetic terms, but the picture is fascinating as an example of contemporary propaganda and for its unusual stylistic confusion.

Jacob Jordaens (1593–1678)
64 Portrait of Govaert van Surpele (?) and his Wife

Canvas, 84 × 74¾ in. About 1636–7(?). London, National Gallery.

The coat of arms incorporated into the architecture in the centre at the back is that of the van Surpele family of Diest in South Brabant. The man is Govaert van Surpele (1593–1674), who held a number of important posts in the government of Diest. It is most likely that the portrait was painted to commemorate his appointment to a civic office, whose emblem is the staff in his hand. It may have been the *president de la loi*, which van Surpele held in the year 1636–7. In that case, the woman would be van Surpele's second wife, Catharina Coninckx. On the other hand, in view of the sword and sash he wears, his appointment may be a military one. It seems that Jordaens's original idea was to paint the couple in three-quarter length, and that he subsequently extended the composition.

Peter Paul Rubens (1577–1640)
65 (top) A Fallen Tree

Black chalk and wash, 7¼ × 12¼ in. About 1617–19. Chatsworth, The Duke of Devonshire and the Trustees of the Chatsworth Settlement.

This is one of a series of drawings in which Rubens noted down motifs which were likely to be useful for his paintings.

Peter Paul Rubens (1577–1640)
(bottom) A Lion Hunt

Panel, 29⅛ × 41¼ in. 1615–17. London, National Gallery.

This sketch, painted in 1615–17, is executed in a dark brown oil paint with white highlights on a light brown panel. It vividly evokes the speed and ferocity of a lion hunt in the deserts of North Africa. The dramatic central episode is repeated in the top right-hand corner: there the lion's grip is even firmer. Unexpectedly, the composition derives from the *Battle of Anghiari* fresco by Leonardo da Vinci, which Rubens drew when he was in Florence.

Peter Paul Rubens (1577–1640)
66 A Young Woman with Crossed Hands

Red, black and white chalk, 18⅝ × 14 in. About 1630. Rotterdam, Boymans-van Beuningen Museum.

A sheet of great delicacy and beauty, it is usually dated about 1630. It may well be a preparatory drawing for the figure of a female saint on the left of the central panel of the Ildefonso altar, which Rubens painted in 1630–2. The position of the saint's head and body are very similar though the hands are different. However, in the oil sketch in Leningrad which is preparatory to the painting, the same woman, seen from the side, holds her hands in front of her, left hand over right, as she does in the drawing.

Bartholomeus van der Helst (1613–70)
67 Portrait of Abraham del Court and his Wife Maria de Keerssegieter

Canvas, 67¾ × 57⅜ in. Signed, lower left, B vander Helst fecit 1654. Rotterdam, Boymans-van Beuningen Museum.

Bartholomeus van der Helst replaced Rembrandt as Amsterdam's most fashionable portrait painter in the mid 1640s. His style was influenced by Flemish portrait painting, and in particular by Van Dyck. The del Courts were a rich and successful Huguenot family who had settled in Amsterdam. The young couple wear fashionable French clothes, though their colour shows Dutch restraint. His tasselled collar and her richly embroidered tapering bodice (intended to make the wearer appear slimmer) were the latest imported fashions in Amsterdam. For the tradition of portraying a seated couple in a landscape see the note to Plate 38. 'In fidem uxoriam' (marital fidelity) is represented in this way in the most influential of all emblem books, Alciati's *Emblemata*. The joined hands of the couple form both the actual and the figurative centre of the picture. While del Court looks tenderly at his wife, she looks out of the picture, holding the stem of a rose between the fingers of her left hand. Her gesture refers to the love emblem *'geen roosje zonder doornen'* (no roses without thorns). The fountain which plays behind Maria is also a love emblem with a long literary and visual tradition.

Peter Paul Rubens (1577–1640)
68 Landscape with the Château of Steen

Panel, 51¾ × 90½ in. 1636. London, National Gallery.

Rubens bought the Château of Steen, between Brussels and Malines, in 1635 in order that he could paint in peace and study landscape. In his last years he spent more and more time with his new young family at the château. This early morning view was painted soon after he had bought it. The *Château of Steen* had an important influence on English landscape painting. It belonged to Constable's patron Sir George Beaumont, and when Constable lectured on Rubens's landscapes in 1833 he said: 'In no other branch of art is Rubens greater than in landscape – the freshness of the dewy light, the joyous and animated character which he has imparted to it, impressing on the level monotonous scenery of Flanders all the richness which belongs to its noblest features. Rubens delighted in phenomena – rainbows upon a stormy sky – bursts of sunshine – moonlight – meteors – and impetuous torrents mingling their sound with wind and wave.'

Johannes Vermeer (1632–75)
69 View of Delft

Canvas, 38⅝ × 40 in. Monogrammed, lower left, on the boat: IVM. About 1661. The Hague, Mauritshuis.

The town of Delft is viewed from the Rotterdam canal: the Schiedam gate is in the centre, to the right the Rotterdam gate. Between the two gates in the background is the tower of the New Church where Vermeer was baptized; the other tower, further to the left, is the Old Church where he was buried. Vermeer's earliest paintings are large figure scenes in the manner of the Utrecht followers of Caravaggio. In 1667 a local poet wrote that Vermeer rose from the fire that destroyed Carel Fabritius and was following the same path. While there is no evidence that Fabritius (who died in the explosion of the municipal powder magazine in Delft in 1654) was Vermeer's master, there are close stylistic links between the two artists. It may have been the

influence of Fabritius (and perhaps de Hoogh) that caused Vermeer to abandon his early style in favour of the painting of genre pictures and town views. Even in Vermeer's small and extraordinary *oeuvre,* this painting in both its scale and subject-matter is unique. The city is seen after a storm with the sun playing on the roof tops: the texture of stone and water is rendered in dots of pure pigment applied with great delicacy with a loaded brush.

Johannes Vermeer (1632–75)
70 The Artist in his Studio

Canvas, 51⅛ × 43¾ in. Monogrammed on the map IVM. About 1665–6. Vienna, Kunsthistorisches Museum.

This painting is alternatively known as *An Allegory of Painting,* and it does seem to be an allegorical representation of that art. The female figure whom the artist is painting is Clio, the Muse of History: she is holding a trumpet and a book and is thus described in Cesare Ripa's famous *Iconologia,* of which a Dutch edition appeared in 1644. Painting does not have a Muse of its own, and is usually associated with Clio. Beyond this, the painting is a puzzle. It is not clear why the artist himself is dressed in sixteenth-century fashion, nor the precise significance of the mask on the table. The painting on the easel gives us a rare chance to see how Vermeer worked. X-rays of his paintings reveal no preliminary drawing, and on the prepared ground the artist here has only painted the wreath on the girl's head. The rest is lightly sketched in white on a pale grey ground, and such preliminary outlines would be undetectable by X-ray or infra-red photographs. Vermeer's compositions are so perfect and executed with such an apparently unhesitant touch that he might be expected to have made preliminary drawings, yet none exist.

Peter Paul Rubens (1577–1640)
71 Self-Portrait

Black and white chalk, 18½ × 11½ in. About 1633–5. Paris, Louvre.

There are only two surviving self-portrait drawings by Rubens. Unlike Rembrandt, Rubens always saw himself as a gentleman and man of the world. The painting in Vienna for which this is a study shows him wearing the sword he was entitled to carry.

Rembrandt van Rijn (1606–69)
72 *(top)* Three Studies for a Disciple at Emmaus

Pen and bistre, 6⅞ × 6¼ in. About 1633–4. Paris, Fondation Custodia (F. Lugt Collection).

(bottom) Head of an Oriental in a Turban, and a Dead Bird of Paradise

Pen and wash in bistre, white bodycolour, 7 × 6⅝ in. 1637 (?). Paris, Louvre.

It has been suggested that *Head of an Oriental in a Turban* is preparatory for a painting, the *Susanna and the Elders* at Berlin, which is dated 1647, but it is more likely that it was drawn in 1637, and that it is one of the many sketches that Rembrandt made of the Jewish community in Amsterdam. On his arrival in the city in 1631 or 1632, Rembrandt lodged with the art dealer Hendrick van Uylenburch, whose niece Saskia he married in 1634. Uylenburch lived on the edge of the city's Jewish quarter, and in 1639 Rembrandt himself purchased a house there. Jewish models often recur in Rembrandt's drawings and, of course, in his painted scenes from the Old and New Testaments. He also had a number of close personal friends among the Jewish community.

Rembrandt van Rijn (1606–69)
73 The Raising of Lazarus

Etching, 14⅜ × 10¼ in. Signed, RHL (in monogram) van Ryn f. About 1632.

This etching, made in about 1632, just after Rembrandt's arrival in Amsterdam from Leiden, demonstrates for the first time Rembrandt's mastery of the medium of which he was the greatest exponent. The original idea for this treatment of the subject went back two years to a copy Rembrandt had made of an etching by Jan Lievens, with whom he shared a studio in Leiden. Yet Rembrandt's drawing (now in the British Museum) was no mere copy of Lievens's design: in the course of executing the drawing Rembrandt altered the subject to the Deposition of Christ, and also toned down the more melodramatic

elements in Lievens's etching. These various accounts of the Raising of Lazarus point to the closeness of the working relationship of the two young artists. This etching is a majestic image, which, although referring to the previous compositions, exceeds them all in authority and pathos.

Jan Brueghel the Elder (1568–1625)
74 View of the Town of Spa

Pen and bistre, washed in bistre, blue, red and Indian ink, 10¼ × 16¼ in. Signed and dated, lower left: Spa Bruegel fec. adi 22 Agosto 1612. Paris, Fondation Custodia (F. Lugt Collection).

Spa is a small town in eastern Belgium, to the south-east of Liège. It has been noted for its medicinal springs since Roman times. This drawing is of one of the town squares. The building in the centre is the market hall, with the municipal offices on the first floor. On the right is the 'pirreon', symbolizing the liberties of Liège: laws and decrees were proclaimed here in the so-called 'Cri de Perron'. This is one of a number of drawings of the town made in connection with an extensive bird's-eye view of Spa by Jan Brueghel which was engraved by Willem van Nieulandt.

Jan van Goyen (1596–1656)
75 View of Dordrecht

Canvas, 63½ × 100 in. Sussex, Petworth House, The National Trust.

Jan van Goyen was a pupil of a succession of minor Leiden painters, and then for two years of Willem Gerritsz at Hoorn. At nineteen he went to France for a year, and on his return spent a year in the studio of Esaias van de Velde at Haarlem. He worked in Leiden until 1632 when he moved to The Hague, where he continued to work until his death. Van Goyen's early style shows the influence of Esaias van de Velde up until 1626. Immediately afterwards, he begins to paint in the new monochromatic Haarlem landscape style of which he, Pieter Molijn and Salomon van Ruysdael are the principal exponents.

Peter Paul Rubens (1577–1640)
76 Hélène Fourment in a Fur Wrap (Het Pelsken)

Panel, 69¼ × 32⅜ in. About 1638. Vienna, Kunsthistorisches Museum.

In his will Rubens left his young, second wife Hélène Fourment one picture, this portrait of her in the nude known as *Het Pelsken* (the fur wrap). It is an almost shockingly intimate portrait, confirmation – if confirmation were needed – that the sensuality so evident in Rubens's paintings of women extended into his private life. The painting was no doubt inspired by Titian's half-length *Girl in a Fur.* Rubens must have seen Titian's painting in Charles I's private apartments at Whitehall, and had made a painted copy of it.

Rembrandt van Rijn (1606–69)
77 Portrait of Hendrickje Stoffels

Canvas, 39¾ × 32⅞ in. Signed: Rembrandt. f./ 16 (?5)9. London, National Gallery.

Hendrickje Stoffels is first mentioned as a member of Rembrandt's household in a document of 1649. Saskia had died in 1642. The artist never married Hendrickje, presumably because a second marriage would have deprived him of much-needed income from Saskia's dowry held in trust for Titus under the terms of her will. When Hendrickje became pregnant, she was summoned before the church council, where she 'confessed to the sin of fornication with the painter Rembrandt, was severely punished, admonished to repentance, and excluded from the Lord's Supper'. Despite this public reprimand, Hendrickje stayed with Rembrandt and bore him a daughter. When in 1656 Rembrandt was obliged to apply for a *cessio bonorum* (a form of bankruptcy), auction his collection and move from his house in the Breestraat, Hendrickje and Titus formed a company which made Rembrandt its employee. He made his entire production over to them in return for a wage, and by the use of this legal loophole was able to keep the earnings from his work rather than hand them directly to his creditors. Hendrickje remained with the artist until her death in 1662. There is no documented portrait of Hendrickje as there is of Saskia, but there are a number of paintings representing the same model dating from the time when she lived with the painter. The recurrence of this model and the affection with which she is painted point to her being Hendrickje.

Gabriel Metsu (1629–93)
78 A Man and Woman Seated by a Virginal

Panel, 15⅛ × 12¹¹⁄₁₆ in. Signed, top right, G. Metsu. About 1660. London. National Gallery.

Born in Leiden, son of the Flemish-born painter Jacques Metsue, Gabriel was probably a pupil of Gerrit Dou. He was one of the founder members of the Leiden guild in March 1648. He spent a period outside Leiden in the 1650s, but did not settle permanently in Amsterdam until 1657. The lid of this virginal and the inside of the keyboard cover both bear inscriptions from the Psalms. The same virginal (with slight variations) occurs in other paintings by Metsu. The painting at the back on the left, partly covered by a curtain, is *The Twelfth Night Feast* in the Alte Pinakothek, Munich, an early work by Metsu himself, showing his study of the Utrecht Caravaggists. The landscape hanging on the right is in the style of Jacob van Ruisdael.

Peter Paul Rubens (1577–1640)
79 *(top and bottom)* The Garden of Love

Pen and ink, washed, touched up with indigo, green and white over black chalk, 19¼ × 28¼ in. respectively. About 1632–4. New York, Metropolitan Museum of Art.

This allegorical drawing (the two parts were originally one continuous composition) was done by Rubens as a guide for a woodcut by Christoffel Jegher (1596–1652). The design is full of symbols and seventeenth-century notions: water jets for the unaware were a favourite feature of early garden architecture.

Rembrandt van Rijn (1606–69)
80 Lioness Eating a Bird

Black chalk, wash in Indian ink, heightened with white, 5 × 9½ in. About 1641. London, British Museum.

Rembrandt made several studies of captive wild animals. He made the drawings for use in paintings, but often sold them as independent works of art.

Anthony Van Dyck (1599–1641)
81 A Study of Cows

Pen and brown ink, with brown wash, 12½ × 20¼ in. Chatsworth, The Duke of Devonshire and the Trustees of the Chatsworth Settlement.

There has been some controversy whether this drawing is by Van Dyck or by Rubens. It has been supposed to be an original study by Rubens for the *Landscape with Cows* at Munich, a late work of about 1636–8. In fact the relationship between the drawing and the painting is not very close, and it is more likely that Rubens incorporated into his painting elements of his gifted assistant's drawing, which was already in his studio.

Rembrandt van Rijn (1606–69)
82 The Hundred Guilder Print

Etching, 11 × 15¼ in. About 1649.

The popular title by which this print is known can be traced to the famous French eighteenth-century print collector Mariette, who records that the artist himself bought back an impression of the print for 100 guilders. This title is convenient as the subject seems to be the whole of chapter 19 of the Gospel of St Matthew, which describes Christ's activities after 'He departed from Galilee; and came into the coasts of Judaea beyond Jordan', and each of the various events described by St Matthew can be identified in the etching. The right half illustrates how 'great multitudes followed Him; and He healed them there'. The Gospel goes on to recount at length how the Pharisees tried to provoke Christ into a discussion on the lawfulness of divorce, to which Rembrandt refers by the inclusion of a group of Pharisees in the left-hand background. The most important event on the left-hand side of the print illustrates verses 13 and 14: 'Then were brought unto Him little children, that he should put his hands on them, and pray. And the disciples rebuked them; but Jesus said: Suffer little children, and forbid them not, to come unto me; for of such is the kingdom of heaven.' Peter, recognizable by his bare head, to the immediate left of Christ, pushes a woman back with his hand, at the same time looking toward Christ for approval. He receives a firm rebuke, as Christ, with an unequivocal gesture of his right hand, invites the mothers and children forward. The thoughtful young men

in fine clothing, sitting on the ground between the two mothers, refer to the incident of the rich young man who was told to give up his riches in order to follow Christ. The camel on the extreme right may refer to Christ's words after the rich young man had gone on his way: 'It is easier for a camel to go through the eye of a needle than for a rich man to enter the Kingdom of Heaven.' Thus, in this uniquely complex print, Rembrandt has with enormous skill of design united four separate incidents within one composition. The print was executed in about 1649 and represents the culmination of Rembrandt's etching activity in the 1640s.

Meindert Hobbema (1638–1709)
83 A Woody Landscape with a Cottage

Canvas, 39⅛ × 51⅜ in. About 1665. London, National Gallery.

In July 1660, Jacob van Ruisdael, who had settled in Amsterdam by June 1657, testified that Hobbema had been his apprentice for 'some years'. His most characteristic compositions – forest landscapes organized around a pool or a path – were painted between 1663 and 1668. Thereafter he painted few pictures, though among them is his masterpiece, *The Avenue at Middelharnis* (dated 1689; National Gallery, London), based on the memory of a visit to South Holland. There are at least three other versions of Plate 83. It is an outstanding example of Hobbema's favourite subject, a woody landscape illuminated by strong shafts of sunlight.

Frans Hals (*c.* 1581/5–1666)
84 Portrait of a Seated Woman

Panel, 17⅞ × 14⅛ in. Signed, lower right corner, with the FH monogram. About 1660–6. Oxford, Christ Church.

The only extant female portrait from Hals's last period, that is, 1660–6, a date established by the freedom of handling. The candour of the presentation and the looseness of the brushwork, the qualities which we value so highly in Hals's work today, were presumably not in demand among Dutch women of the period. The pose suggests that the portrait originally had a pair.

Rembrandt van Rijn (1606–69)
85 Portrait of an Elderly Man

Canvas, 32¼ × 26½ in. Signed, Rembrandt f 1667. Private Collection.

Far from being the forgotten genius of popular legend, Rembrandt continued to receive important commissions after his bankruptcy (see note to Plate 77). He contributed to the decoration of the new town hall, painting *The Conspiracy of Julius Civilis* (now in Stockholm) in 1661–2. In 1662 he painted the group portrait of *The Staalmeesters* (Rijksmuseum, Amsterdam), and in 1663 the *Equestrian Portrait of Frederik Rihel* (National Gallery, London). This is a vigorous late portrait, consistent in style with the other commissioned portrait of 1667, the *Portrait of a Fair-Haired Man*, now in the National Gallery of Victoria at Melbourne. In the eighteenth and nineteenth centuries the portrait was variously identified as 'Admiral Ruyter' and 'van Tromp', but it bears no resemblance to de Ruyter or either of the Tromps.

Jacob van Ruisdael (1628/9–82)
86 An Extensive Landscape with a Ruined Castle and a Village Church

Canvas, 43 × 57½ in. Signed, in the water, lower right: JvRuisdael (JvR in monogram). About 1665–70. London, National Gallery.

The greatest of all Dutch landscape painters, Jacob van Ruisdael was born in Haarlem. By 1657 he had settled in Amsterdam where he lived for the rest of his life. His early work shows the influence of his uncle Salomon van Ruysdael and of the Haarlem landscapist Cornelis Vroom, but later, having studied the work of 'Italianizing' artists like Both and Asselijn, he painted monumental compositions with a subdued palette. Ruisdael had many pupils (including Hobbema) and followers, and was also influential in the development of landscape painting in nineteenth-century England and France. This imaginary view was painted in the later 1660s: Ruisdael painted the same view in at least four other paintings. The Dutch countryside provides a foil to the clouds glowering grimly above, and throwing dark shadows across it. In his third lecture to the Royal Academy, Constable said: 'Ruisdael delighted in, and has made delightful to our eyes, those solemn days, peculiar to his country and to ours, when without storm,

large rolling clouds scarcely permit a ray of sunlight to break the shades of the forest. By these effects he enveloped the most ordinary scenes in grandeur.'

Rembrandt van Rijn (1606–69)
87 The Crucifixion ('The Three Crosses')

Etching, $15\frac{1}{8} \times 17\frac{3}{4}$ in. Signed and dated (in third impression only): Rembrandt.f.1653.

One of the greatest of Rembrandt's religious etchings, in a decade which saw the climax of his work as a printmaker. It has an expressiveness and monumentality which is evident also in the drawings and paintings of religious subjects in this decade. The source is St Luke's description of the Passion (23: 44–8): 'And it was about the sixth hour; and there was a darkness over all the earth until the ninth hour; and the sun was darkened. And the veil of the temple was rent in the midst. And when Jesus had cried with a loud voice, he said: Father, into thy hands I commend my spirit. And having said this, He gave up the ghost. Now when the centurion saw what was done, he glorified God saying: Certainly this was a righteous man. And all the people that came together to that site, beholding the things that were done, smote their breasts and returned.' Rembrandt followed St Luke's text closely: the thief on the left is in shadow and the one on the right lit by a heavenly light, a distinction between the bad and the good thieves which occurs only in St Luke's account. The central episode in the print, however, is the conversion of the centurion, who has dismounted from his horse, removed his helmet and raises his arms in wonder. The Virgin swoons, while St John holds his fist to his head in an expression of anguish. The 'darkness over all the earth' is broken only by shafts of light originating from above Christ.

Rembrandt van Rijn (1606–69)
88 *(top)* Farm Buildings beside a Road

Pen in Indian ink, wash, $4\frac{1}{2} \times 9\frac{3}{4}$ in. About 1650. Oxford, Ashmolean Museum.

(bottom) A Thatched Cottage

Reed-pen and bistre, in parts rubbed with the finger, $6\frac{7}{8} \times 10\frac{1}{2}$ in. About 1652. Chatsworth, The Duke of Devonshire and the Trustees of the Chatsworth Settlement.

89 *(top)* Cottages beneath High Trees

Pen and brush in bistre, wash, $7\frac{5}{8} \times 12\frac{1}{4}$ in. About 1657–8. Berlin, Kupferstichkabinett.
(bottom) The Singel at Amersfoort

Pen and bistre, wash, $6 \times 10\frac{7}{8}$ in. About 1647–8. Paris, Louvre.

Rembrandt's drawings and etchings of landscape form a quite distinct group within his work as a whole. They represent a simple, understated response to nature, and, more particularly, to the countryside around Amsterdam. He often walked out of the city (sometimes accompanied by one or other of his pupils) carrying a sketchbook, and he directly transcribed what he saw. His landscape paintings, of which a dozen or so survive, are (with the exception of the *Winter Landscape* of 1646 at Cassel) quite different. They owe much of their atmosphere and technique to the example of Hercules Segers. They are dramatic in mood, artificial in feeling: the skies are overcast, and the high viewpoint gives almost a bird's-eye view of barren landscapes dotted with fantastic architecture. The comparison reveals a fascinating difference between the relative functions of drawing and painting in Rembrandt's work.

Rembrandt van Rijn (1606–69)
90 *(top)* Saskia Asleep in Bed

Pen and bistre, $5\frac{3}{4} \times 8$ in. About 1635. Oxford, Ashmolean Museum.

(bottom) Saskia's Lying-in Room

Pen and bistre, washes in bistre and Indian ink, heightened with white, $5\frac{5}{8} \times 6\frac{7}{8}$ in. About 1639. Paris, Fondation Custodia (F. Lugt Collection).

Saskia met Rembrandt through her cousin, the art dealer Hendrick van Uylenburch. The couple were married in June, 1634. A number of children were born, though only one, Titus, survived into manhood. Weakened by continual pregnancies, Saskia died in 1642. She had brought Rembrandt a large dowry: on her death, her estate was valued at over 40,000 guilders. *Saskia Asleep in Bed* was drawn only a year or so after their marriage. It is one of the most tender of all Rembrandt's many studies of his wife in bed.

Rembrandt van Rijn (1606–69)
91 Self-Portrait

Canvas, 45×37 in. About 1669. London, Kenwood House, Iveagh Bequest.

One of the greatest and the latest of the remarkable sequence of self-portraits by Rembrandt (an earlier one is Plate 54). It was probably painted shortly before his death, perhaps even in the year of his death, 1669. His brush-strokes are bold and free, the design is deceptively simple. There has been much discussion of the circles on the canvas behind him. It has been suggested that the circle on the left is an emblem of theory and that on the right one of practice: Rembrandt conceived of himself as *'ingenium'* with palette and maulstick, between the emblems of theory and practice. This may be the explanation: certainly they have not been painted on the prepared canvas without a specific purpose.

Paulus Potter (1625–54)
92 The Bull

Canvas, $92\frac{3}{4} \times 133\frac{1}{2}$ in. Signed: Paulus. Potter. f. 1647. The Hague, Mauritshuis.

Paulus Potter had a brilliant but brief career, dying at the age of twenty-nine. He was the son of a painter living in Amsterdam. He worked in Delft, The Hague and eventually returned to Amsterdam. Almost all his paintings are of animals in landscape, and, with few exceptions, are on a small scale. This extraordinary, enormous canvas is the principal exception. *The Bull* was one of the most famous of all Dutch paintings in the nineteenth century, and while we may not share this judgement, it is difficult to deny the impact of the painting. It represents, perhaps, the last word in Dutch realism.

Willem van de Velde the Younger (1633–1707)
93 The Battle of the Texel

Canvas, 59×118 in. Signed, on the back of the canvas: W V Velde of 1687. Greenwich, National Maritime Museum.

In 1674 Willem van de Velde and his father entered the service of Charles II: in the warrant of appointment it is specified what each is to be paid, the father for 'taking and making draughts of sea-fights' and the son for 'putting the said Draughts into Colours'. Much of their work was done at Greenwich where they had a studio in the Queen's House. It is often said of Willem van de Velde the Younger that his best work was done while he was in Holland, and indeed much of the work of his English period is mechanical and repetitive. He abandoned pure seascape for specific vessels and events at sea. However, when he received an important commission such as this one, he was capable of producing work of the highest quality. The Battle of the Texel, an action fought during the Third Anglo-Dutch War, took place on 11 August 1673. As commander-in-chief of the Anglo-French fleet, Prince Rupert's objective was to gain control of the Dutch coast so that a seaborne landing could be made. In this he was thwarted by the Dutch fleet under de Ruyter. This painting, based on drawings by Willem van de Velde the Elder of 1673, is dated on the back of the canvas 1687. Because of the prominence given to Cornelis Tromp's flagship, the *Gouda Leeuw* (Golden Lion), it seems likely that it was commissioned by him. He had close links with the English court. The picture highlights the duel between Tromp, who was admiral of one of the squadrons of the Dutch fleet, and Sir Edward Spragge, admiral of the blue squadron, in his flagship, *The Royal Prince*.

Jan van Huysum (1682–1749)
94 Flowers in a Terracotta Vase, and Fruit

Canvas, $52\frac{1}{2} \times 36$ in. Signed on the ledge, bottom right: Jan van Huijsum/fecit 1736 / en 1737. London, National Gallery.

Jan van Huysum was born in Amsterdam and was a pupil of his father, Justus van Huysum (1659–1716), who was also a flower painter. He remained in Amsterdam all his life, and although he painted a few idealized landscapes, most of his work consists of paintings of flowers and fruit. These highly-finished, brightly-coloured flower paintings brought him great contemporary fame and he was among the most highly-paid painters of his day. He was widely imitated, particularly during the second half of the eighteenth century and the early nineteenth century. In the vase, which is decorated with putti in low relief, are peonies, poppies, blue iris, African marigolds, apple blossom, narcissus, marigolds, tulips, jacinths, roses, ranunculus and auriculas. At the foot of the vase are pink roses, red and white carnations and blue convolvulus, with black and white grapes,

peaches and a chaffinch's nest. Most of the flowers are larger than the natural size. As often in van Huysum's work, the flowers are of different seasons. He sometimes delayed the completion of a painting until a particular flower was in bloom. This would explain the double dates that appear on some of his paintings including this one, which is one of the largest and most elaborate of all his flower-pieces.

Jacob de Gheyn (1562–1629)
95 Study of Nine Heads

Pen and ink, 14¼ × 10¼ in. Signed and dated 1604, bottom centre. Berlin-Dahlem, Kupferstichkabinett.

This sheet of sketches from life is outstanding not only for the precociousness of its realism but also for the spontaneity and liveliness of the pen strokes. De Gheyn asked a young male model to assume a whole range of expressions from the intensely serious to the humorous and the quizzical. He also drew him from a very difficult angle at the bottom left. This sheet gives us some idea of the importance of de Gheyn in the development of realism in the early part of the seventeenth century, and it is surprising to modern observers that the artist who drew this remarkable group of sketches could also have executed the exquisitely-drawn but laboriously conceived *Allegory of Death* (Plate 5).

Jacob van de Ulft (1621–89)
96 A Moscovite Delegation at Gorinchem

Watercolour and gouache on parchment, 10⅝ × 14⅝ in. Signed. Paris, Fondation Custodia (F. Lugt Collection).

Van der Ulft was active as a painter, painter on glass and as a draughtsman, and was probably self-taught. He seems always to have worked at Gorinchem, where, from 1661, he held various public posts. Although there are problems of identification as regards this drawing, it shows very well a ceremonial aspect of seventeenth-century public life.

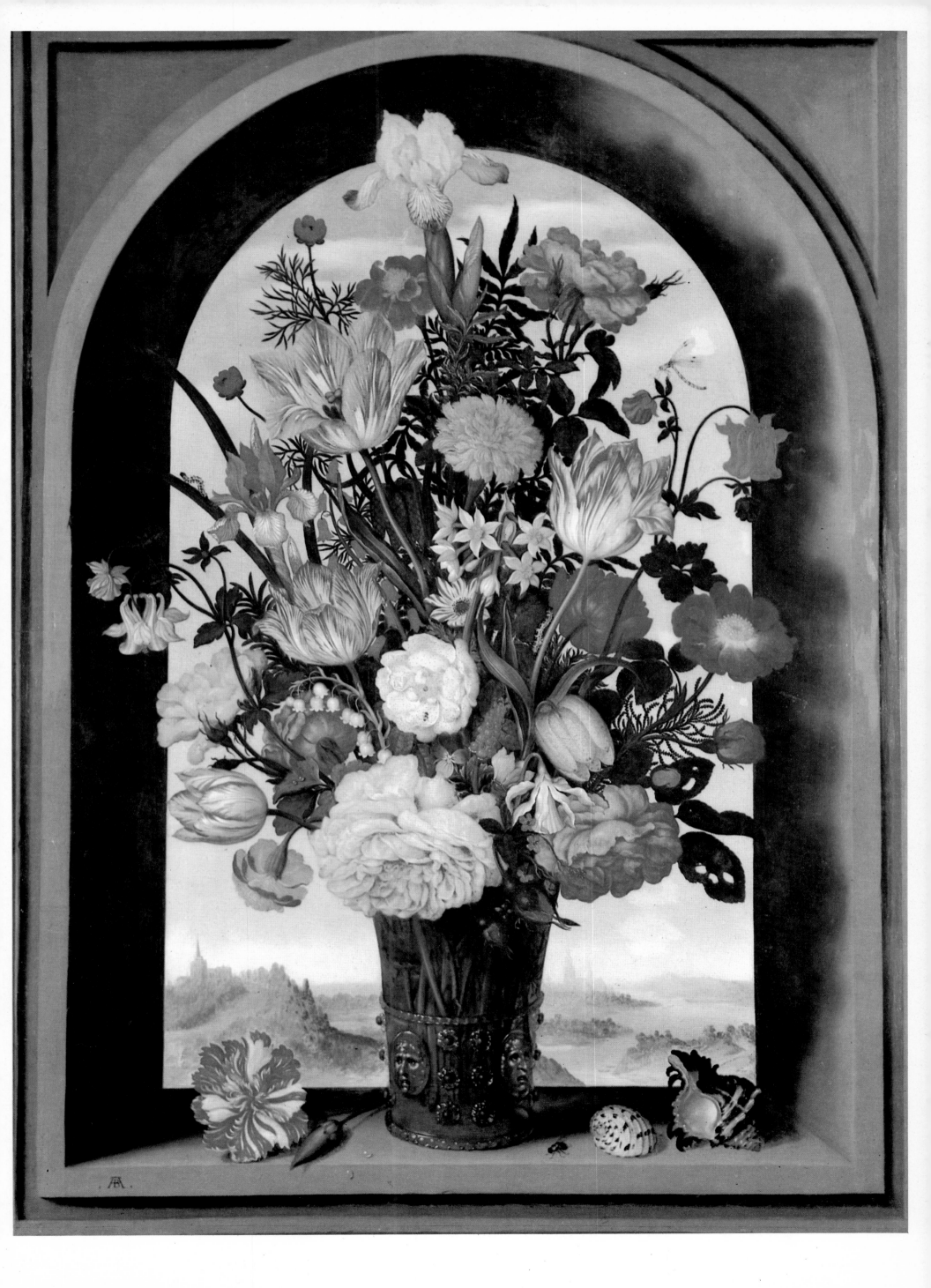

1

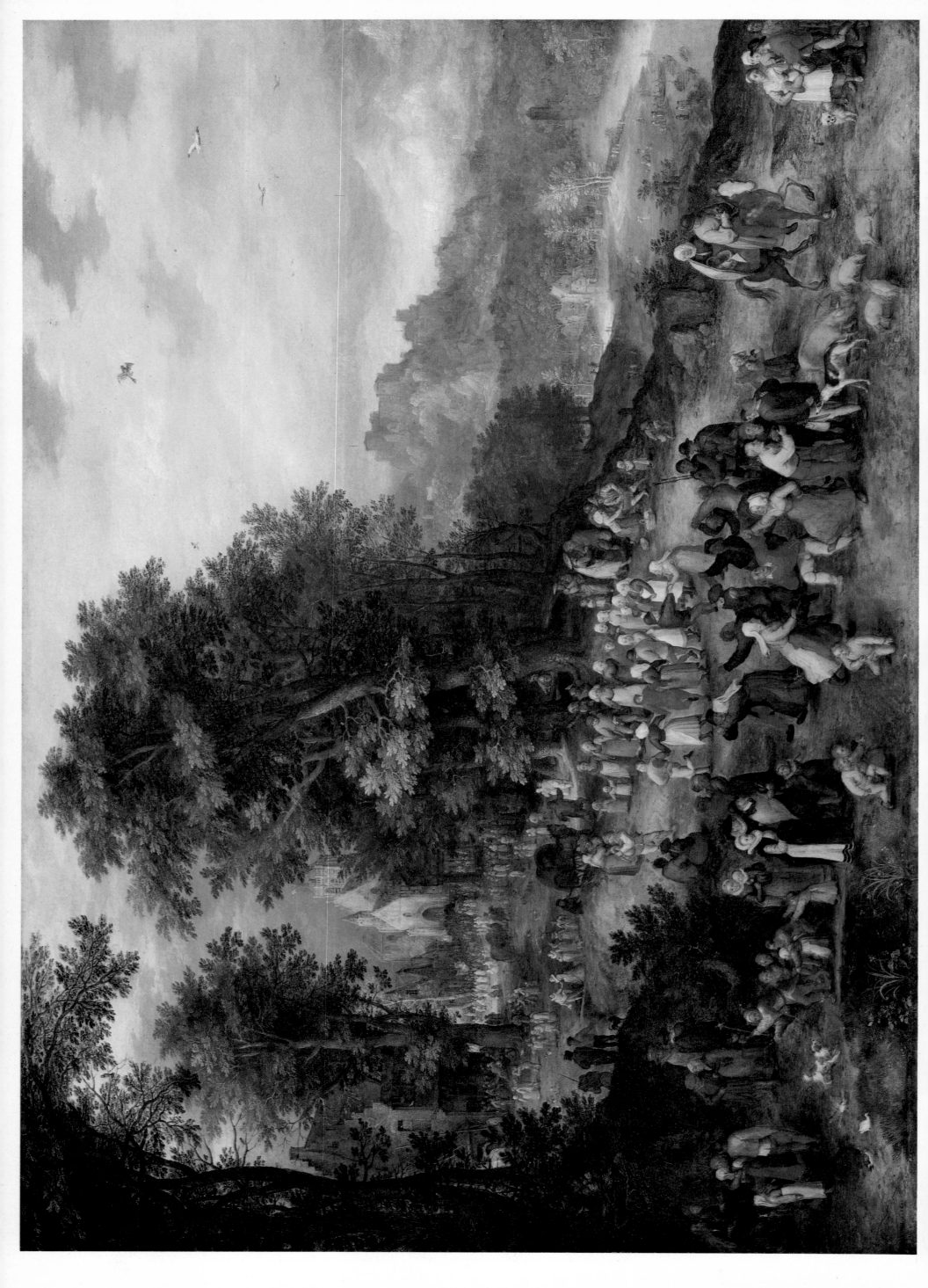

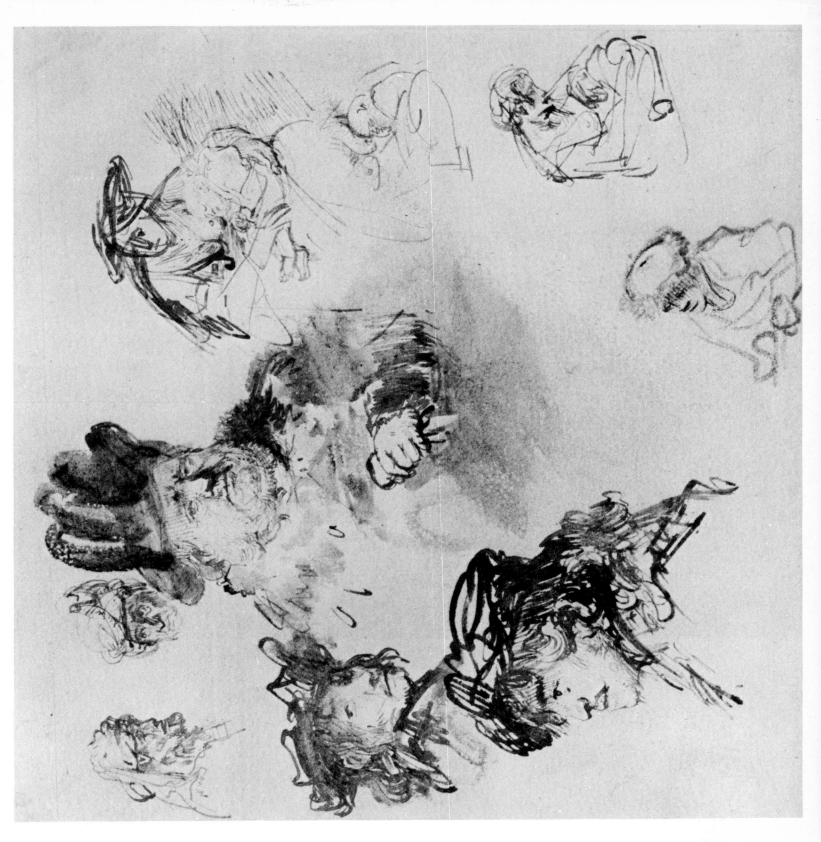

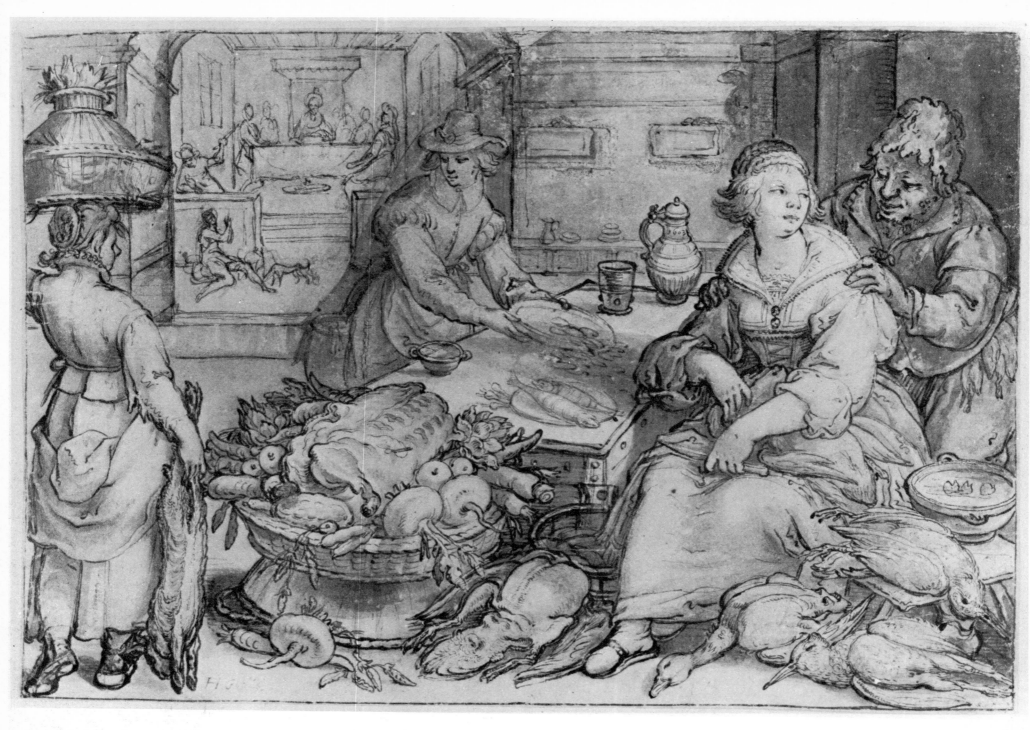

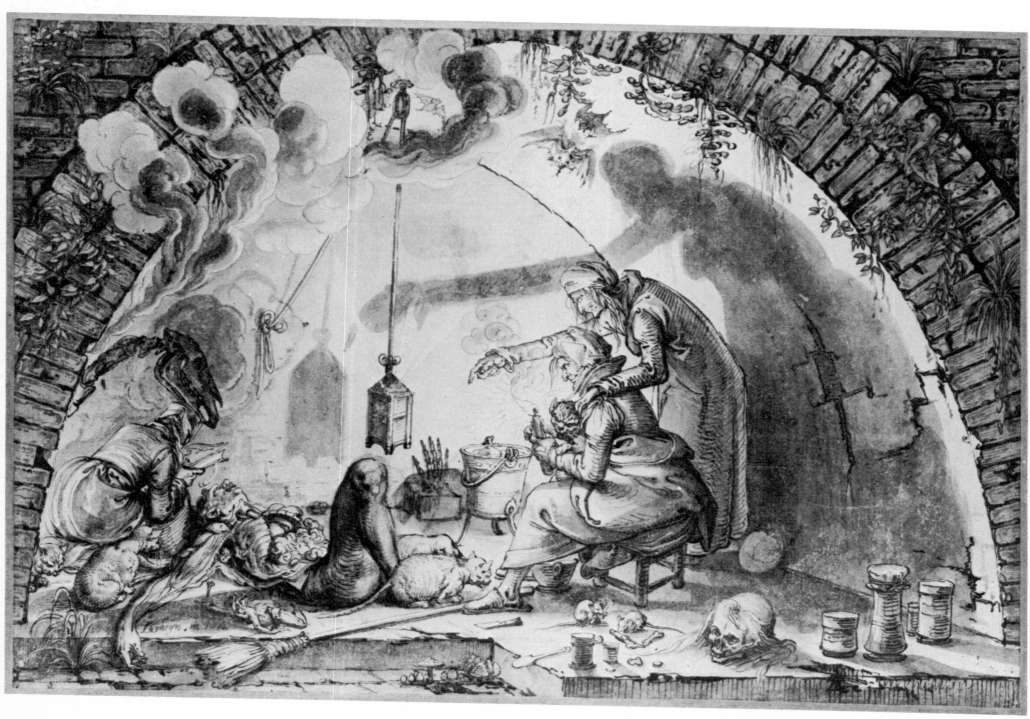

4

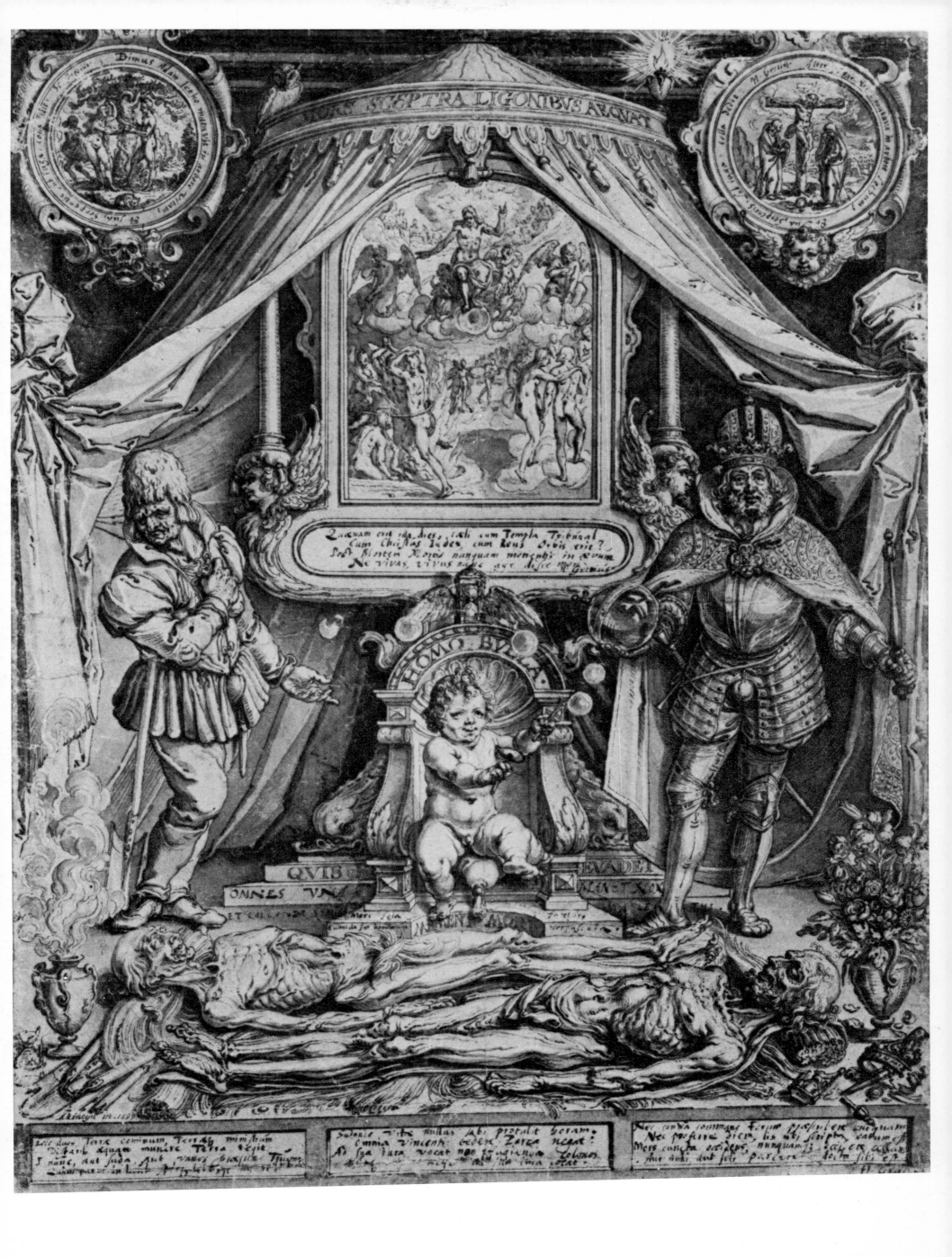

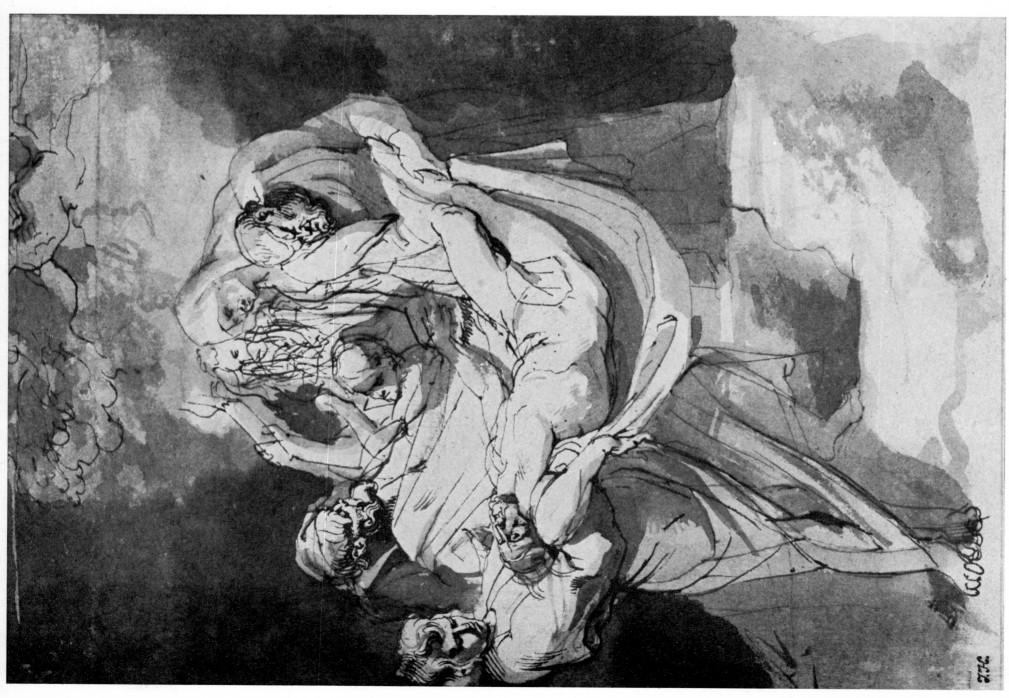

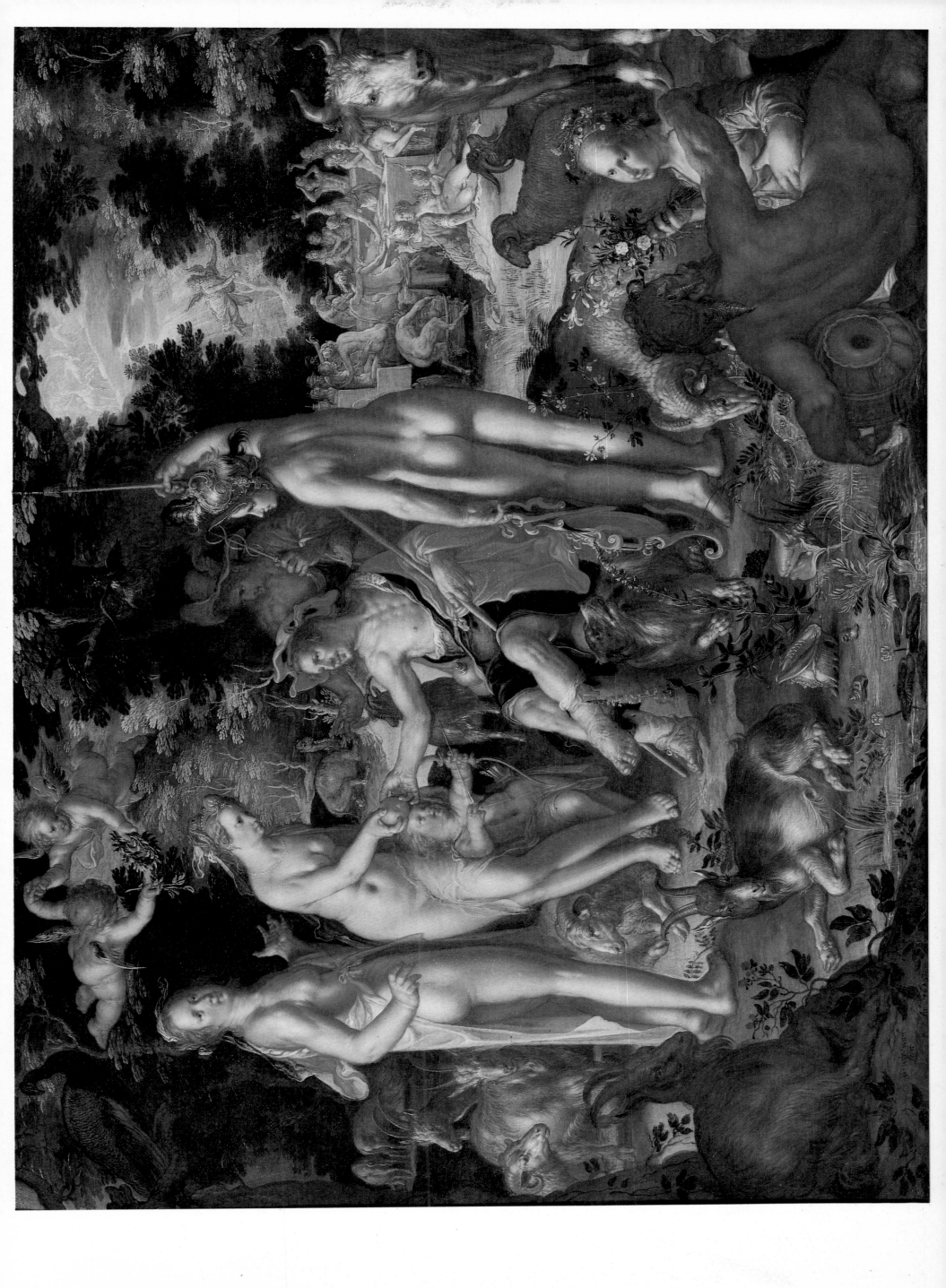

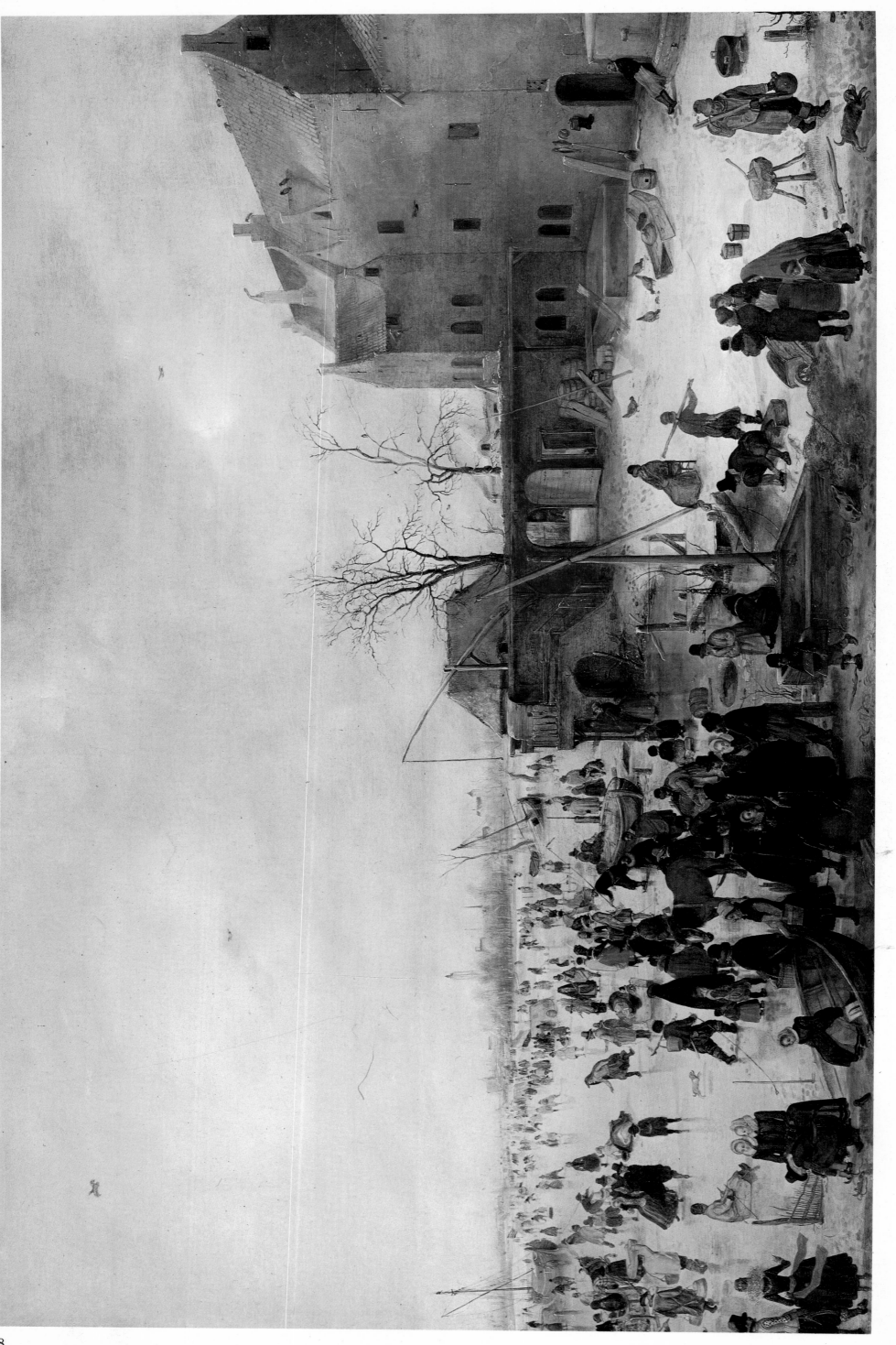

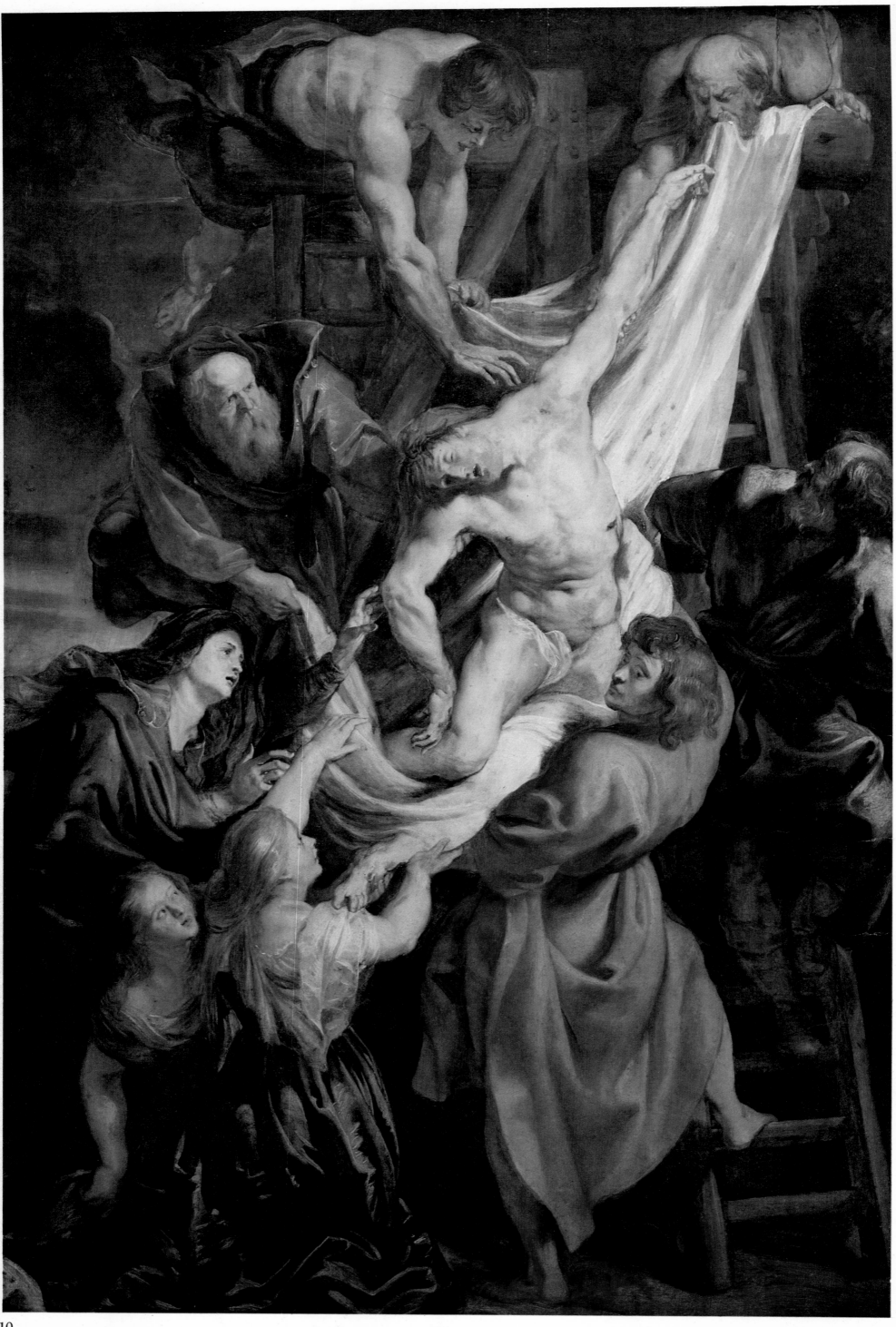

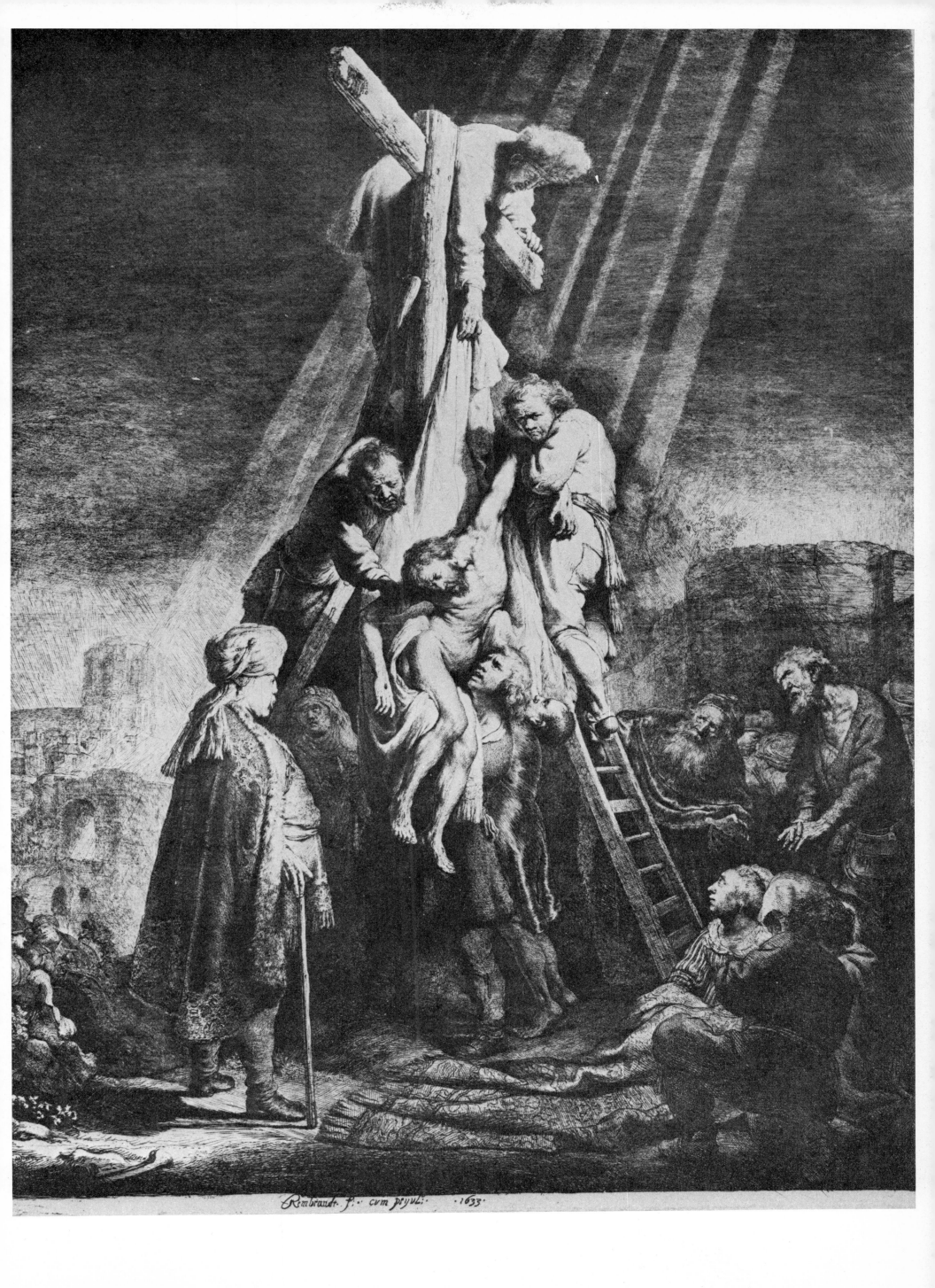

Rembrandt f. cum pryul: 1633.

11

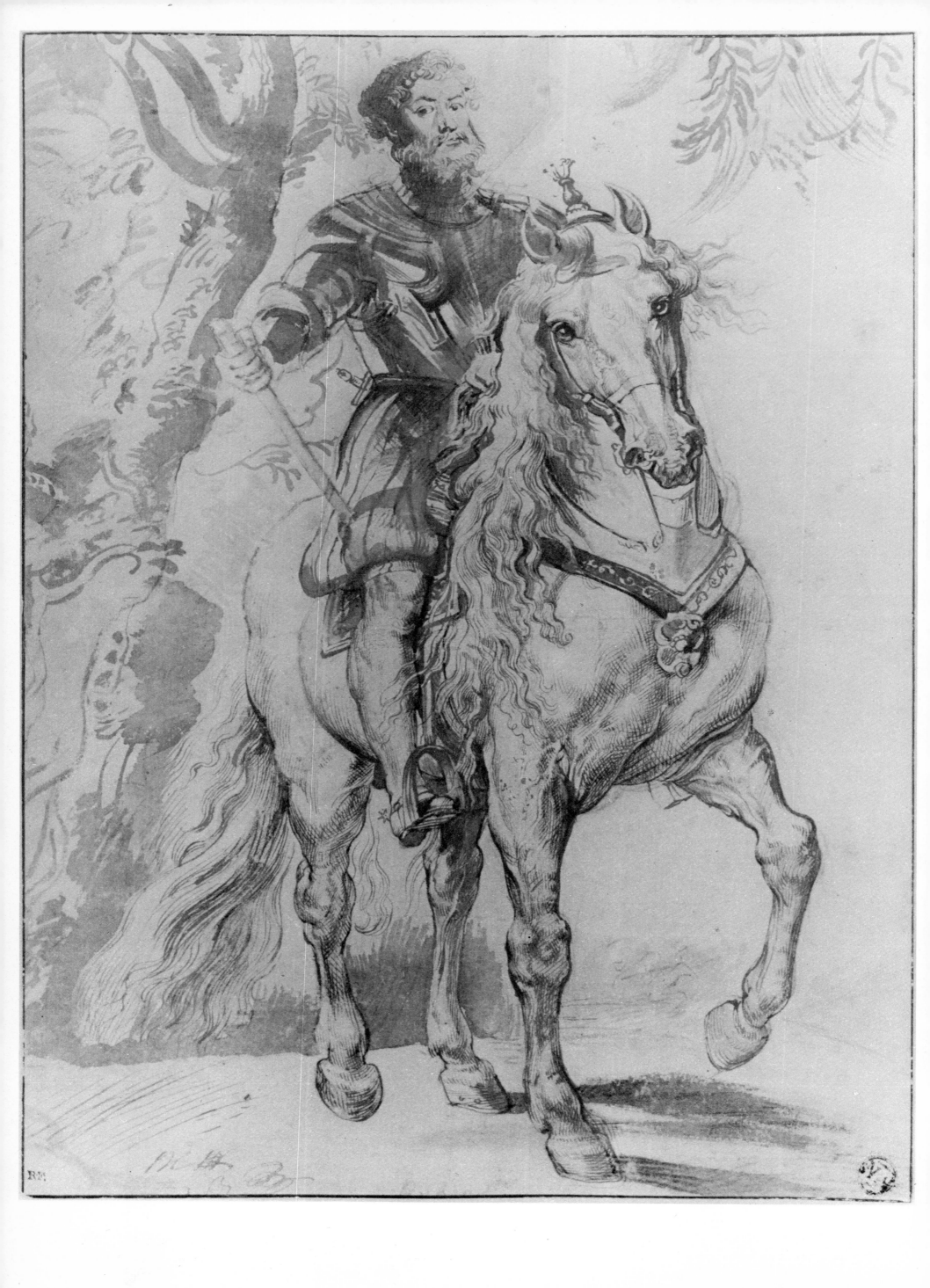

12

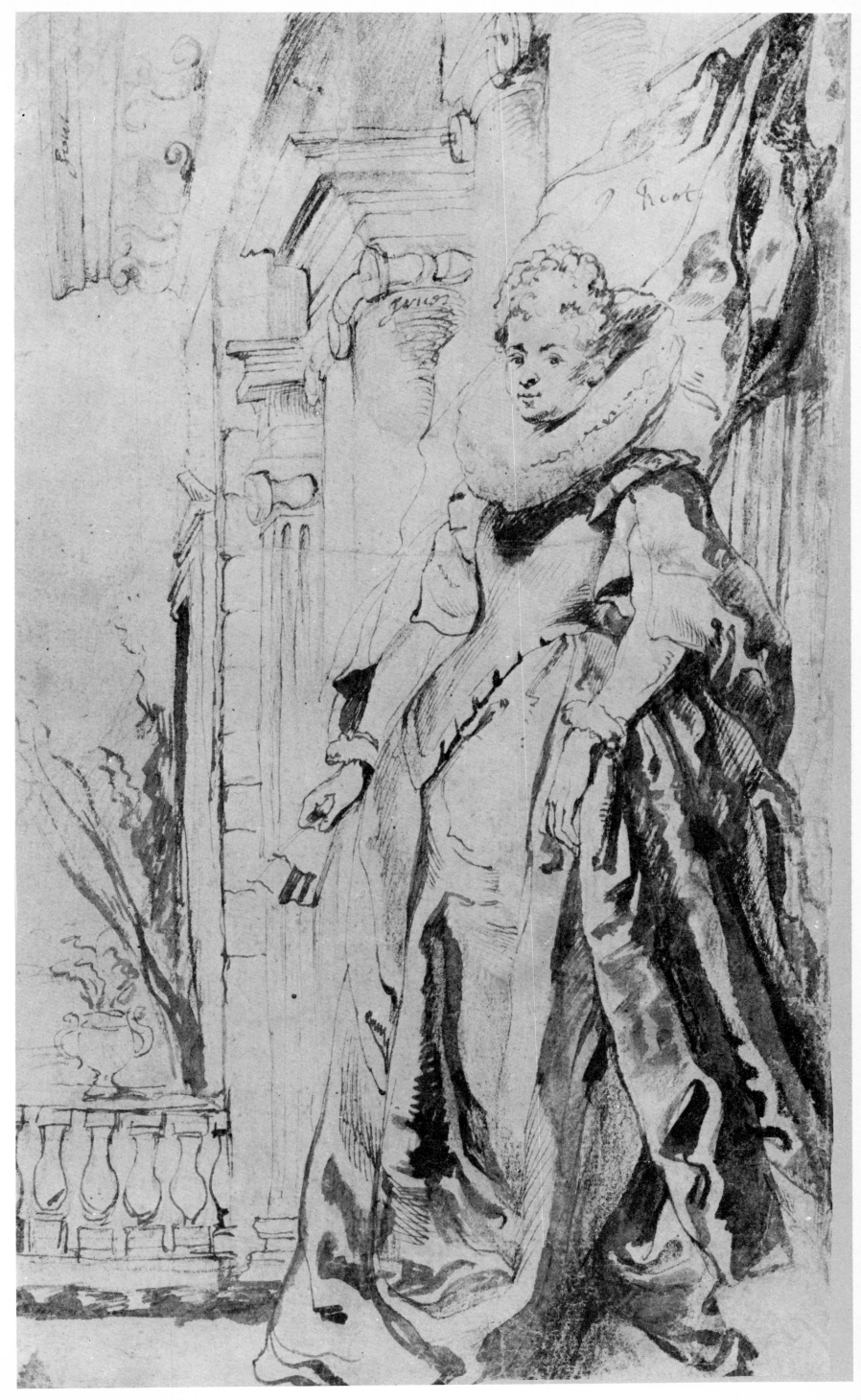

13

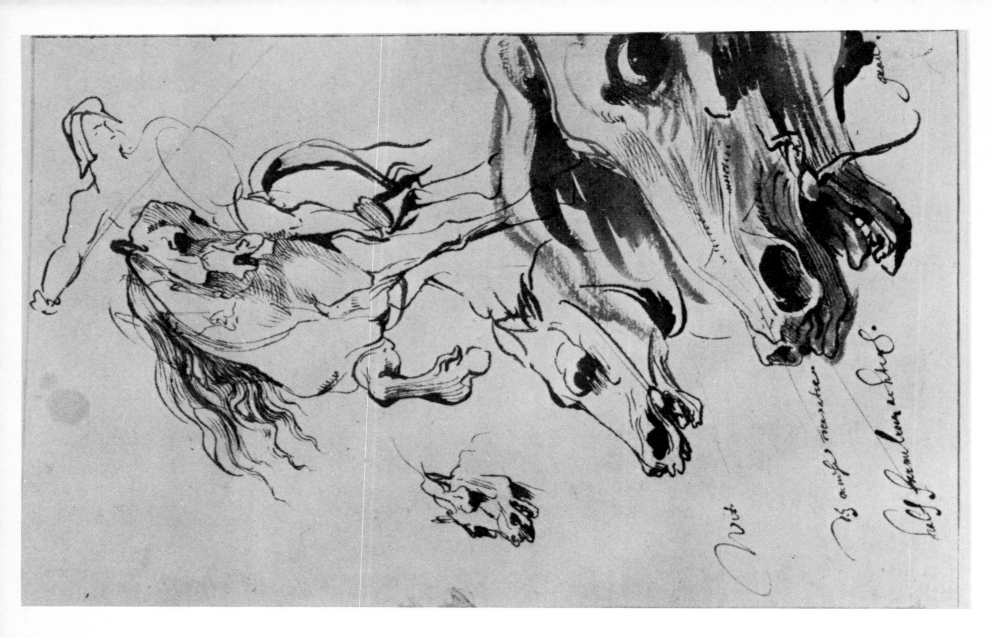

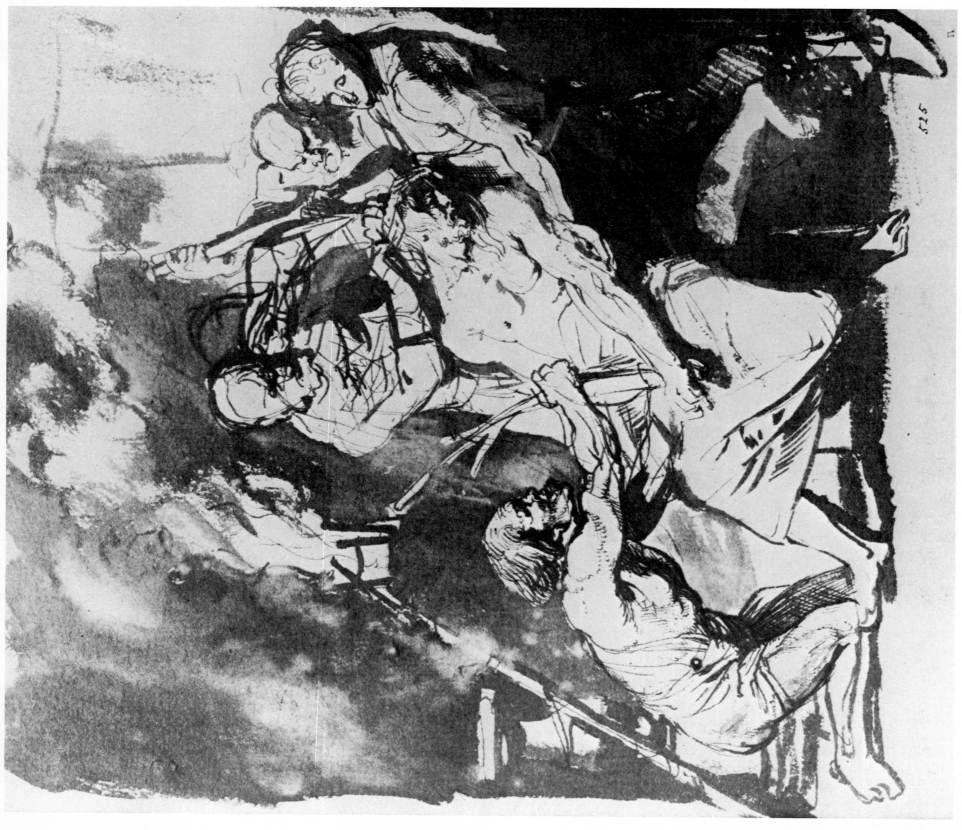

14

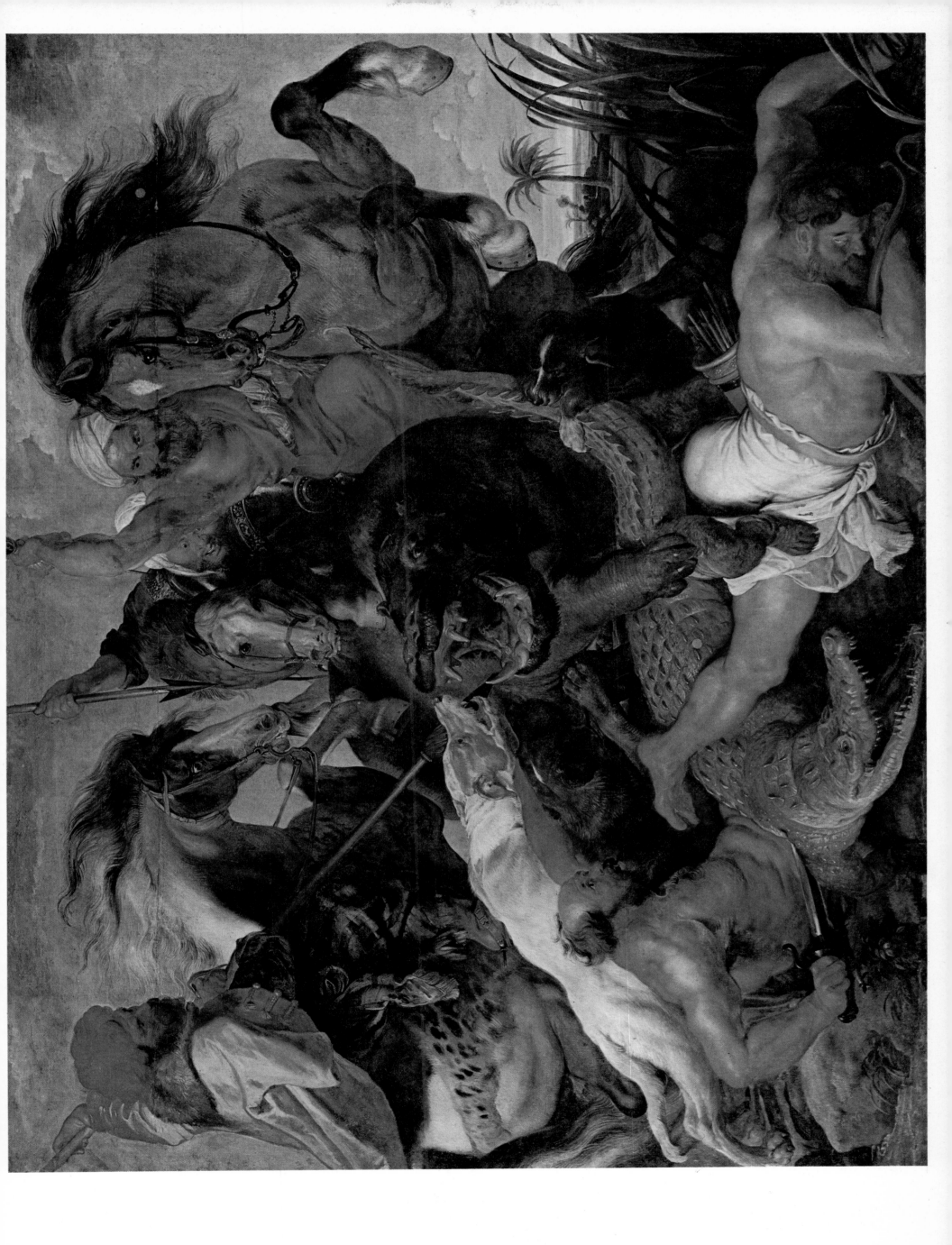

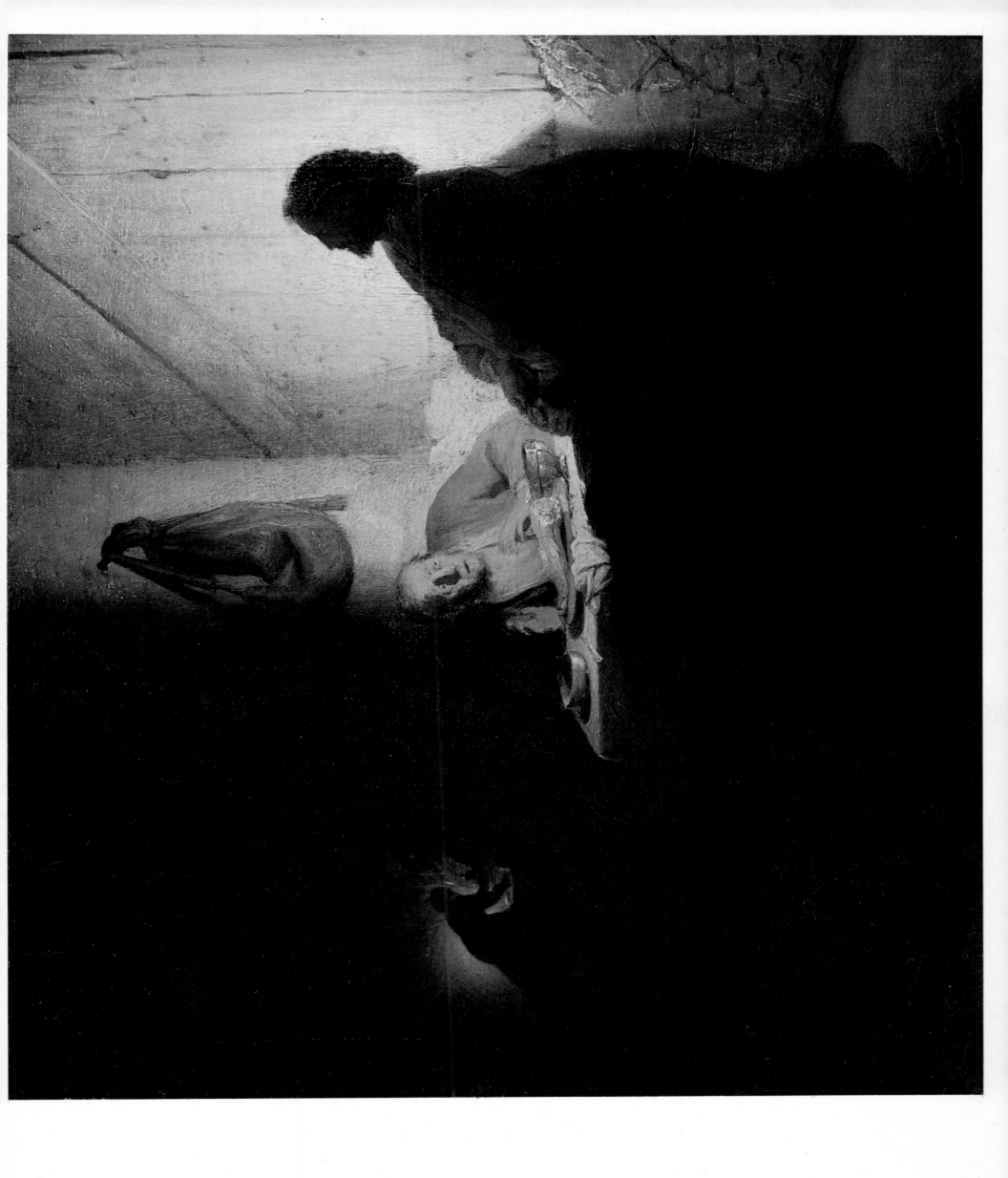

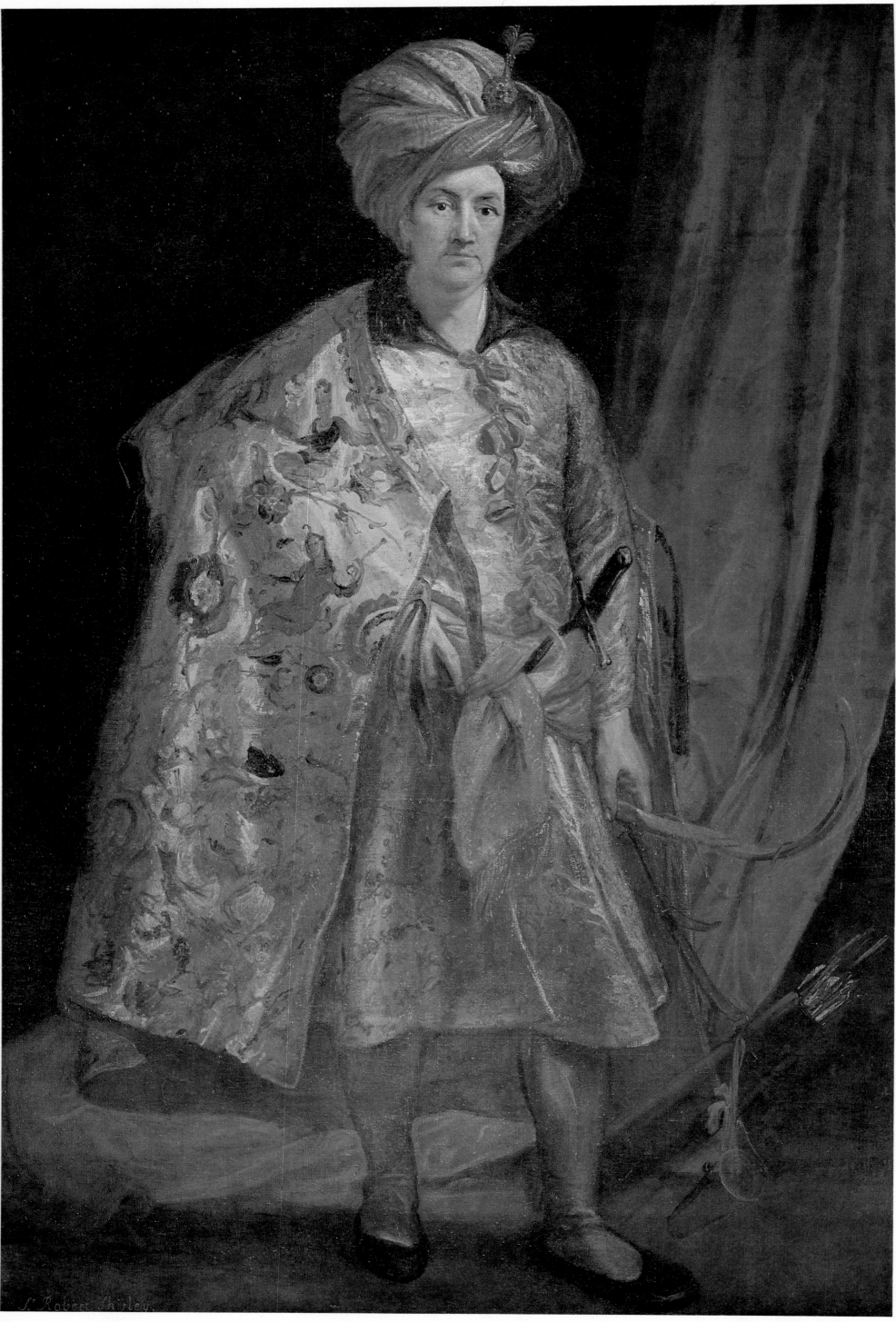

18

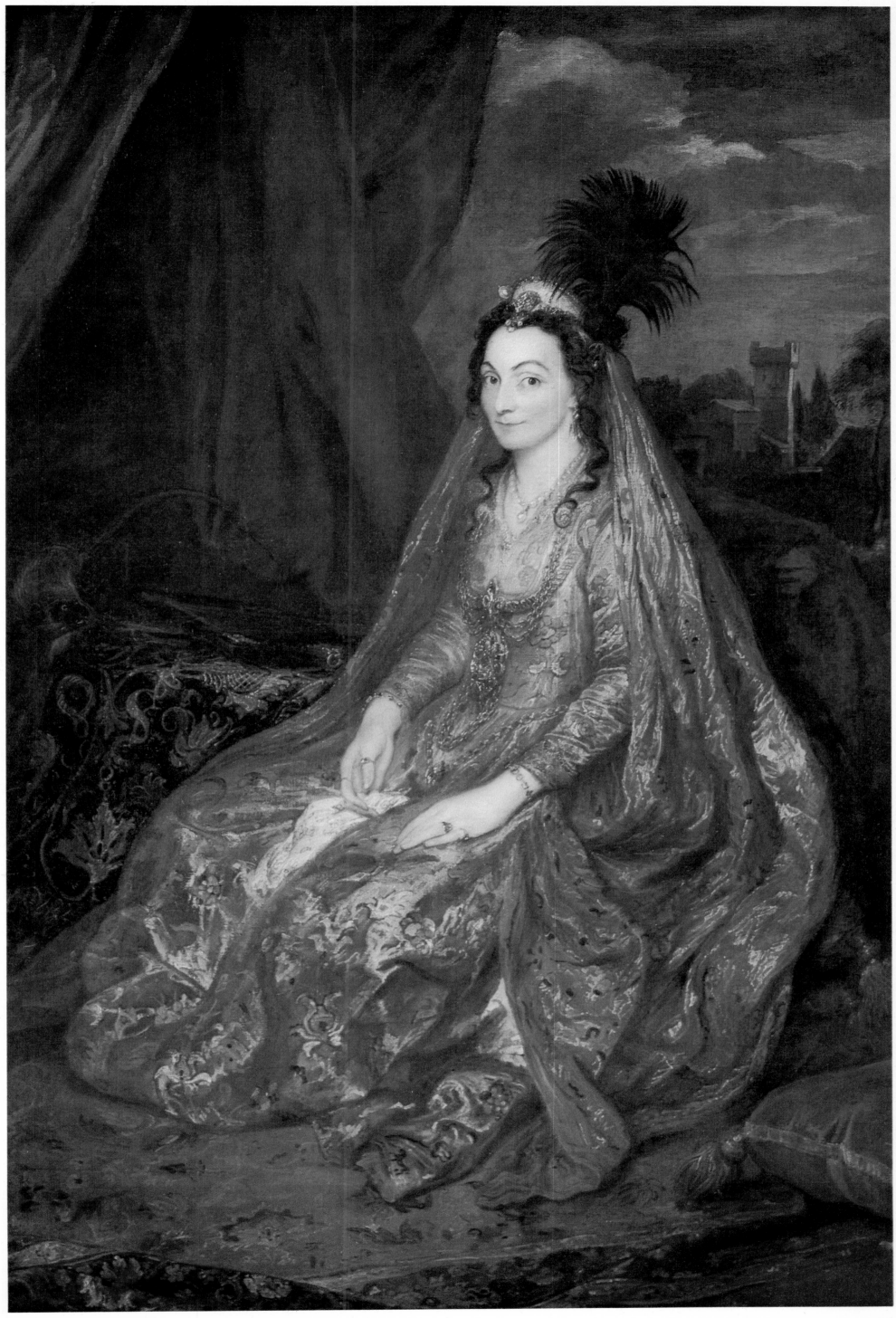

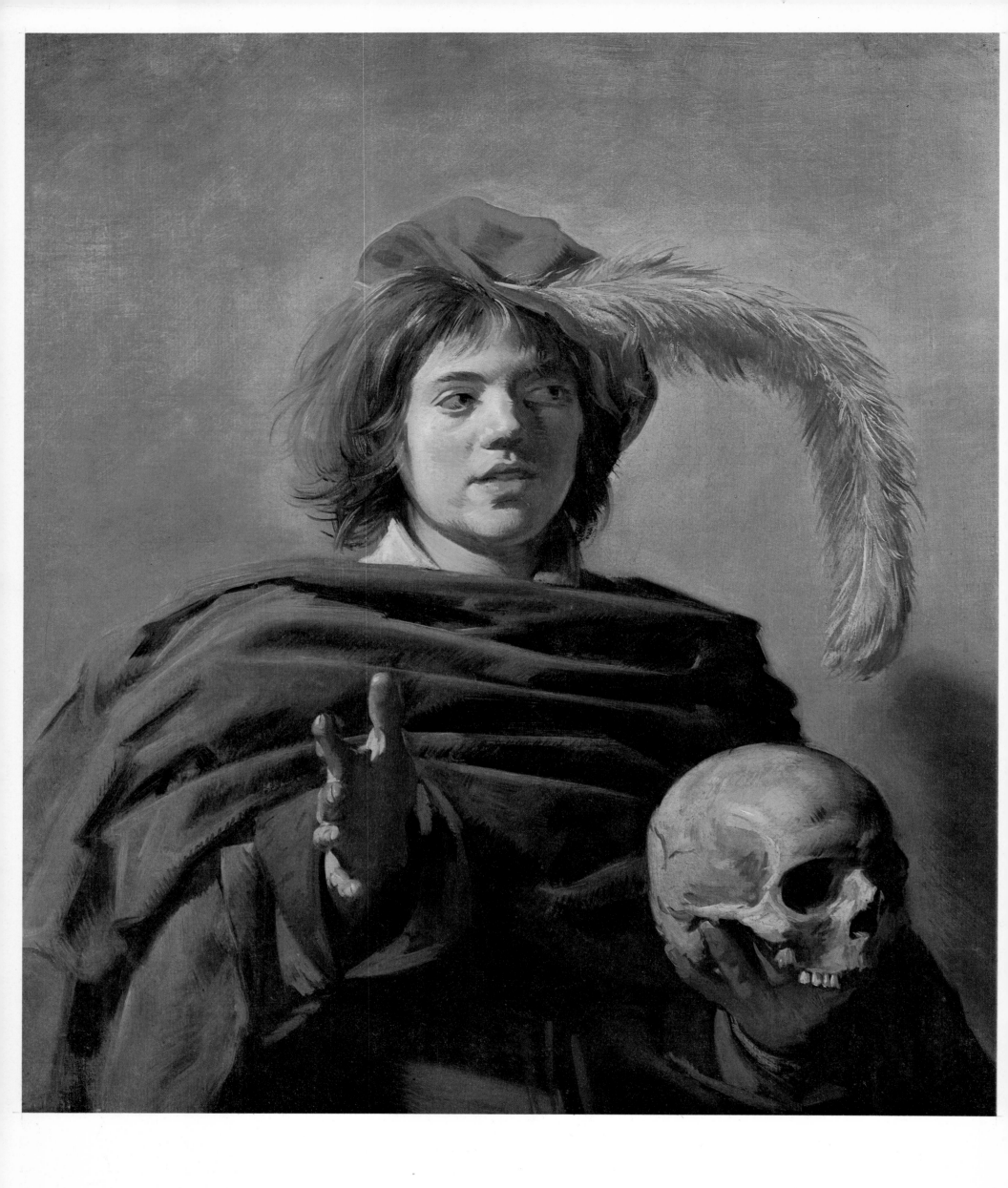

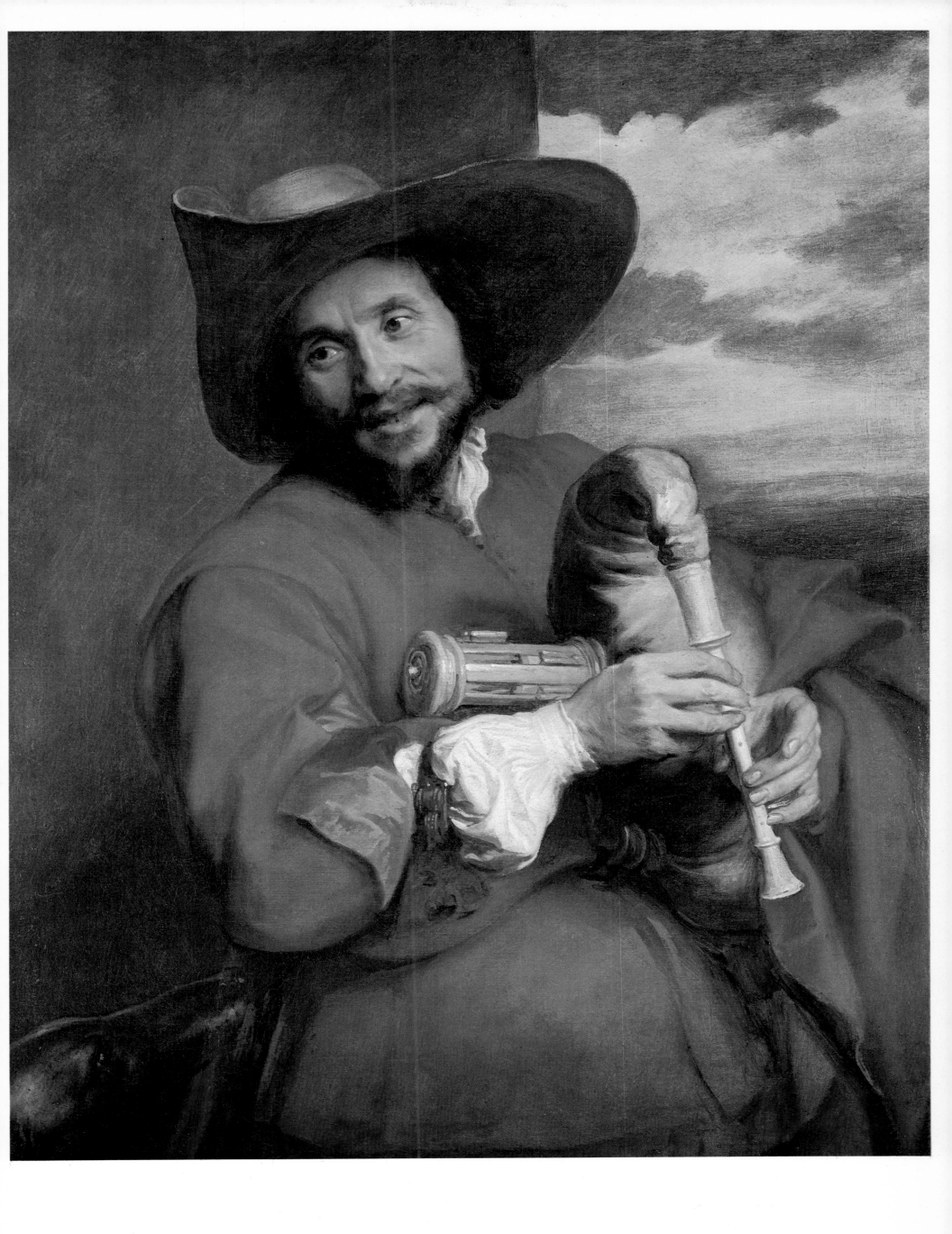

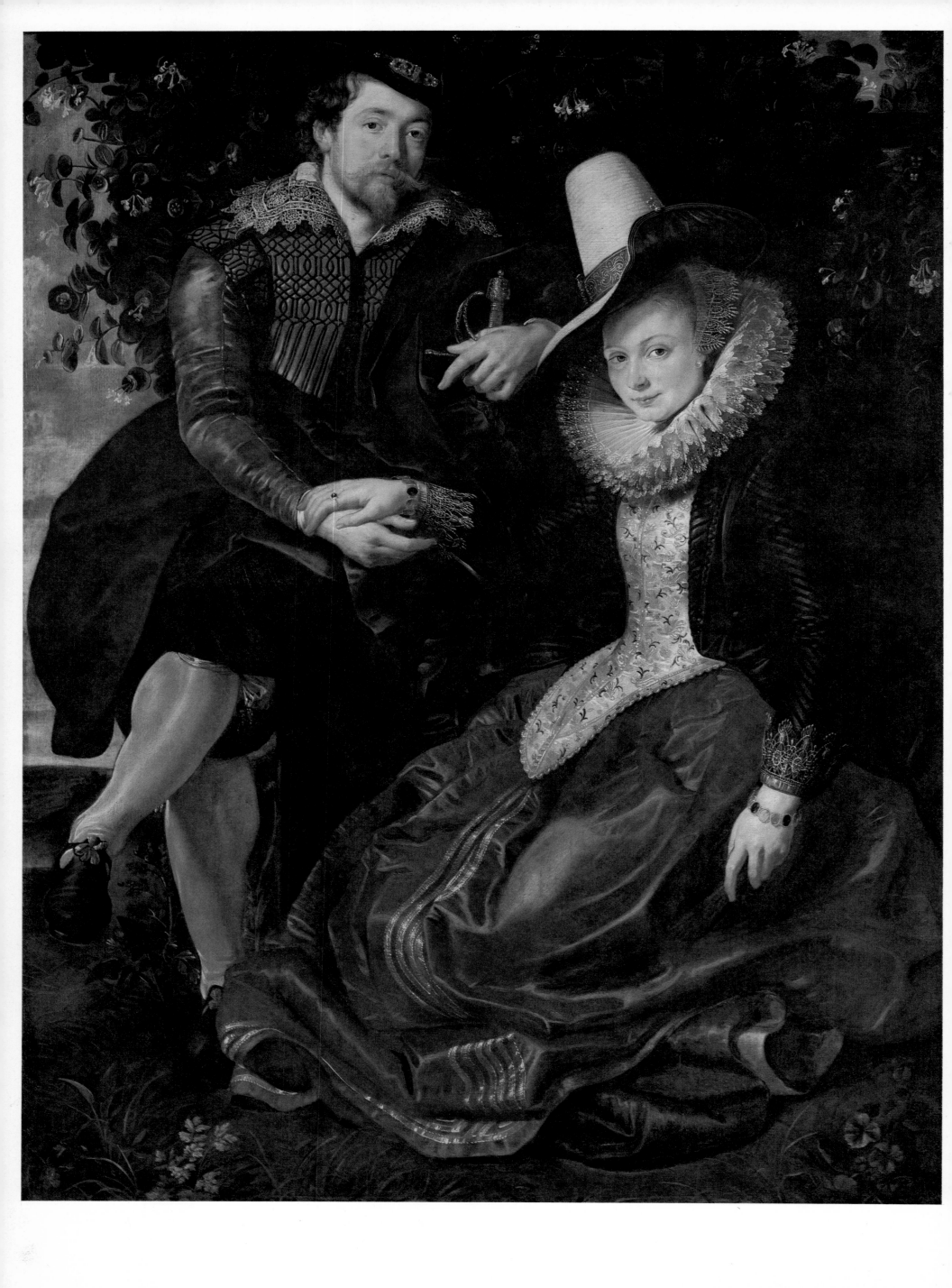

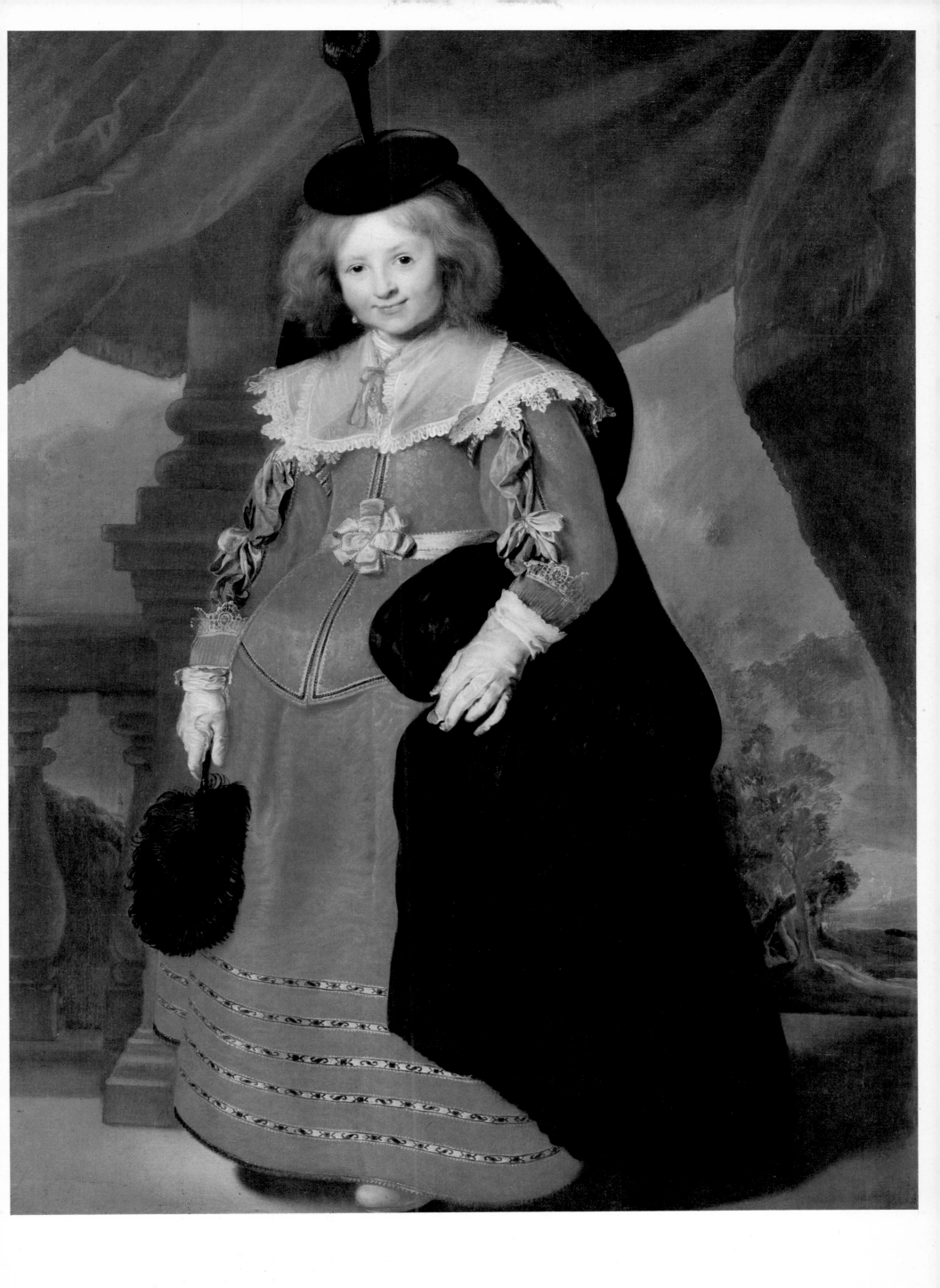

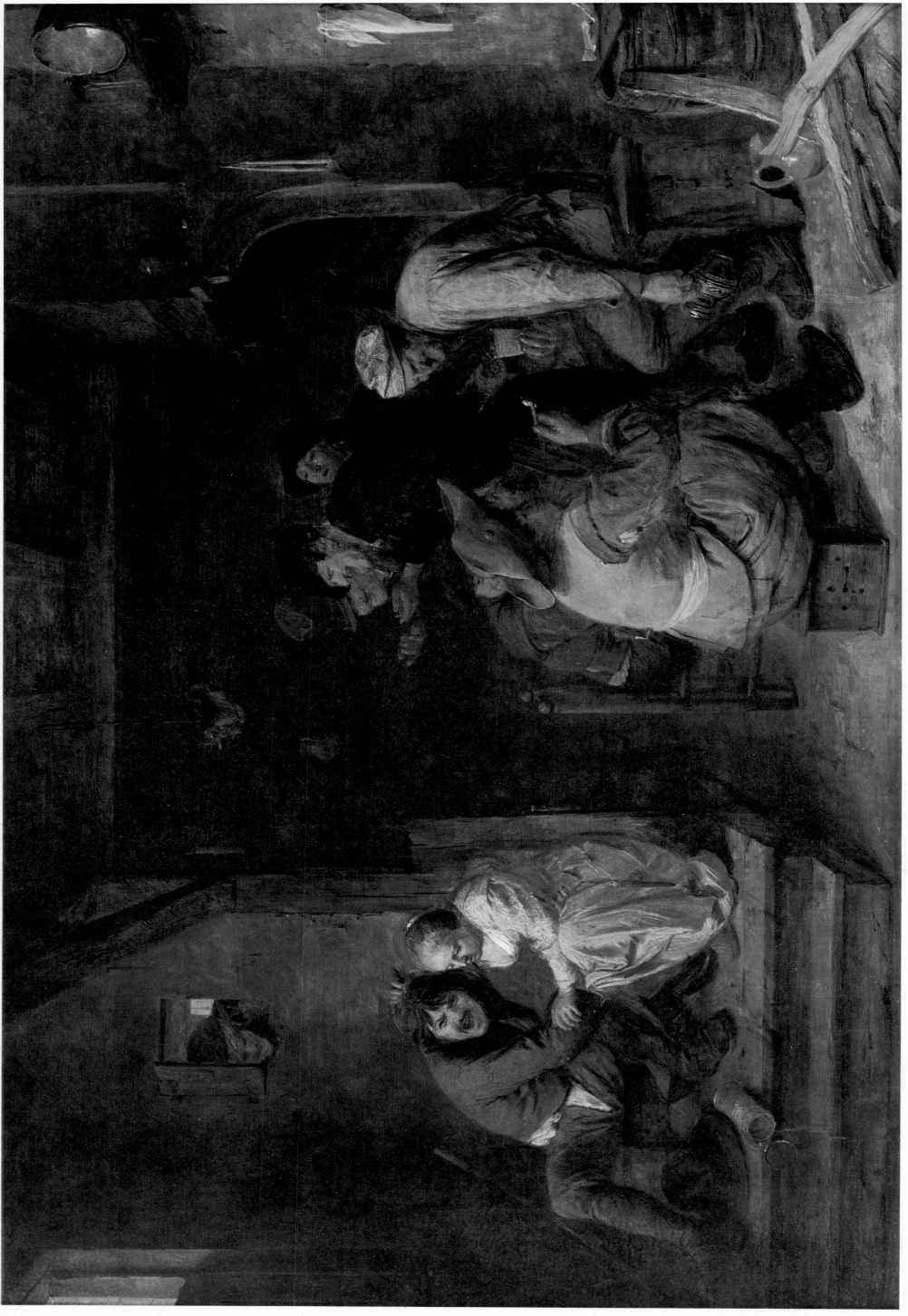

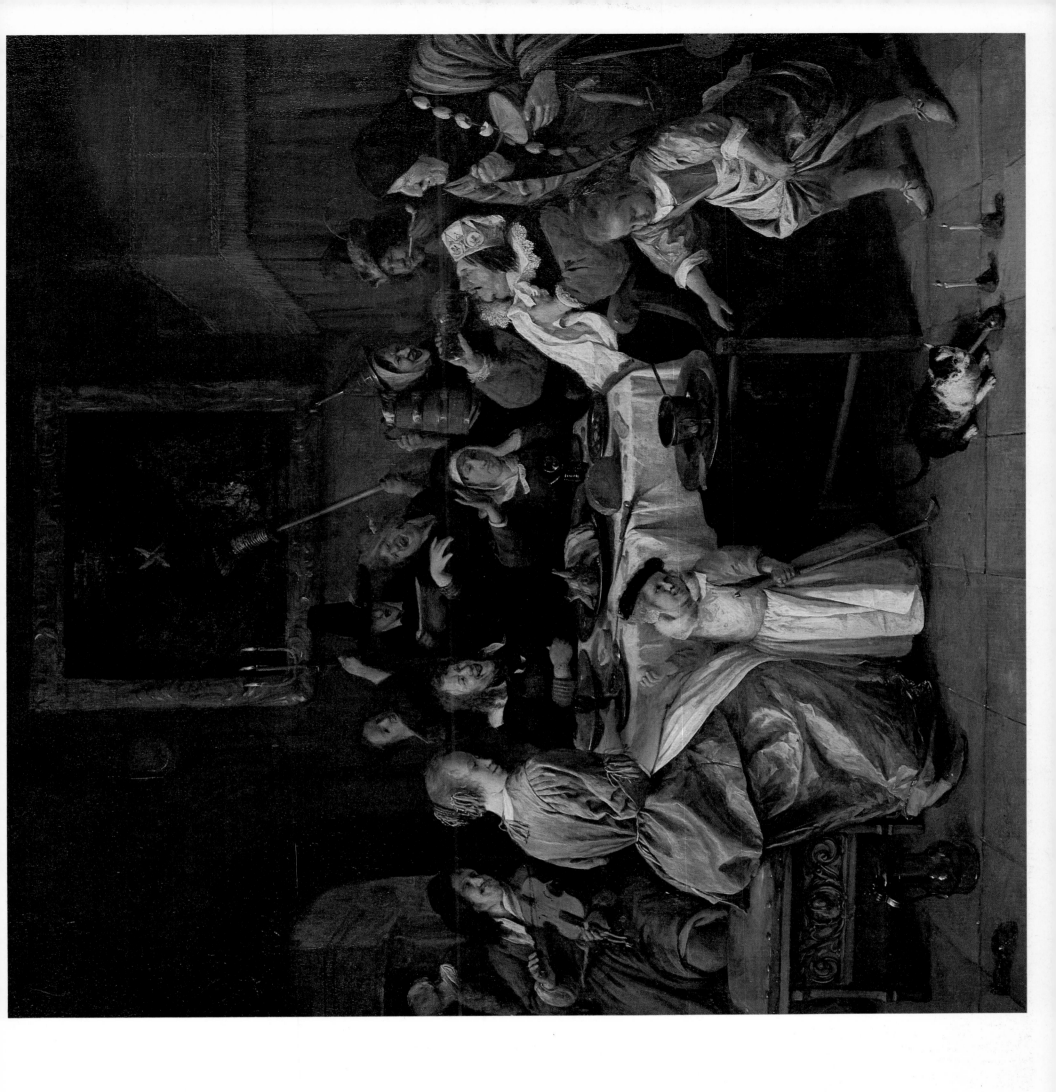

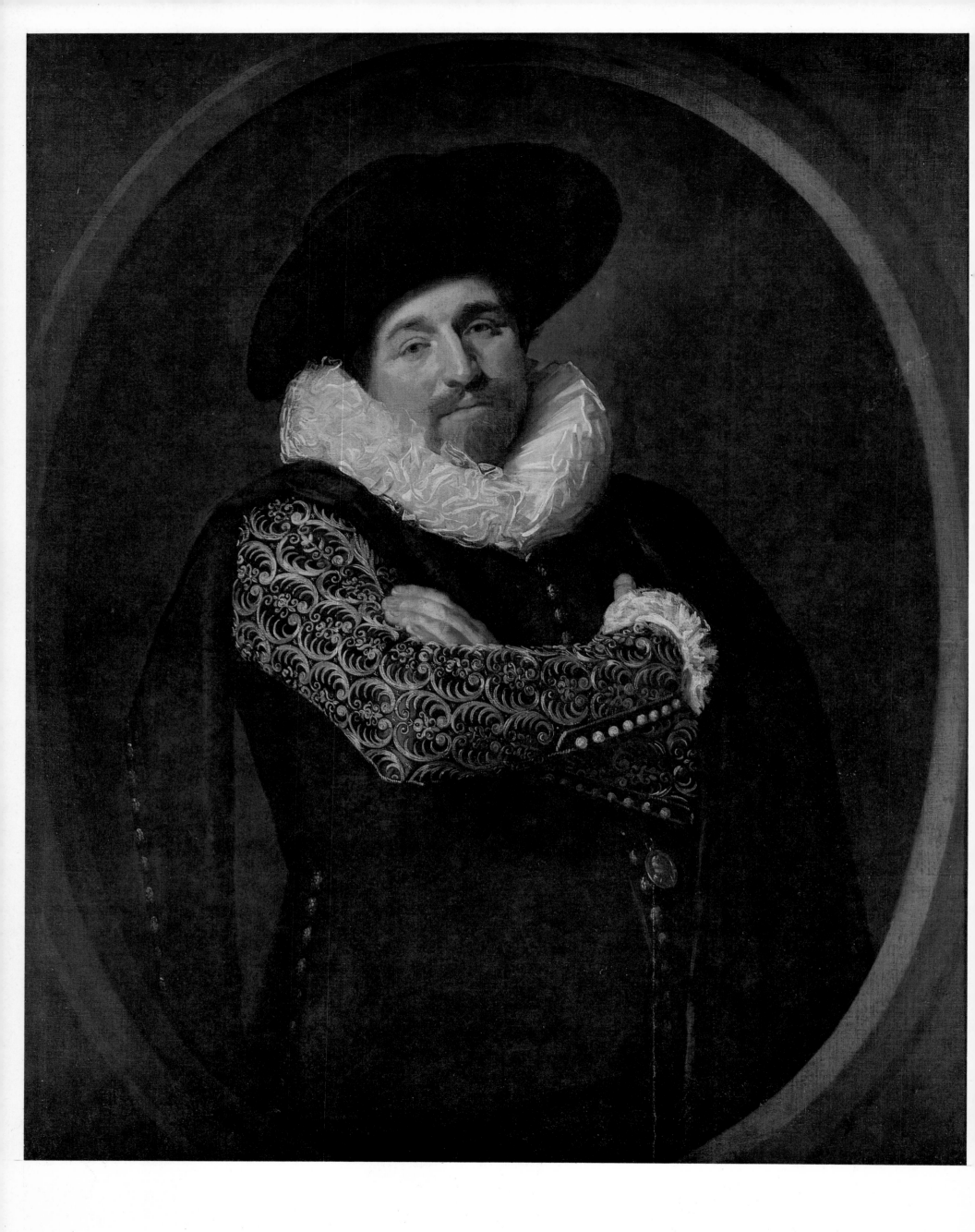

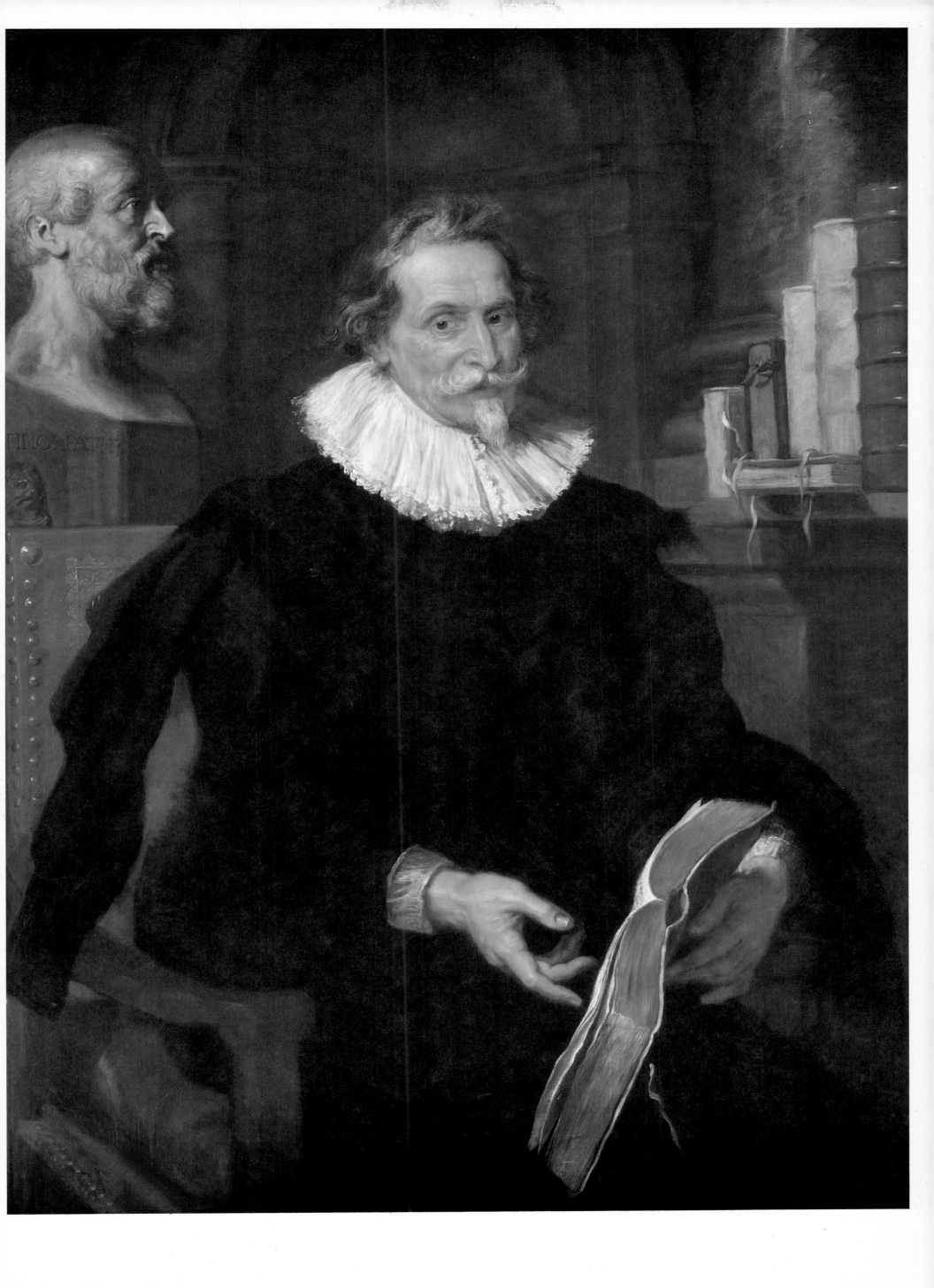

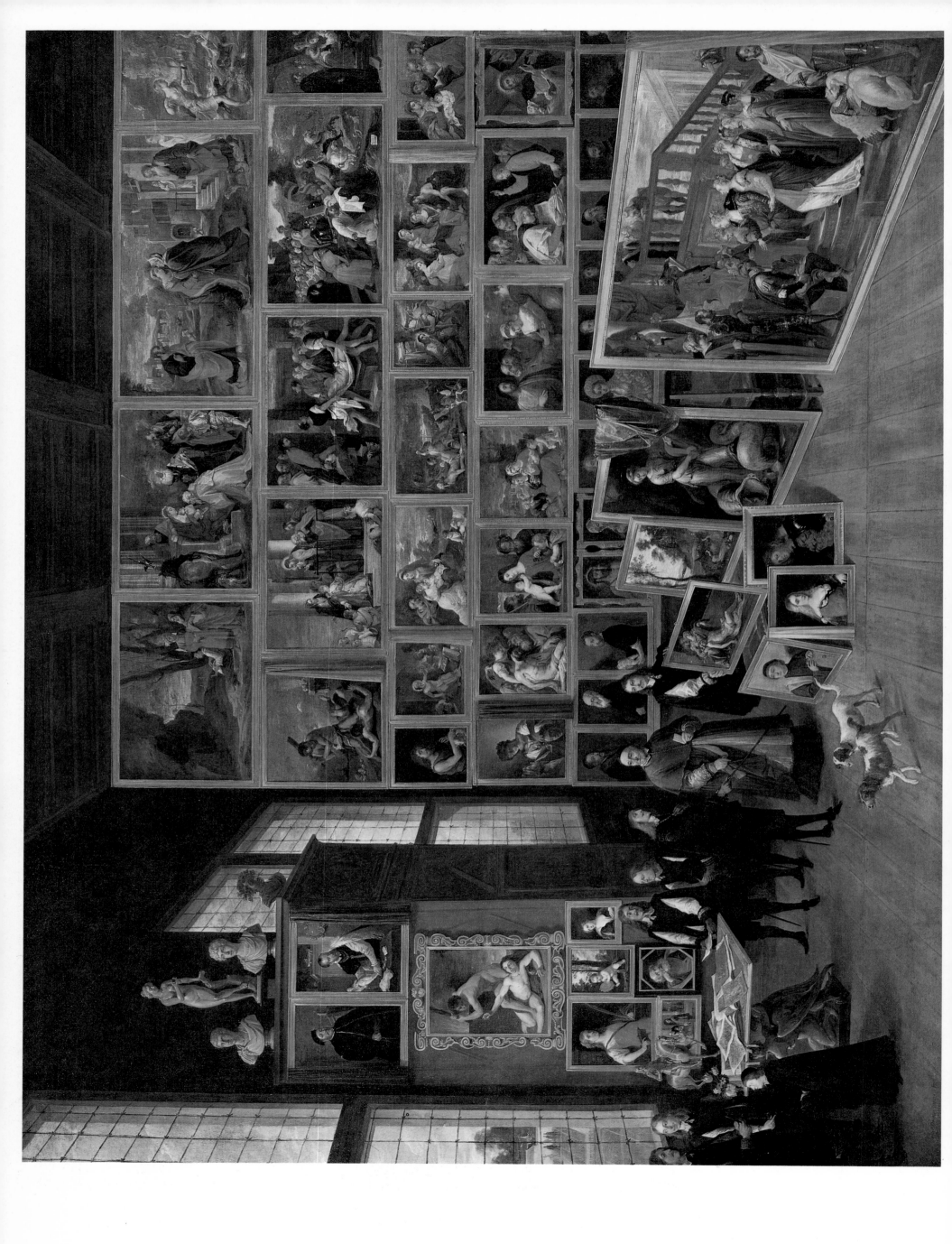

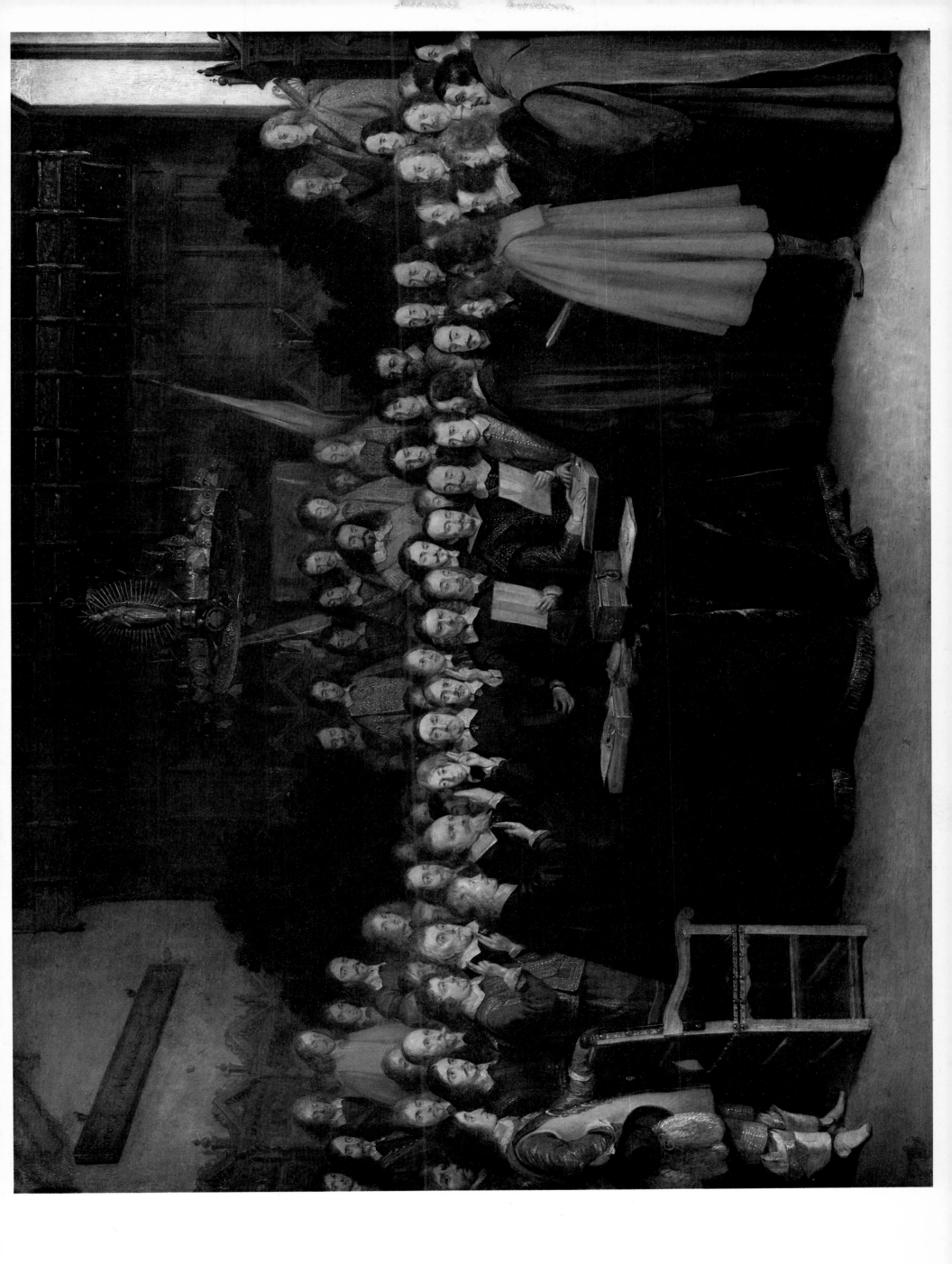

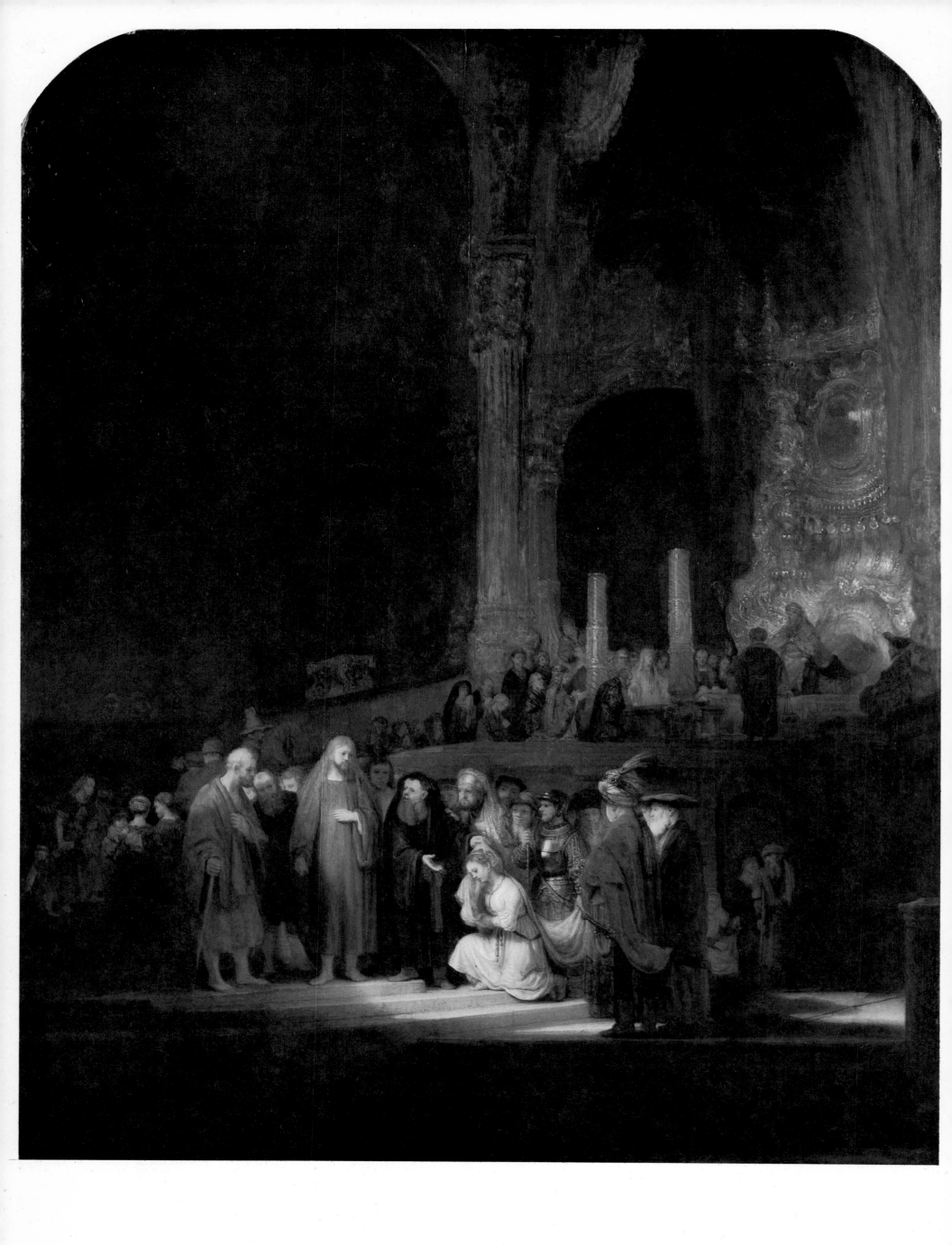

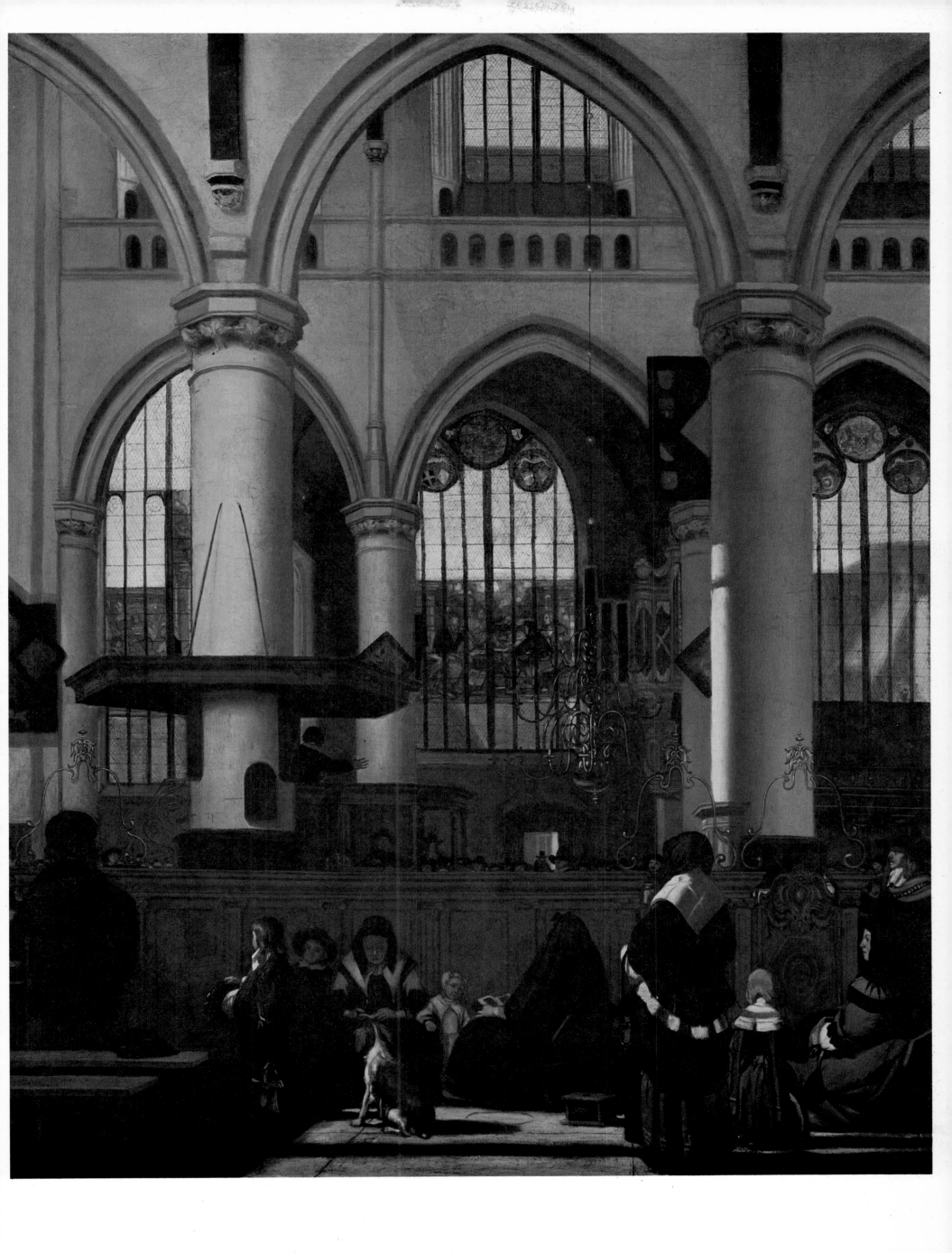

31

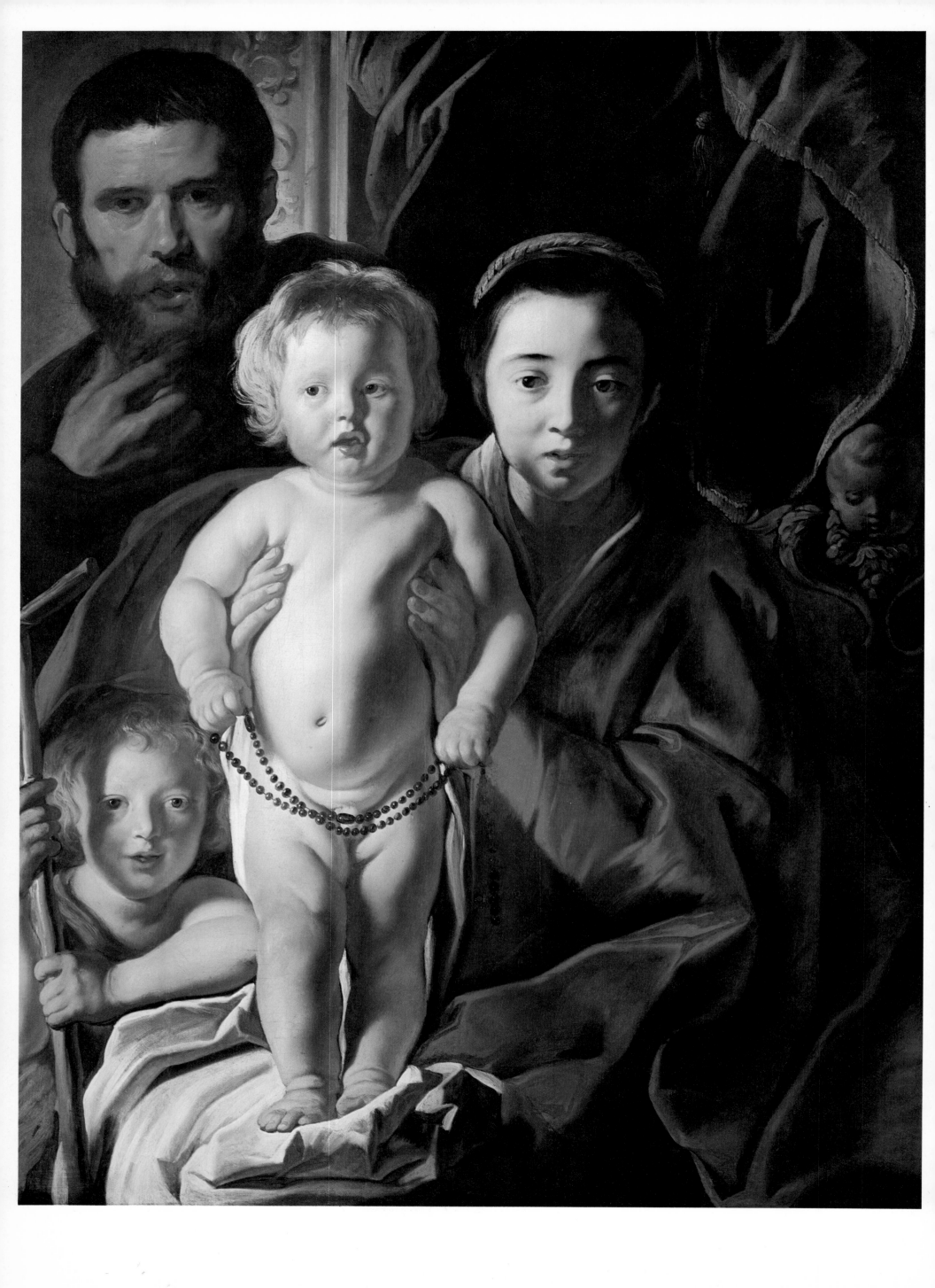

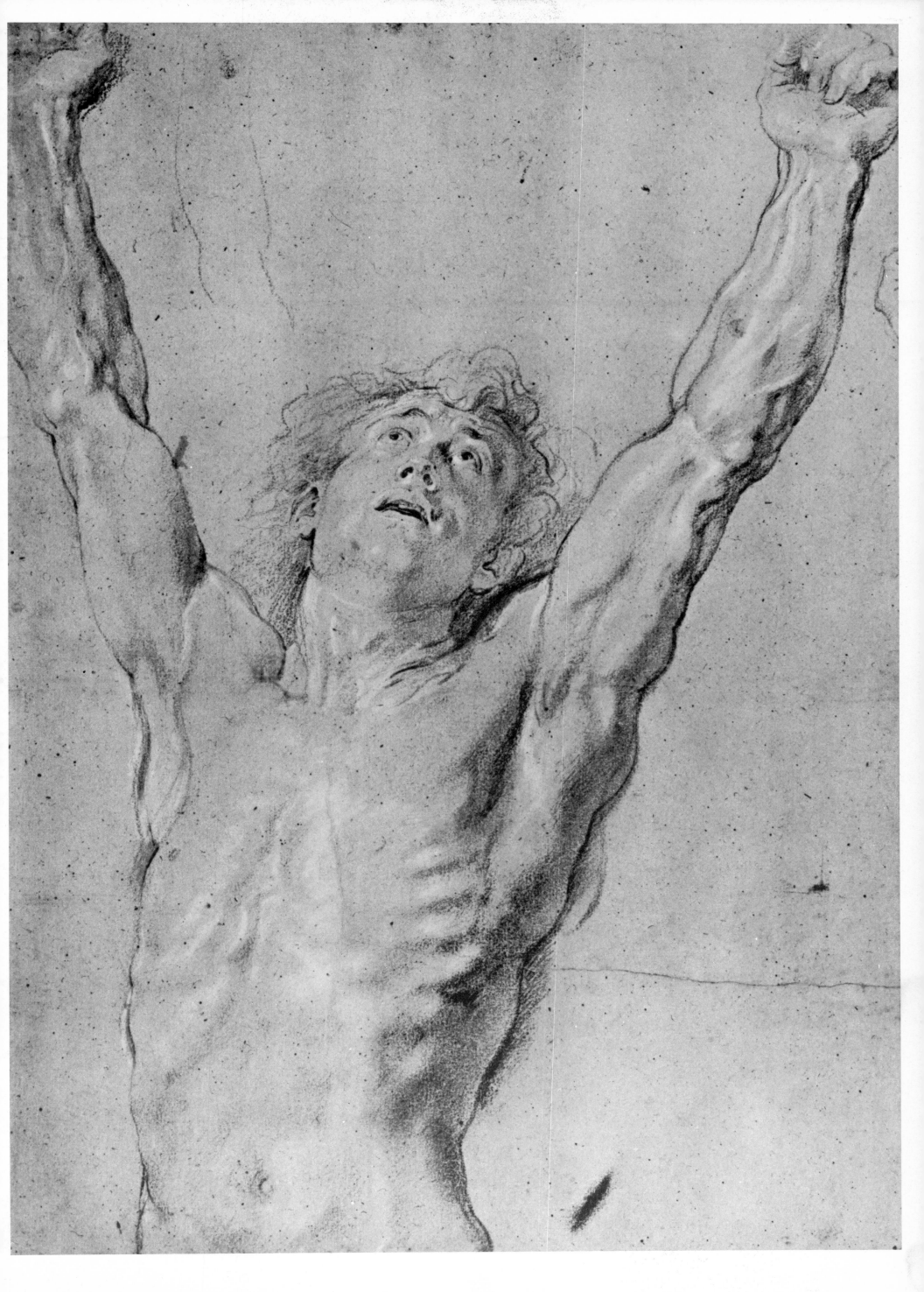

33

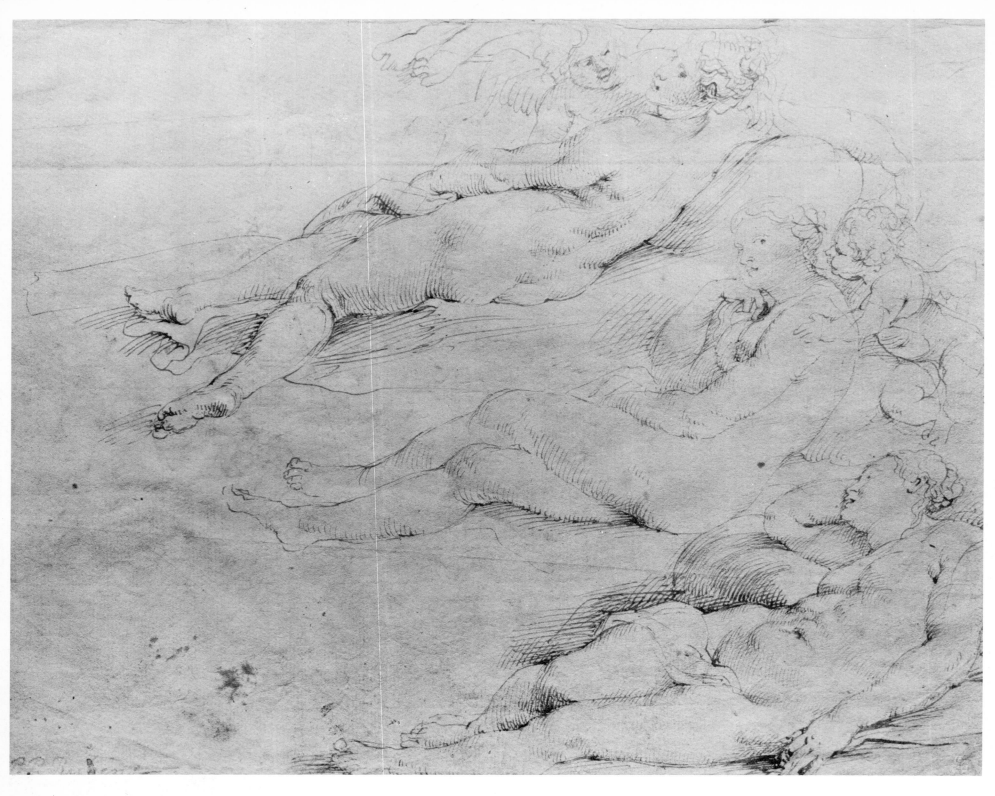

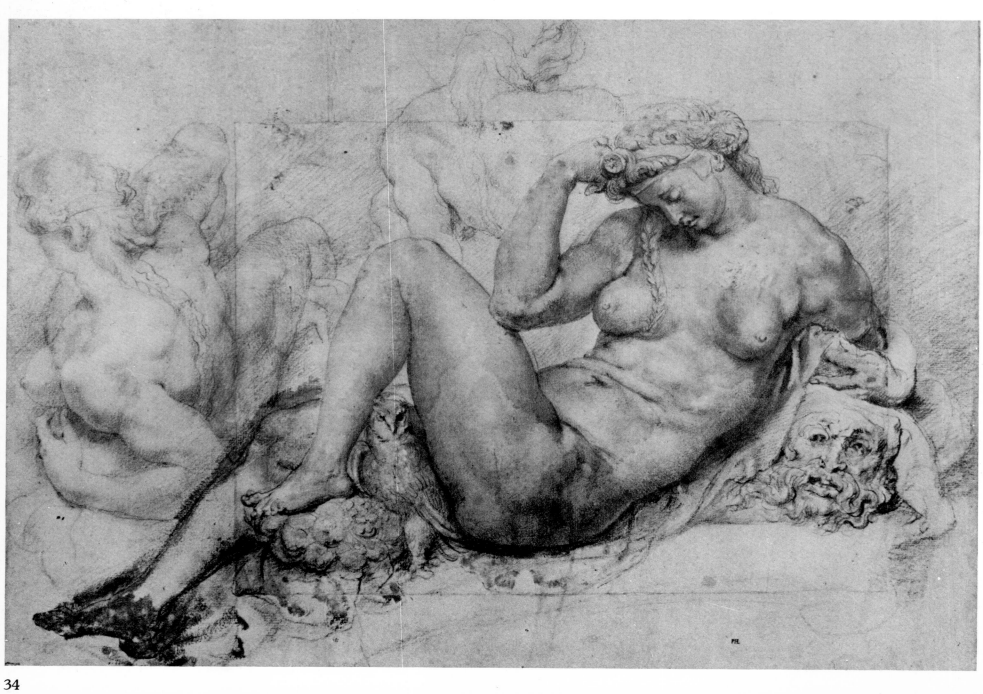

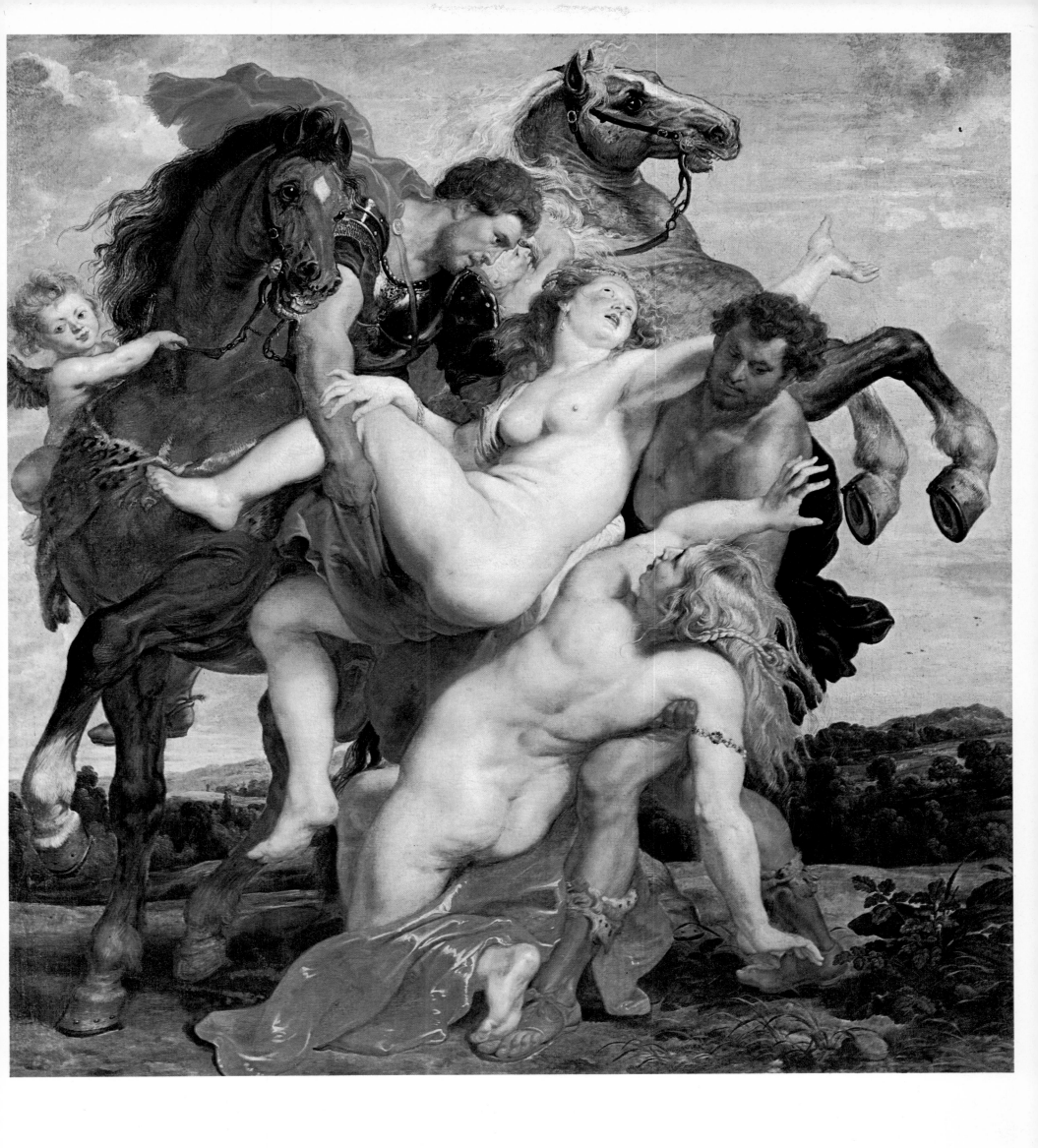

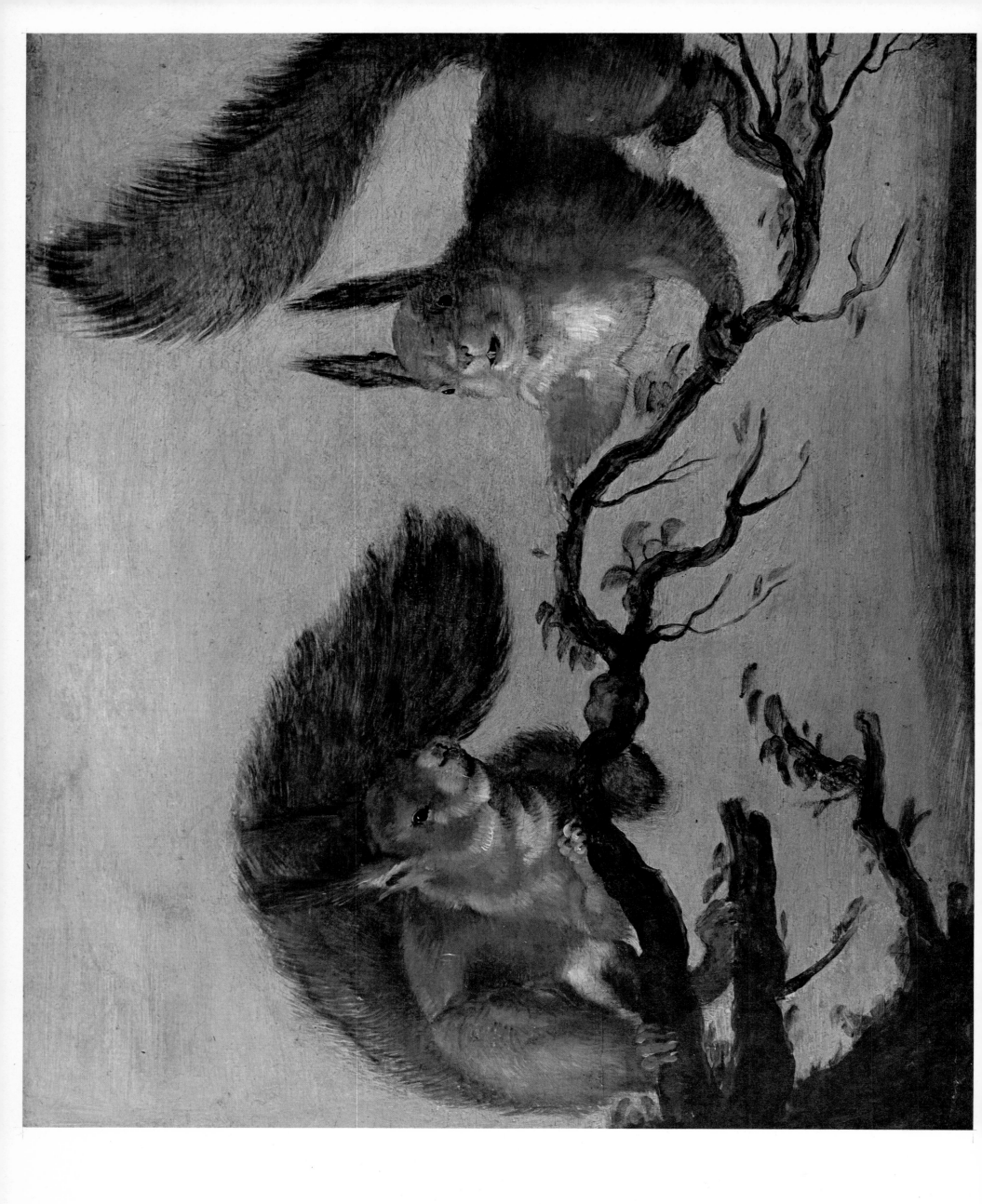

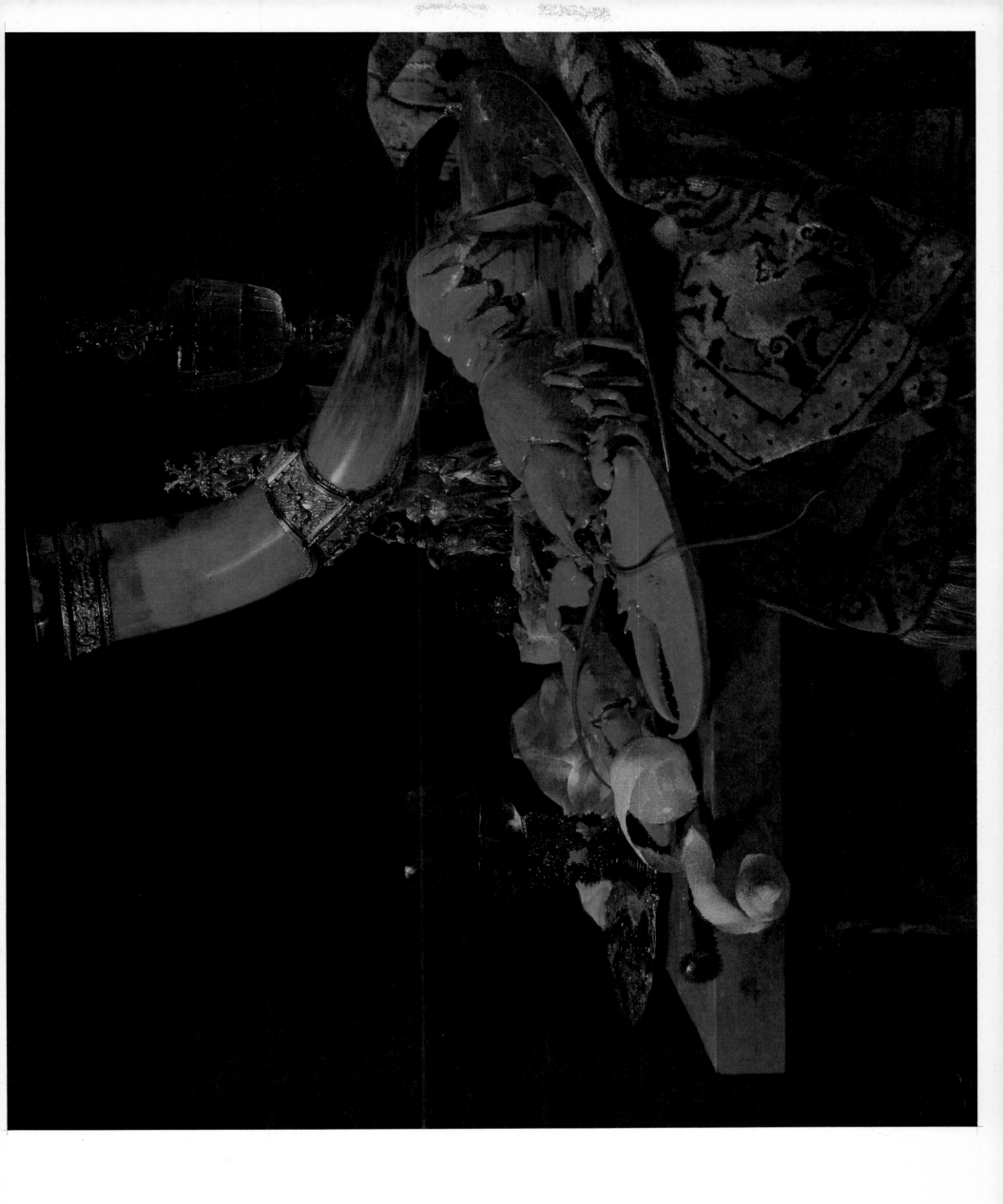

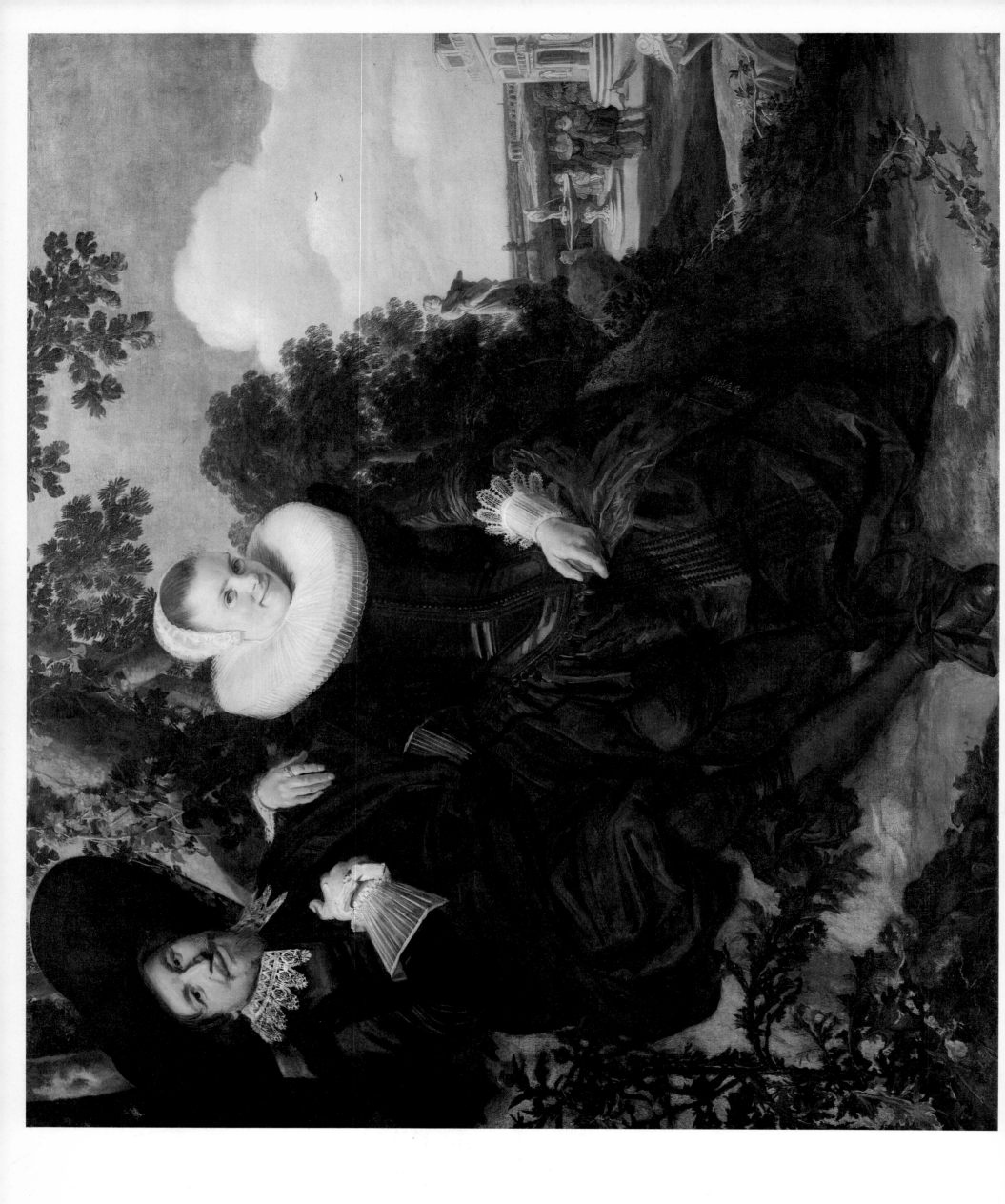

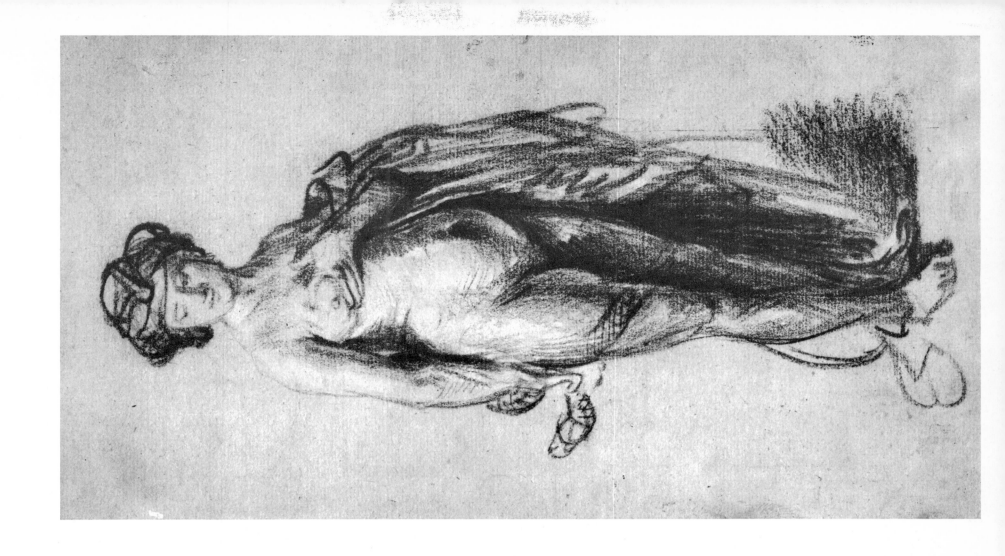

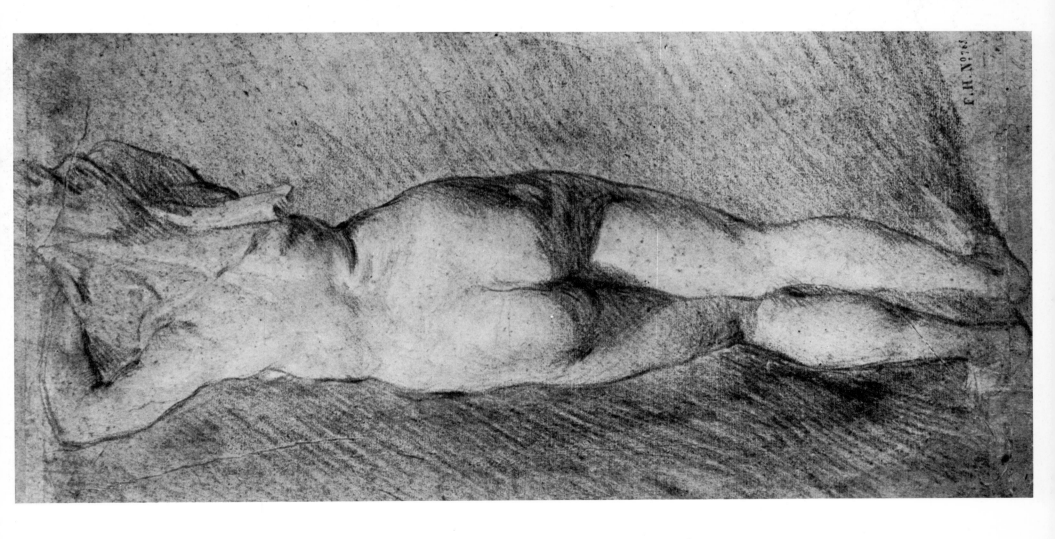

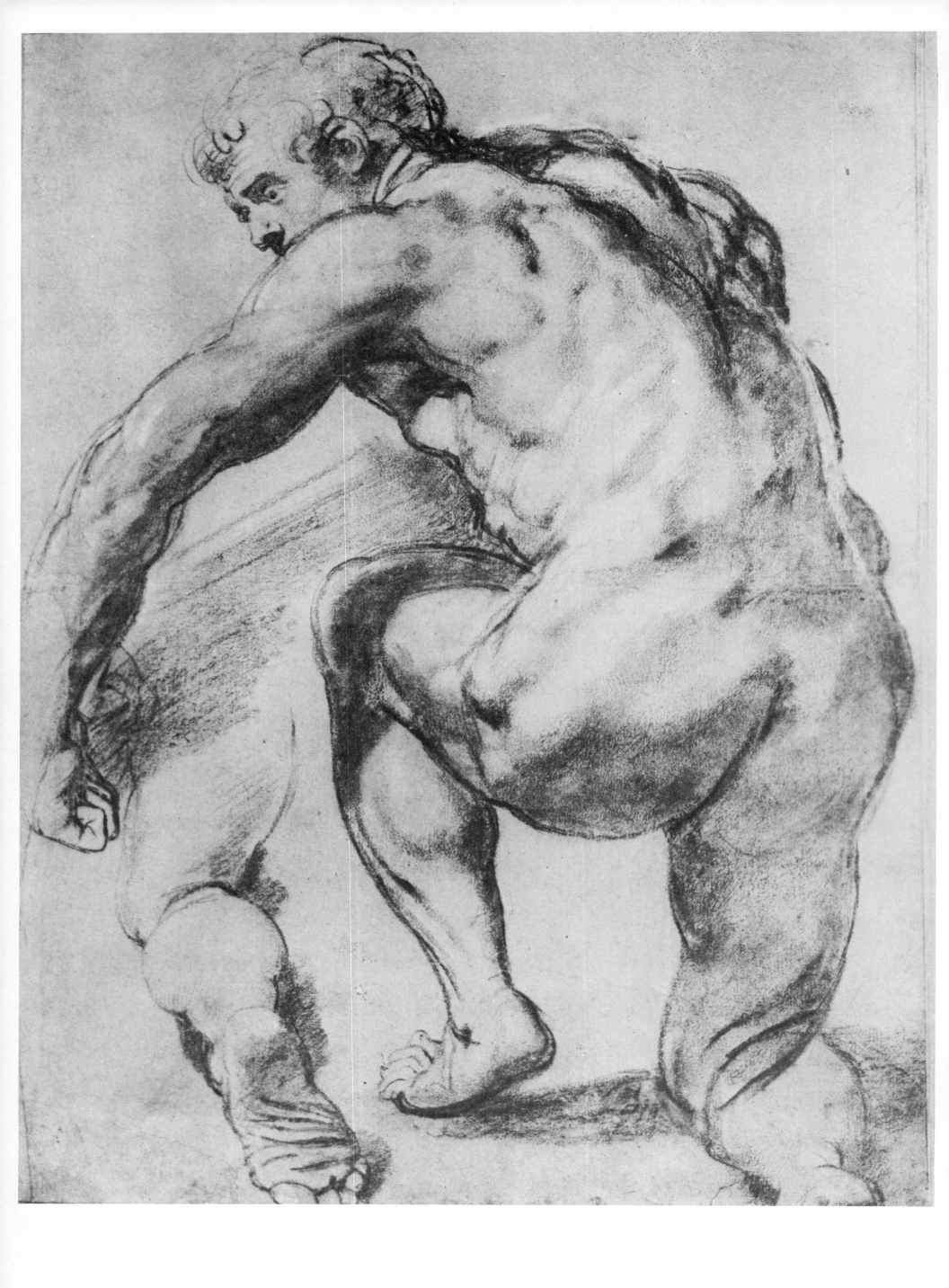

40

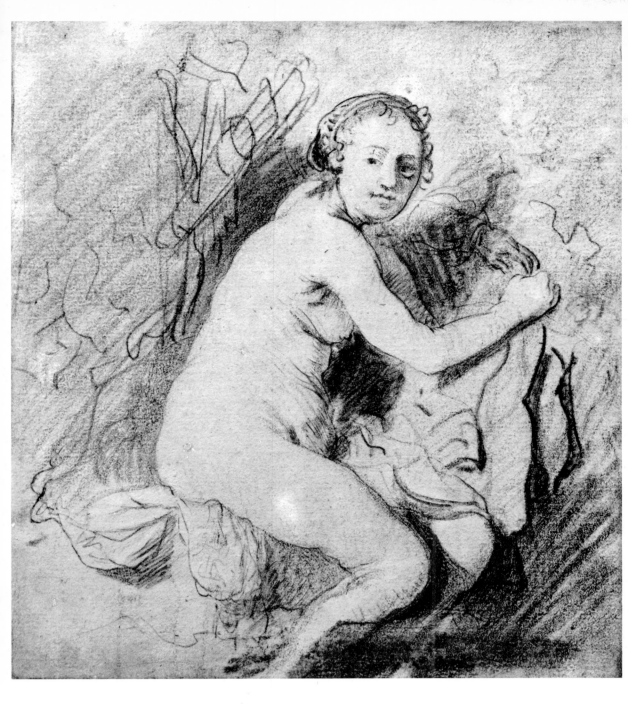

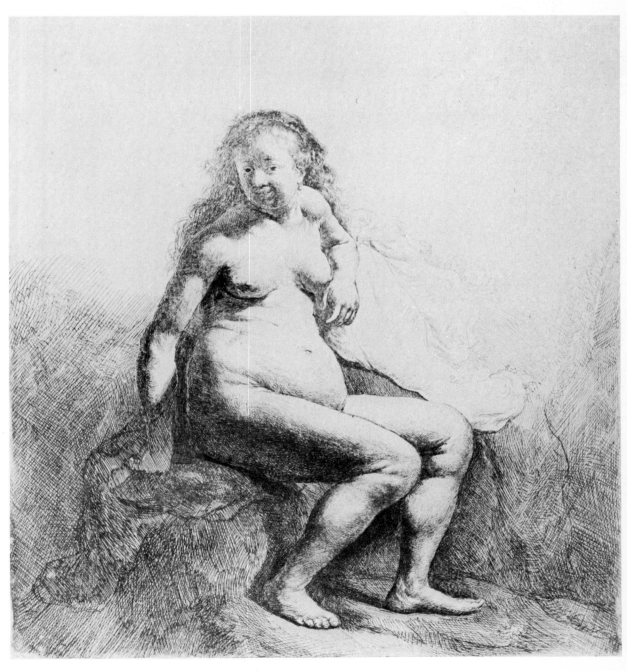

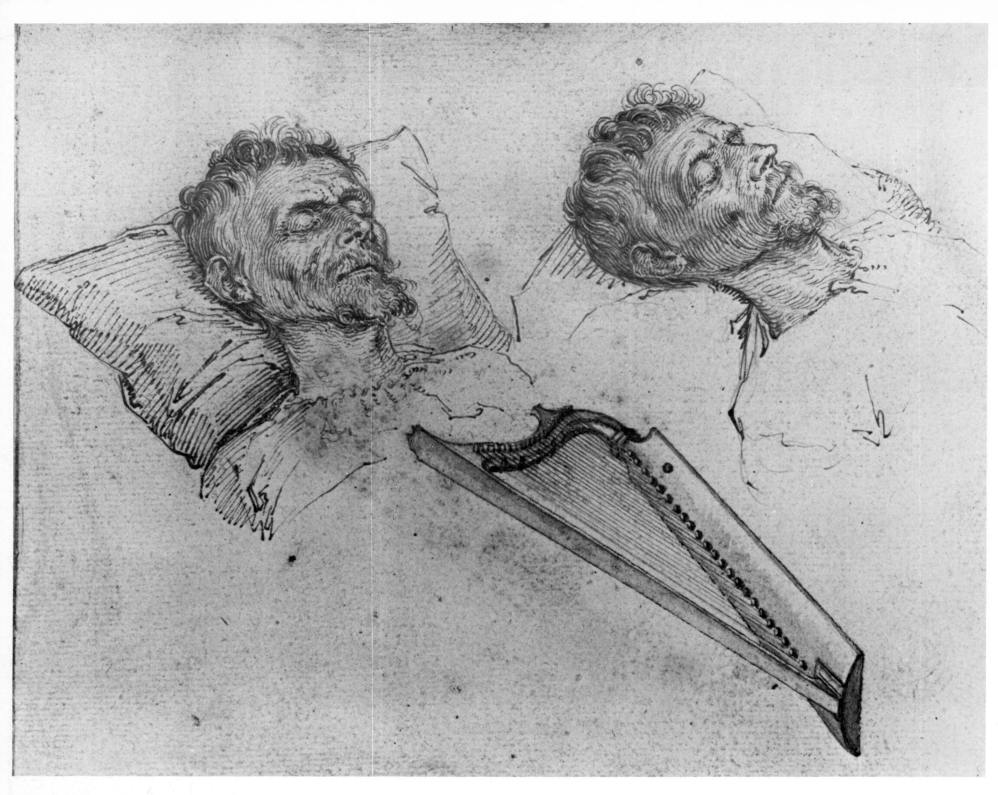

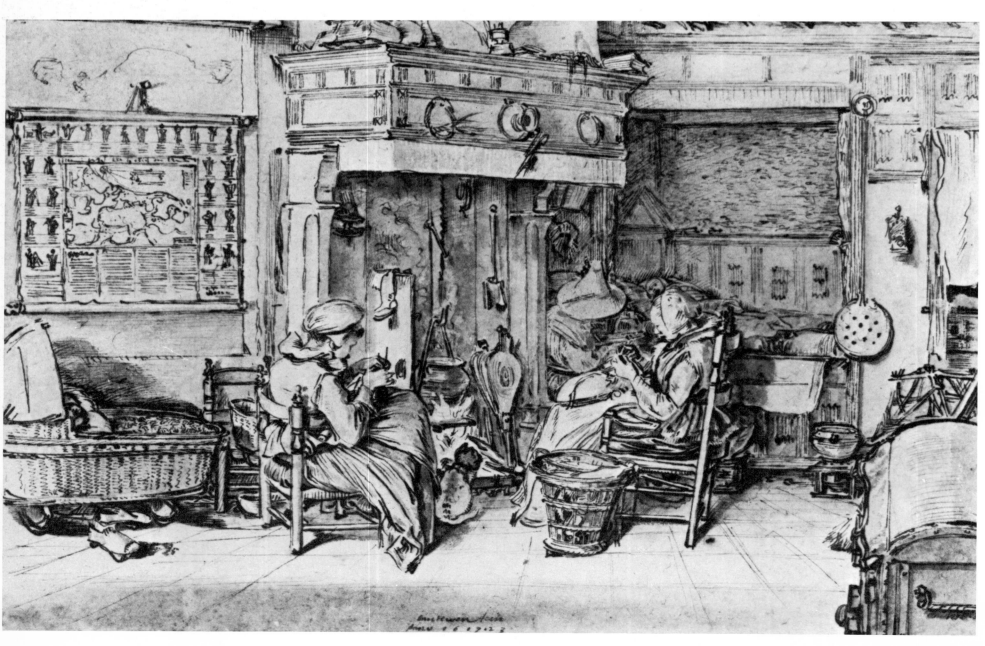

42

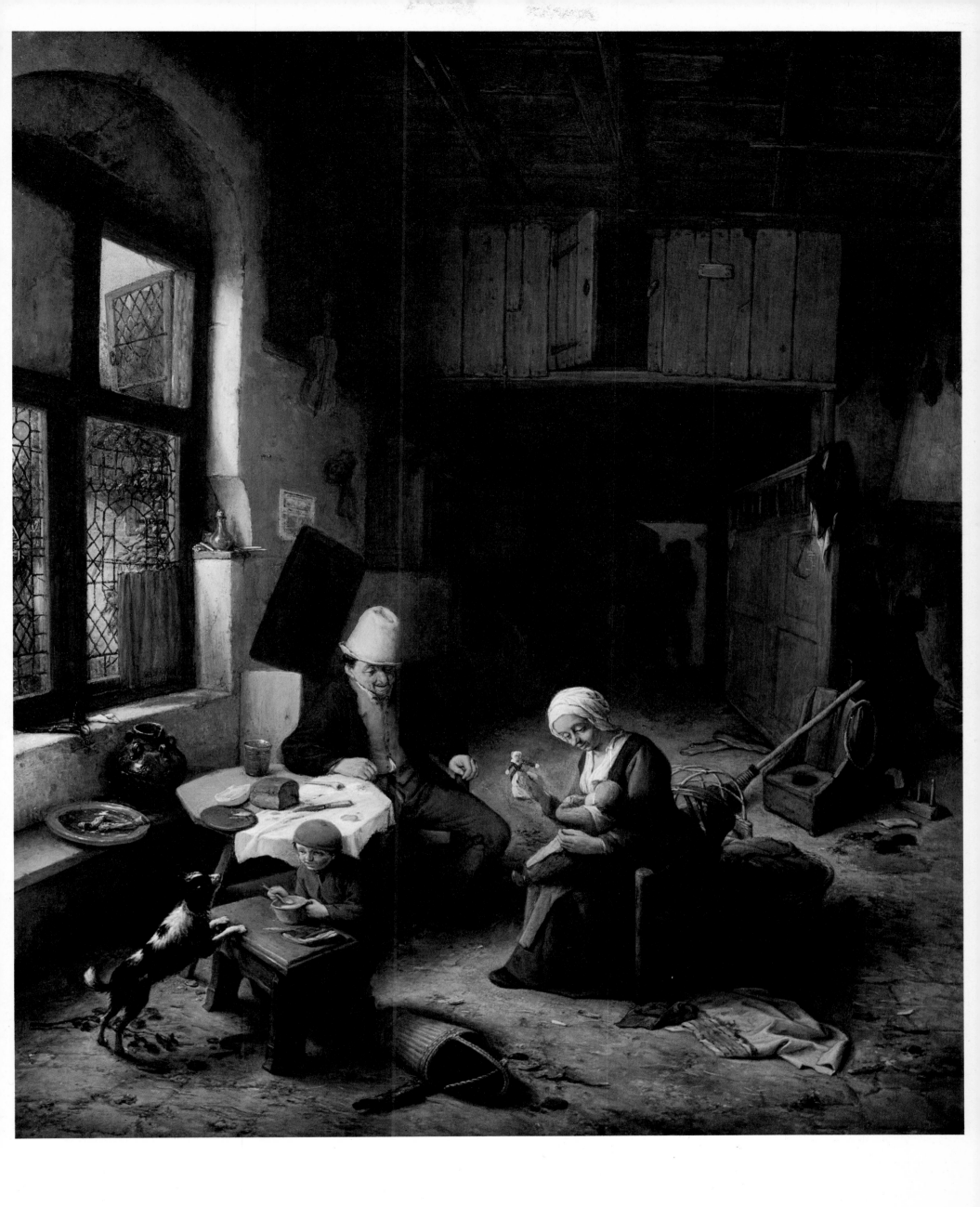

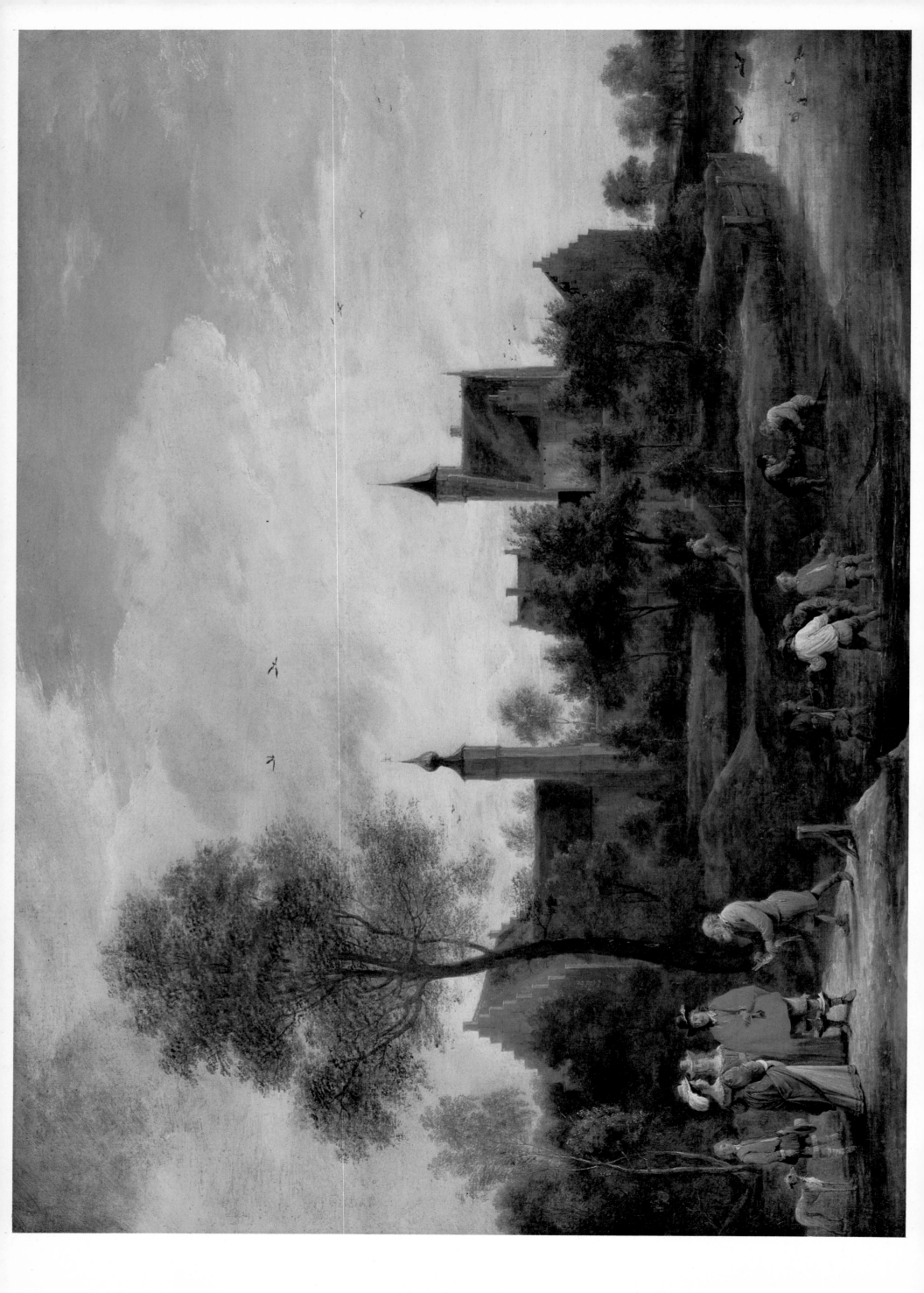

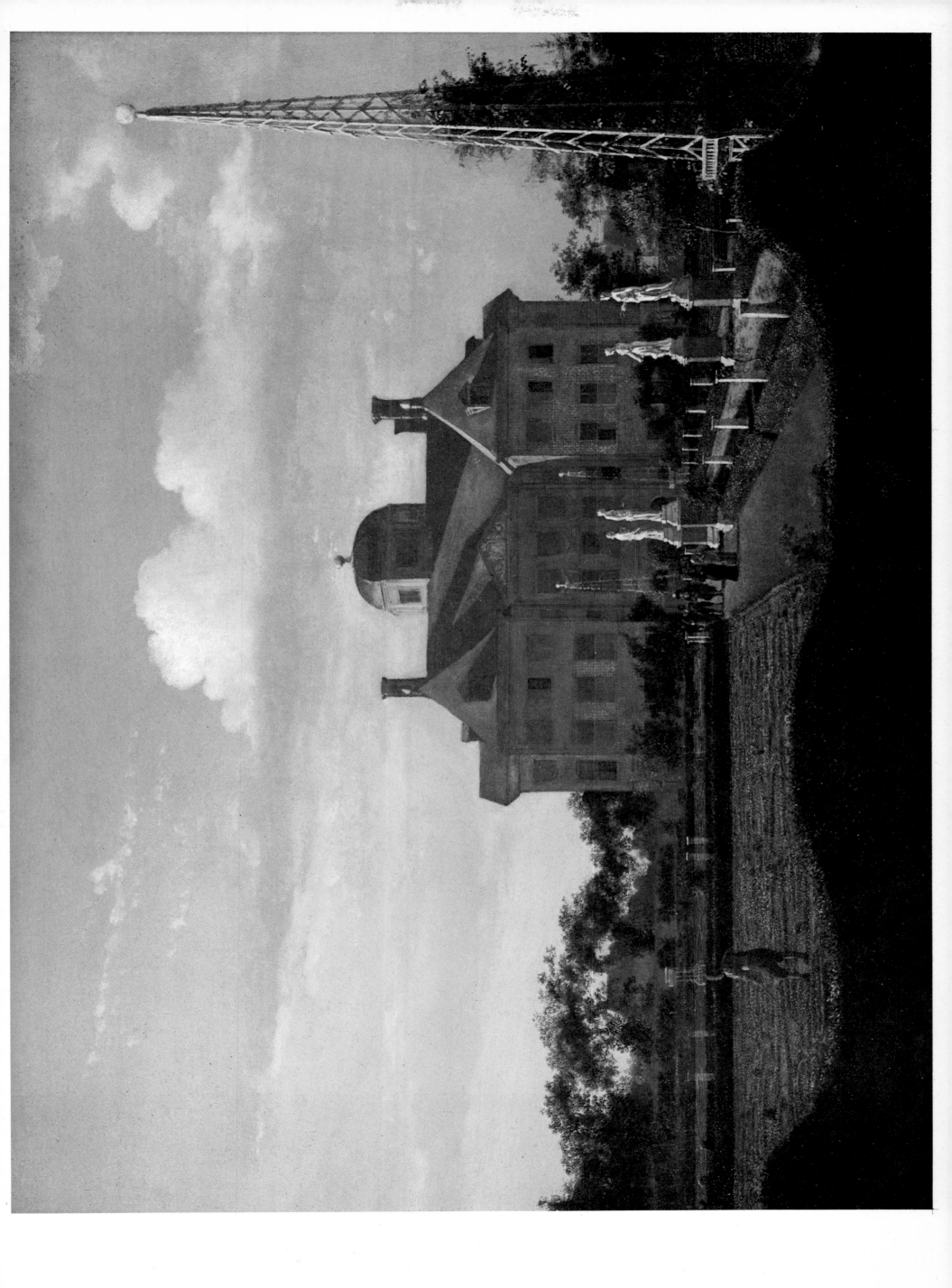

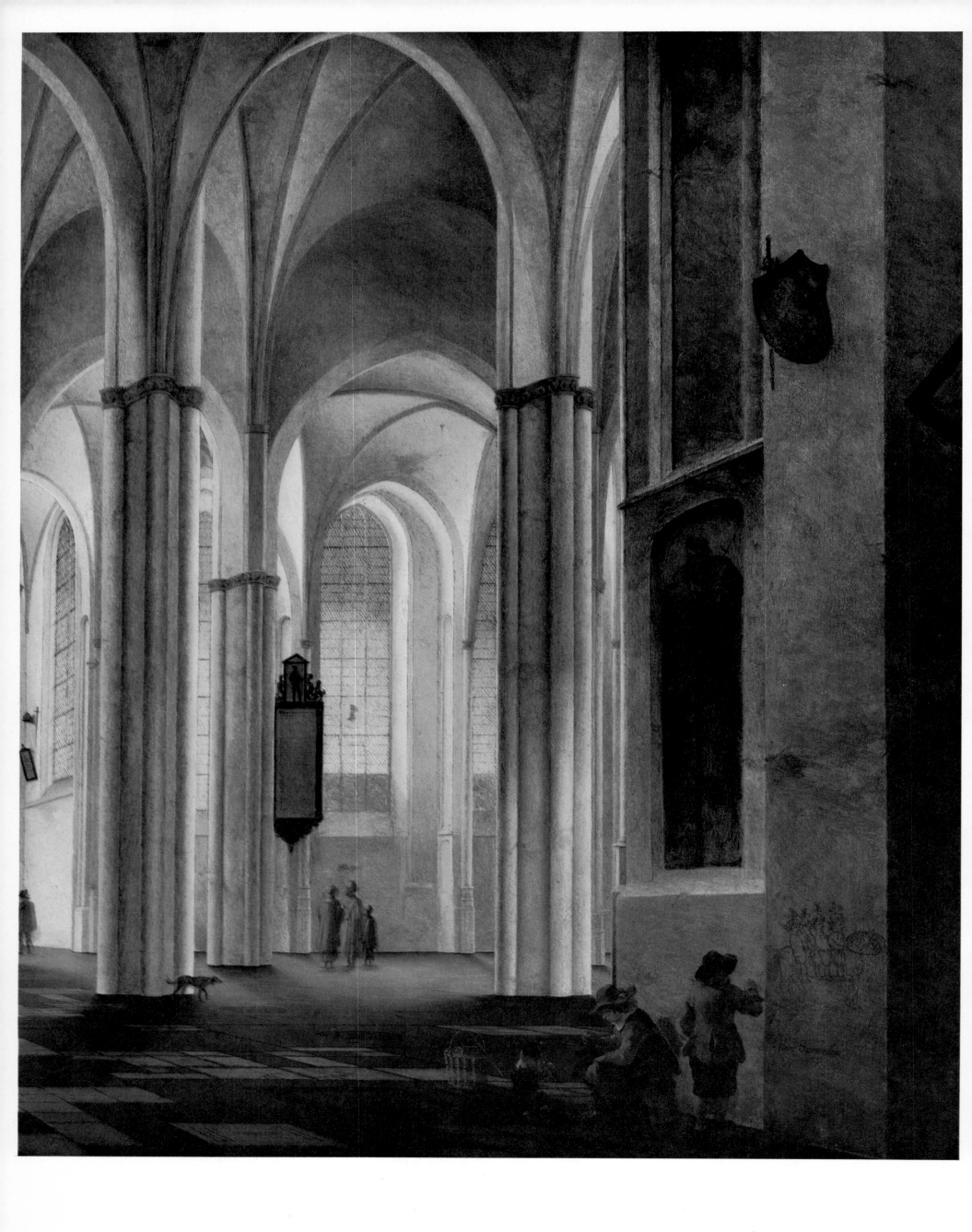

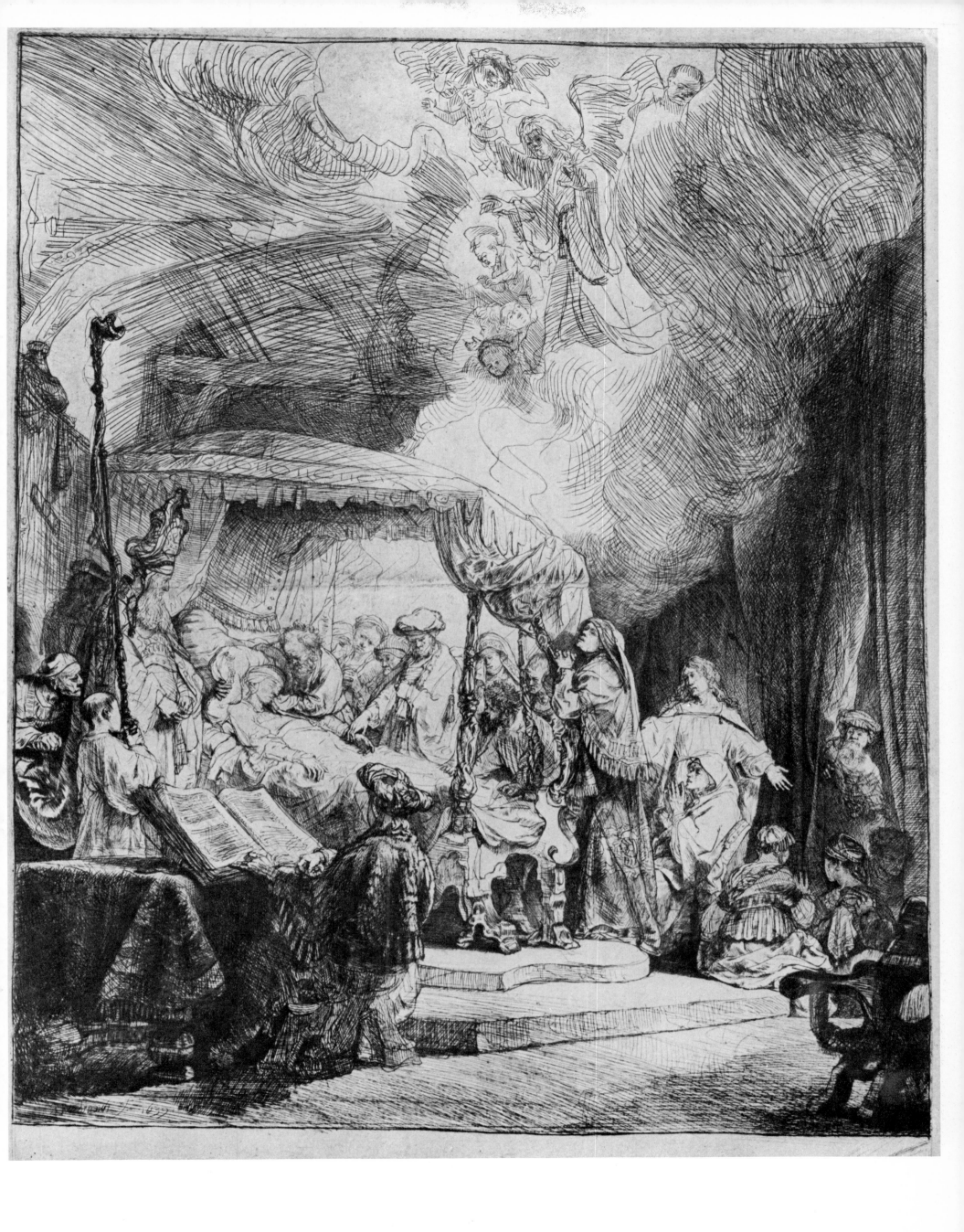

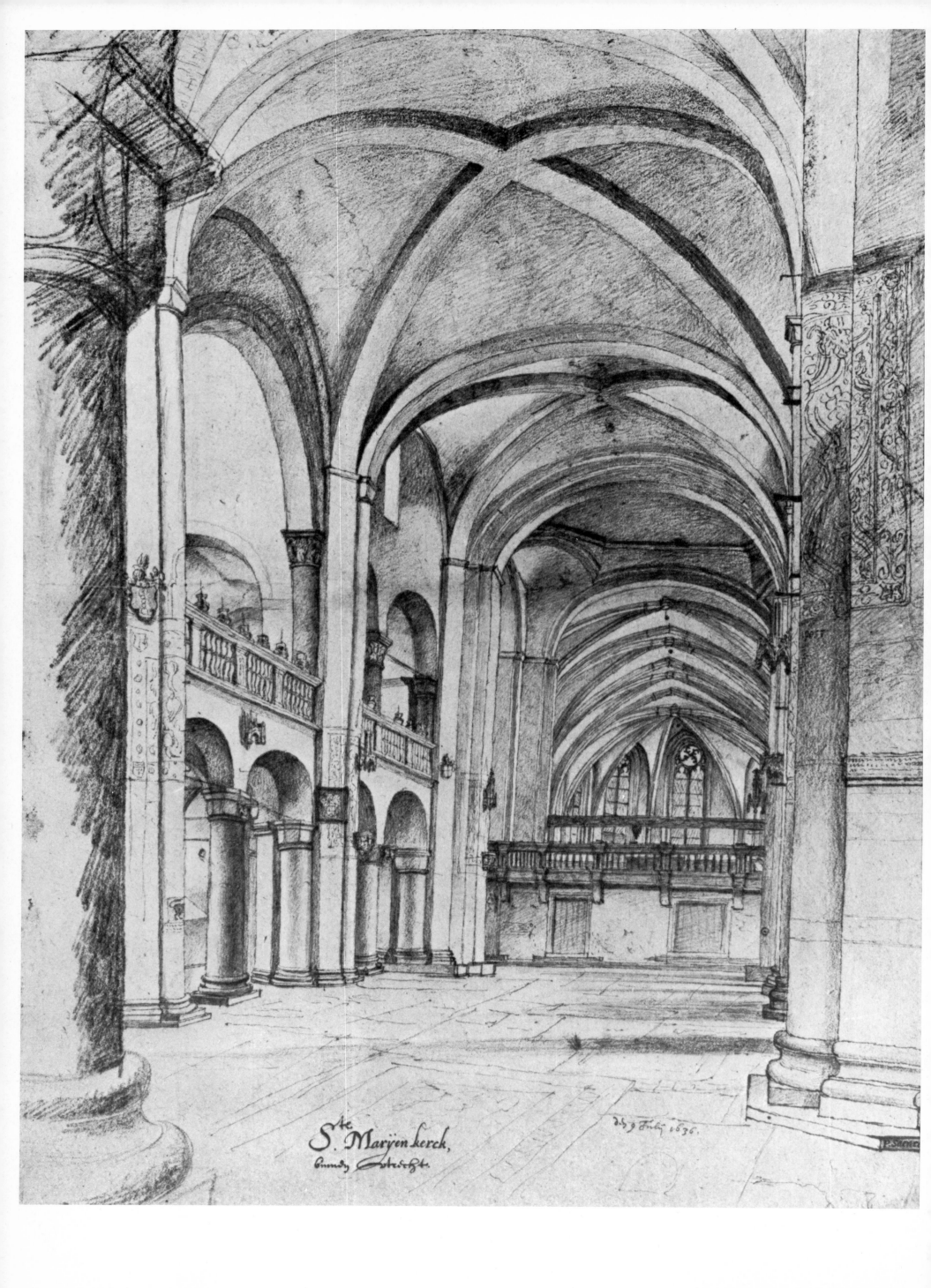

S.te Marÿen kerck,
binnen Vtrecht.

d 9 Julÿ 1636.

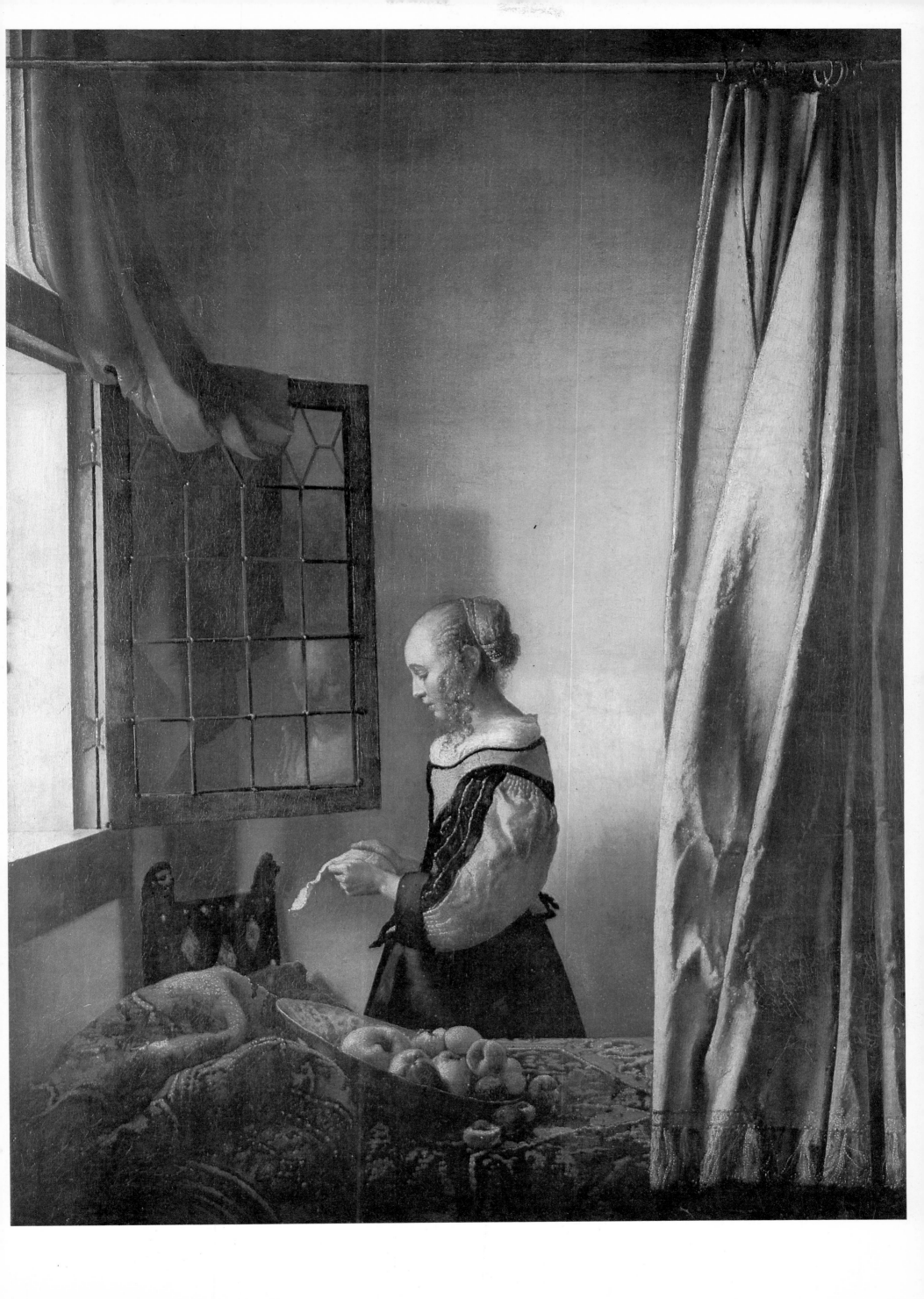

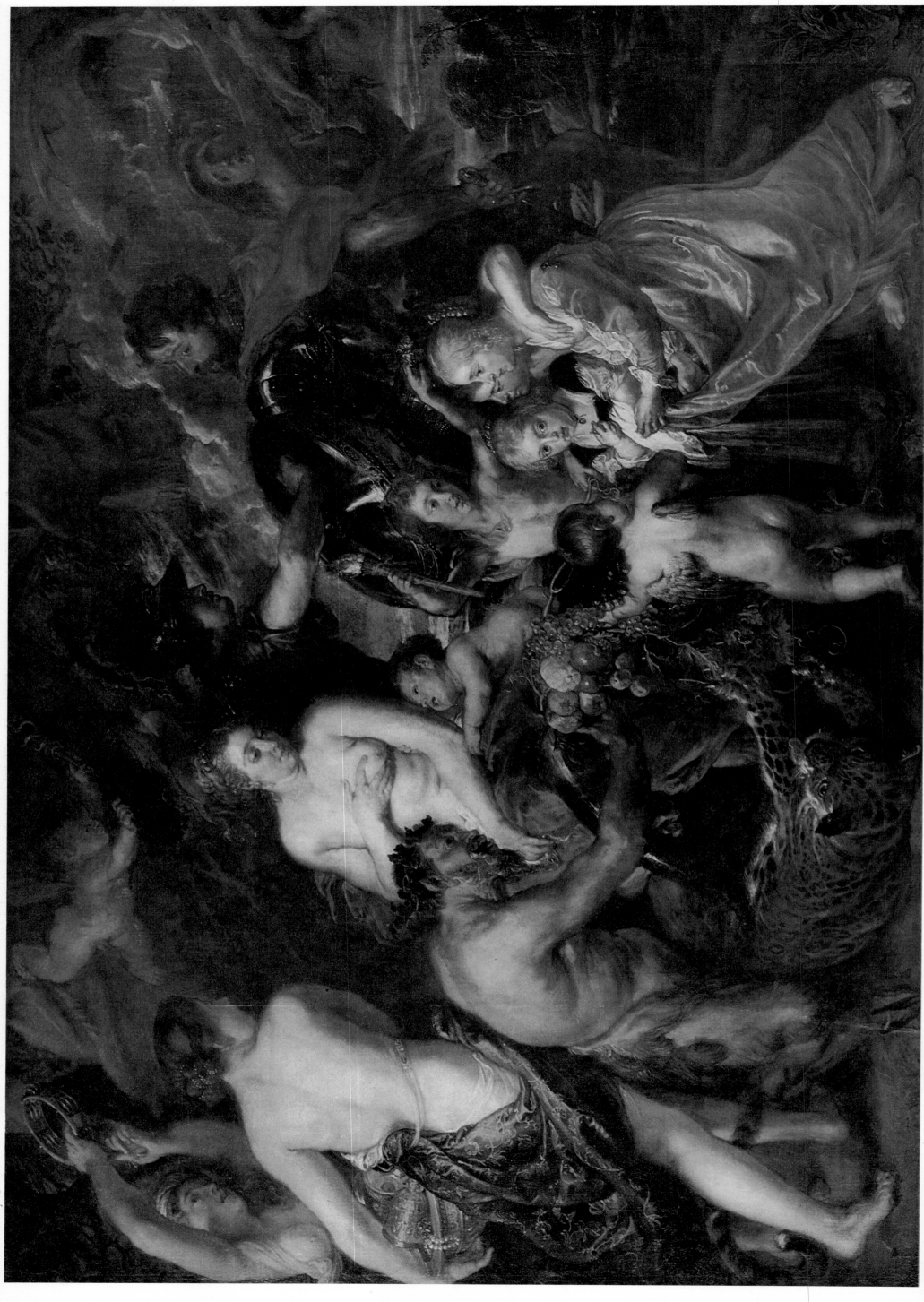

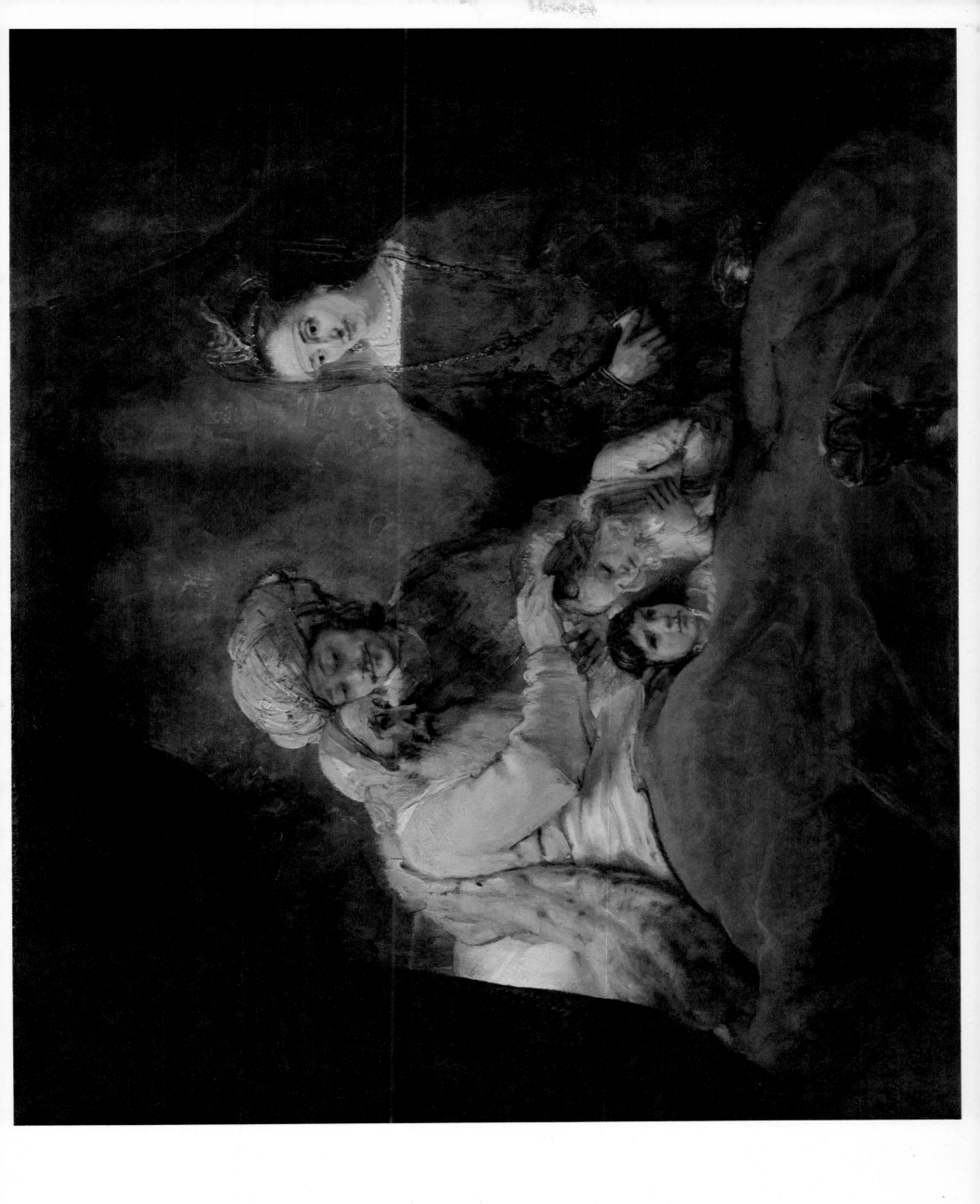

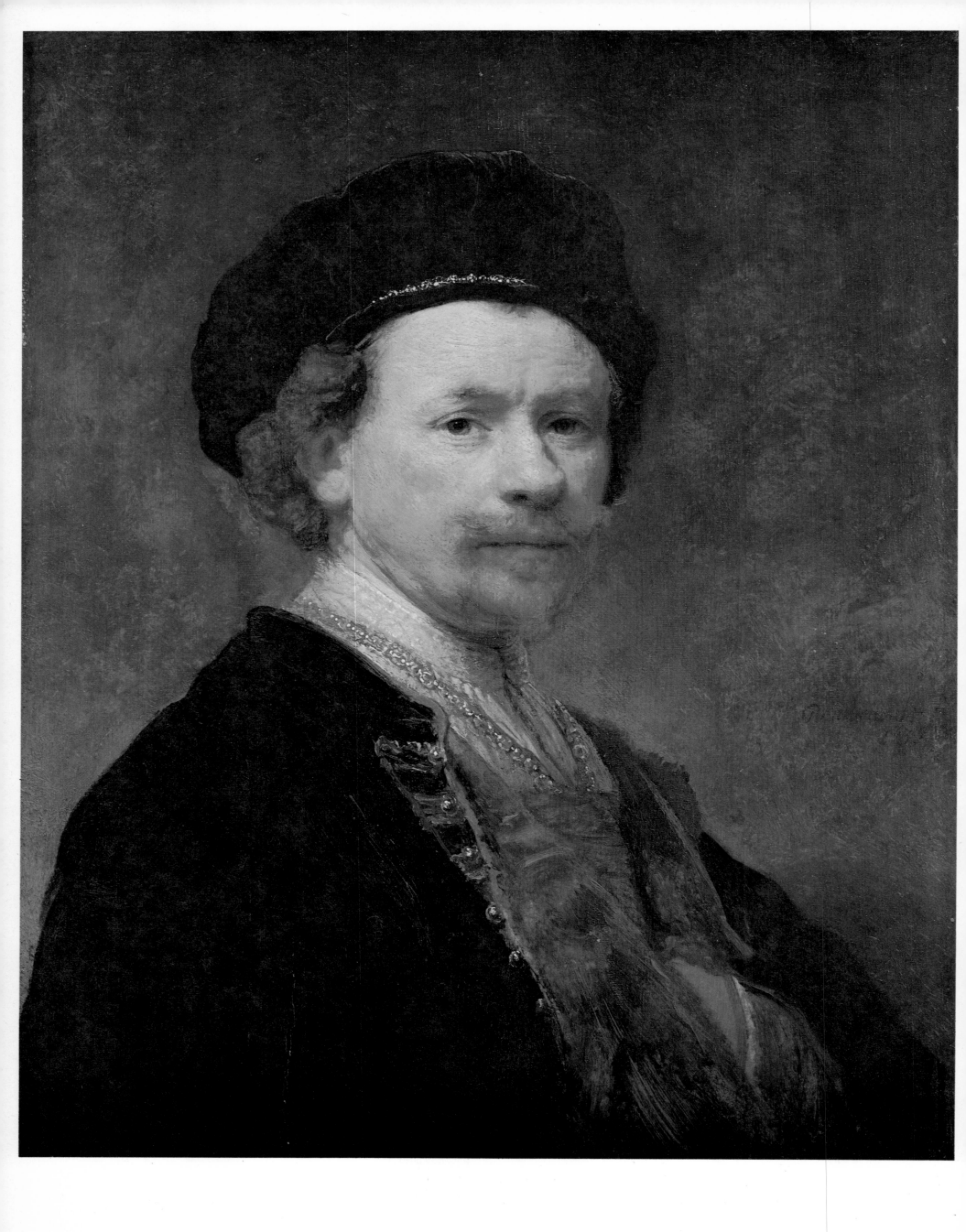

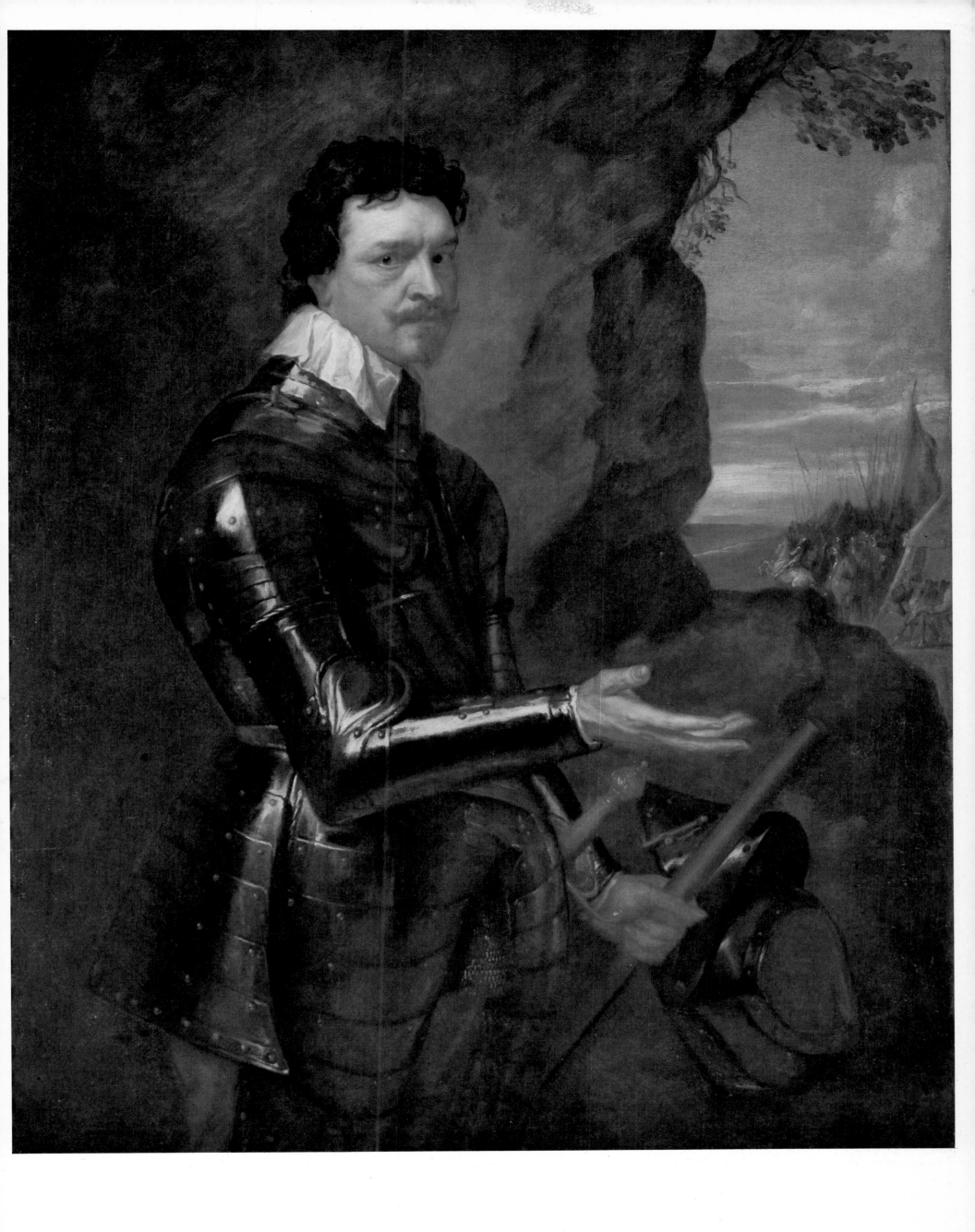

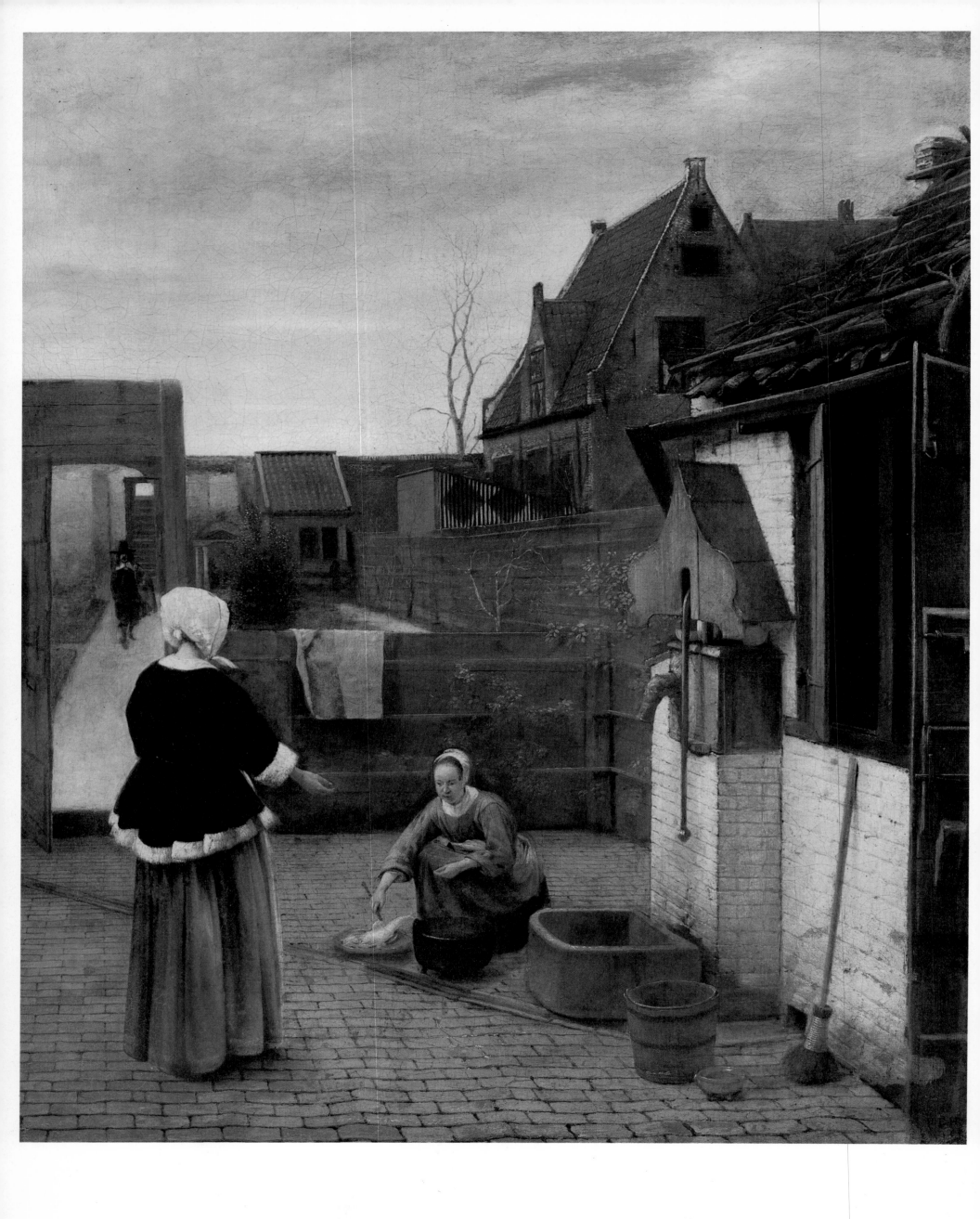

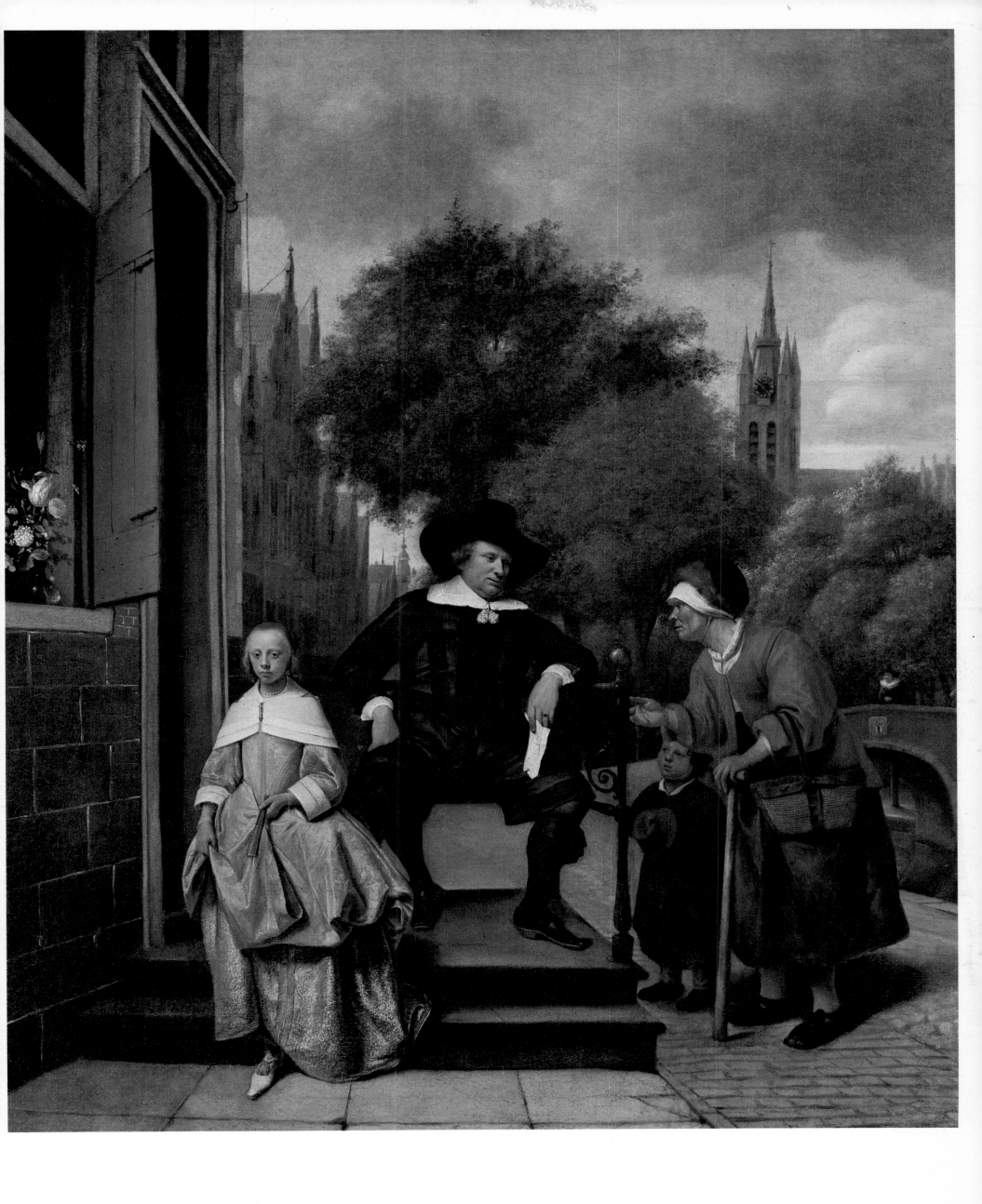

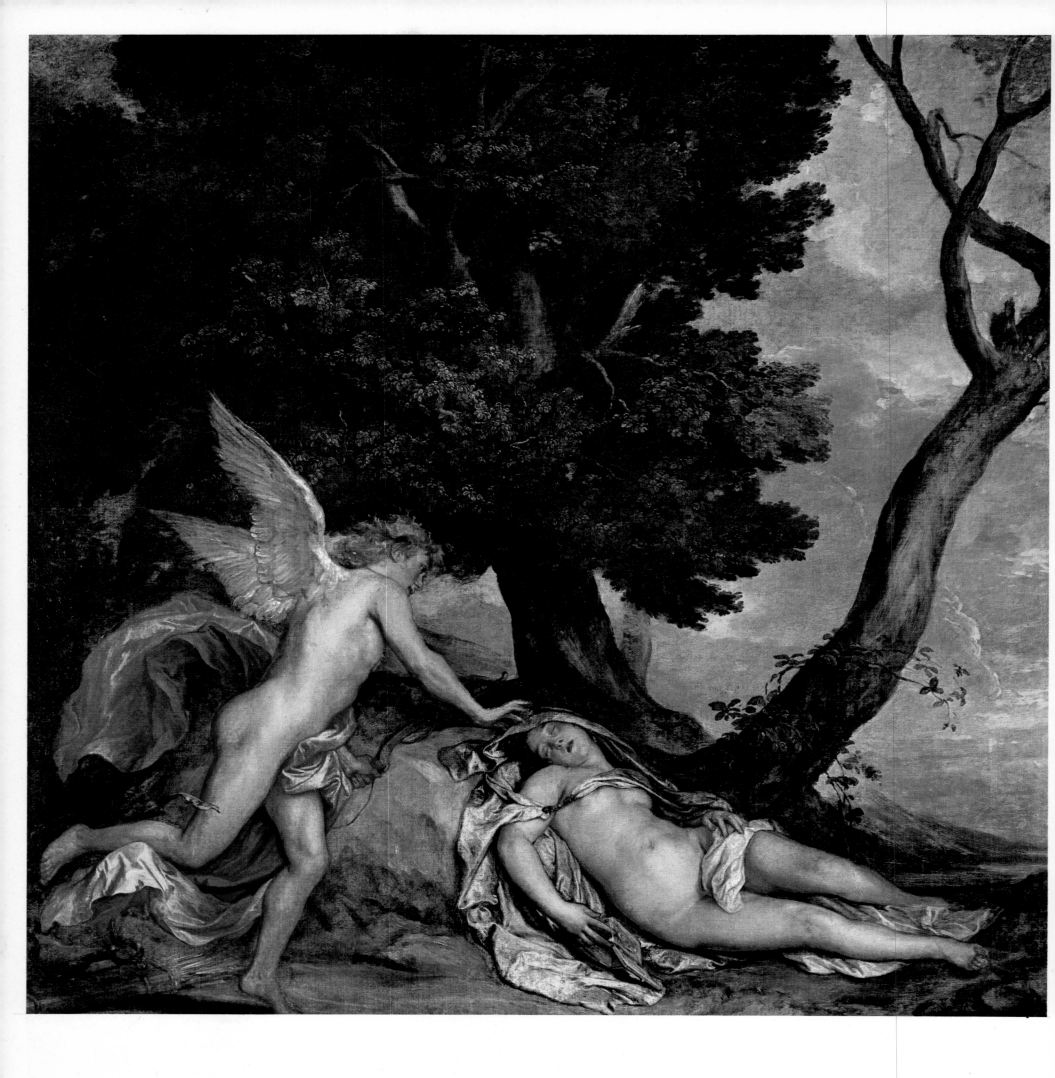

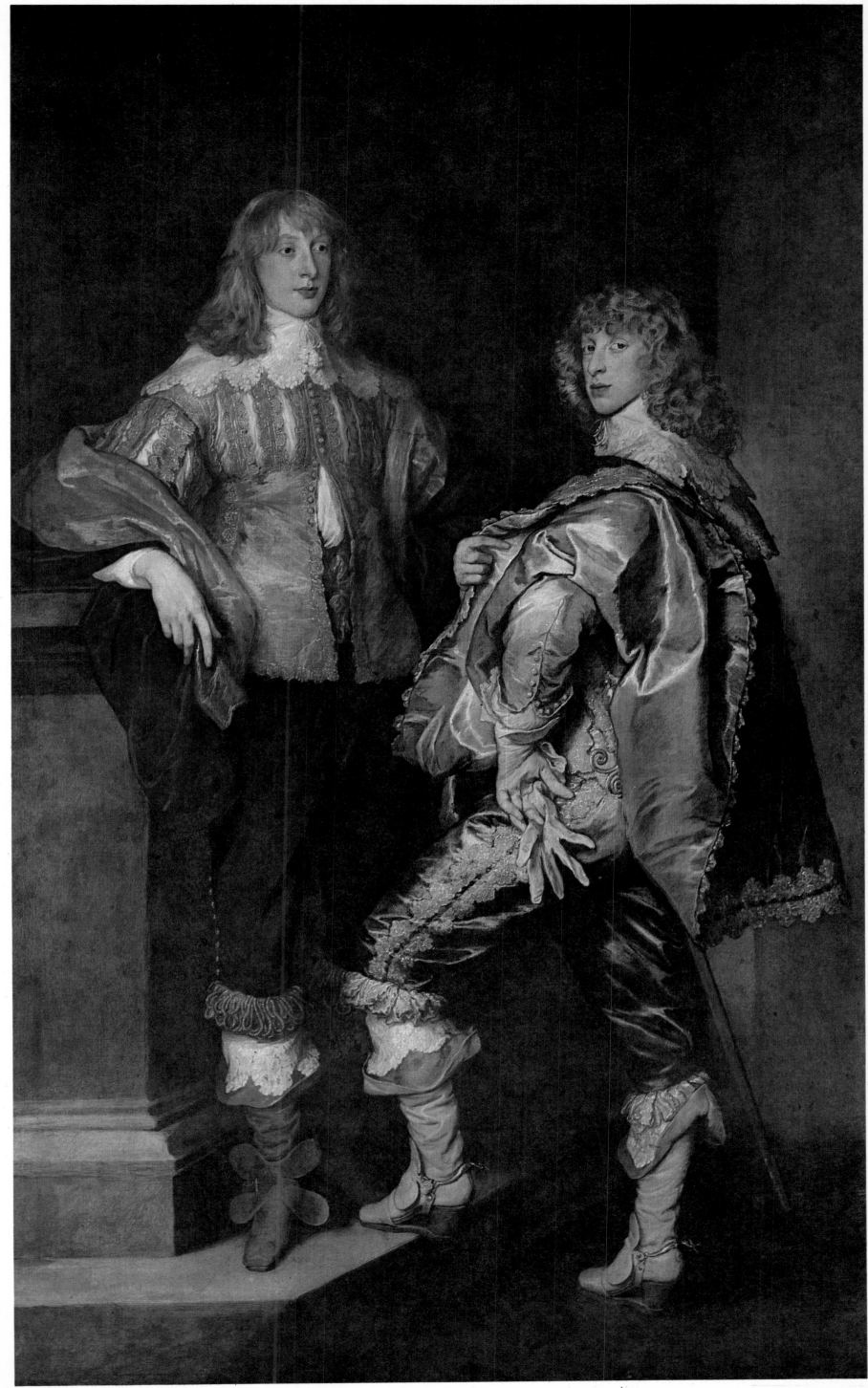

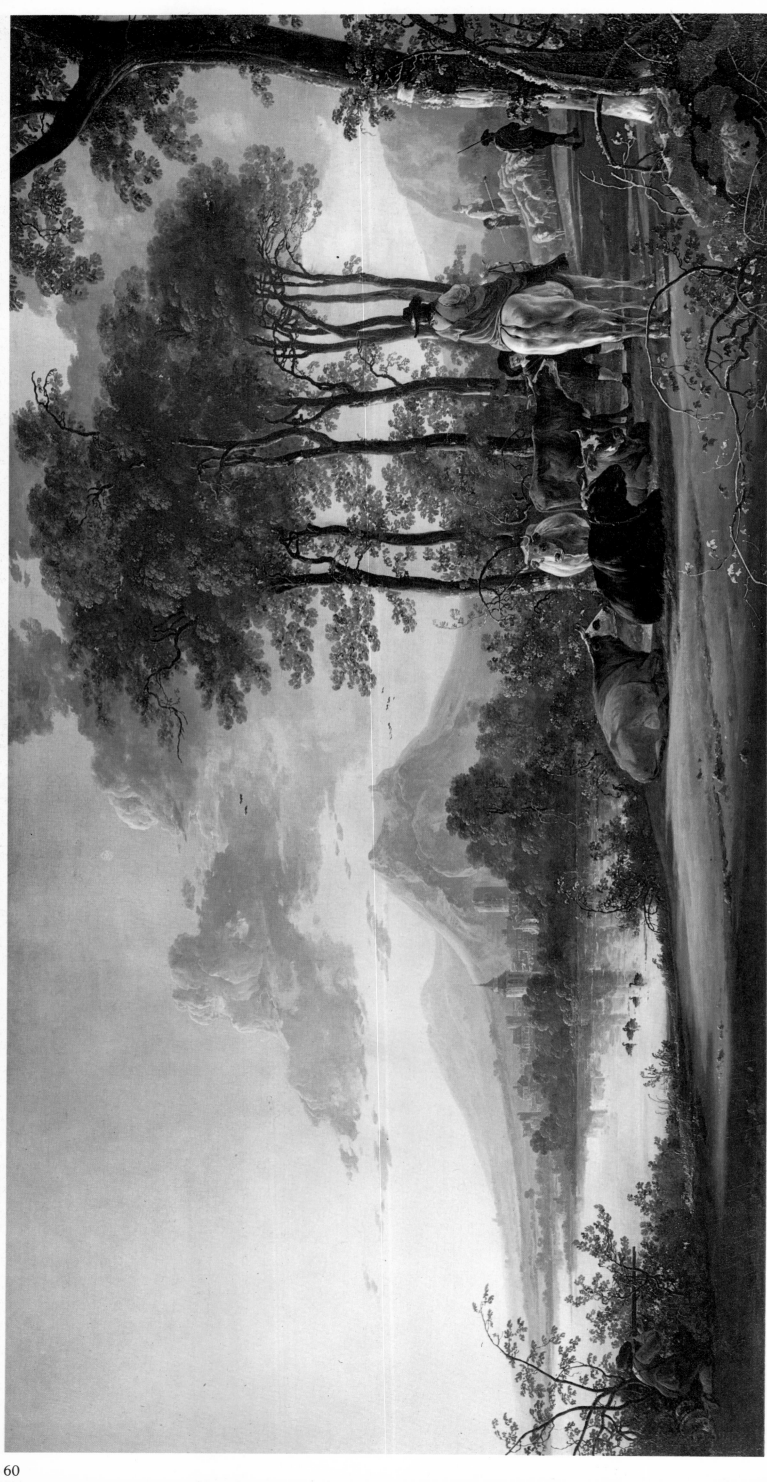

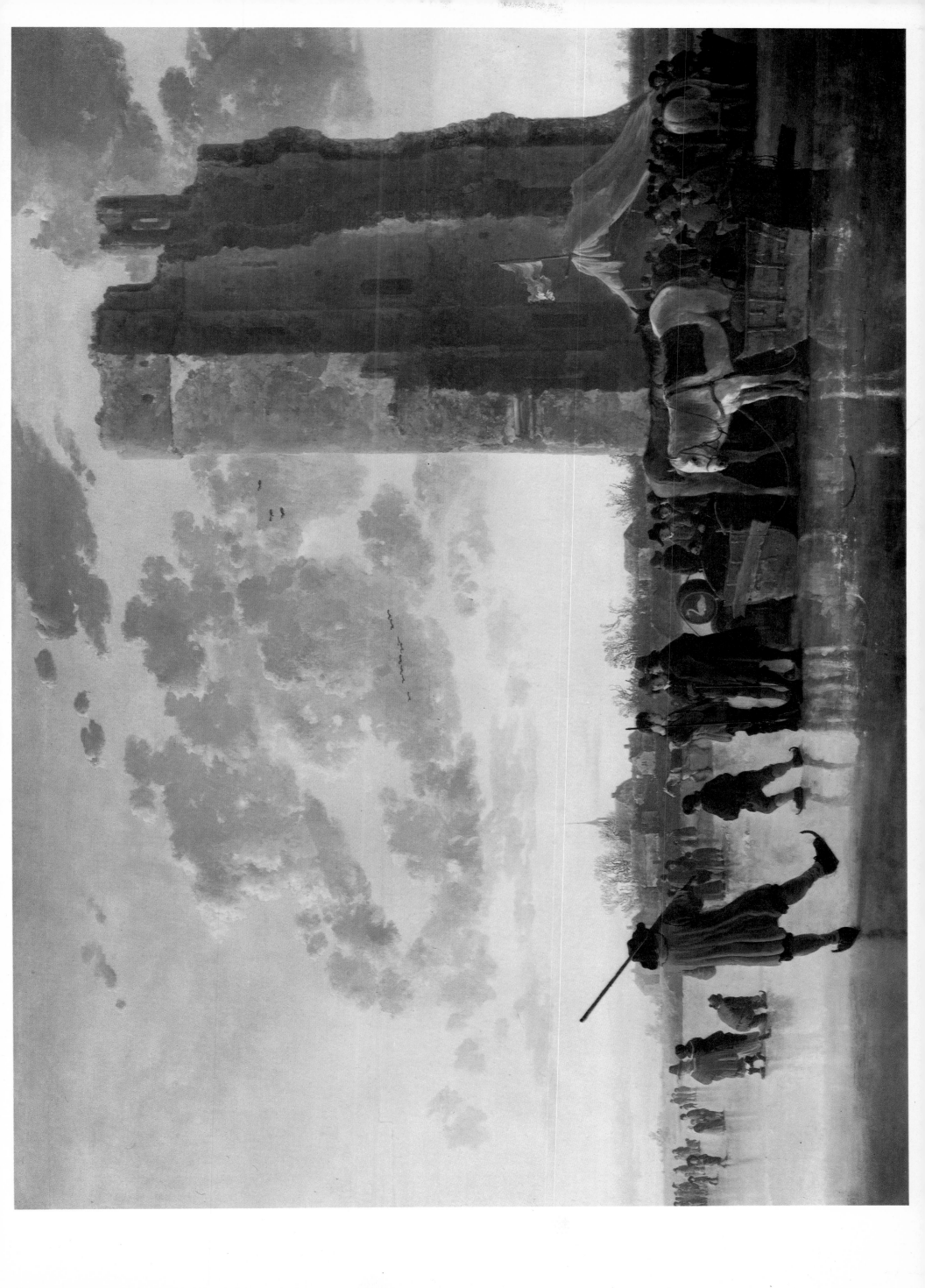

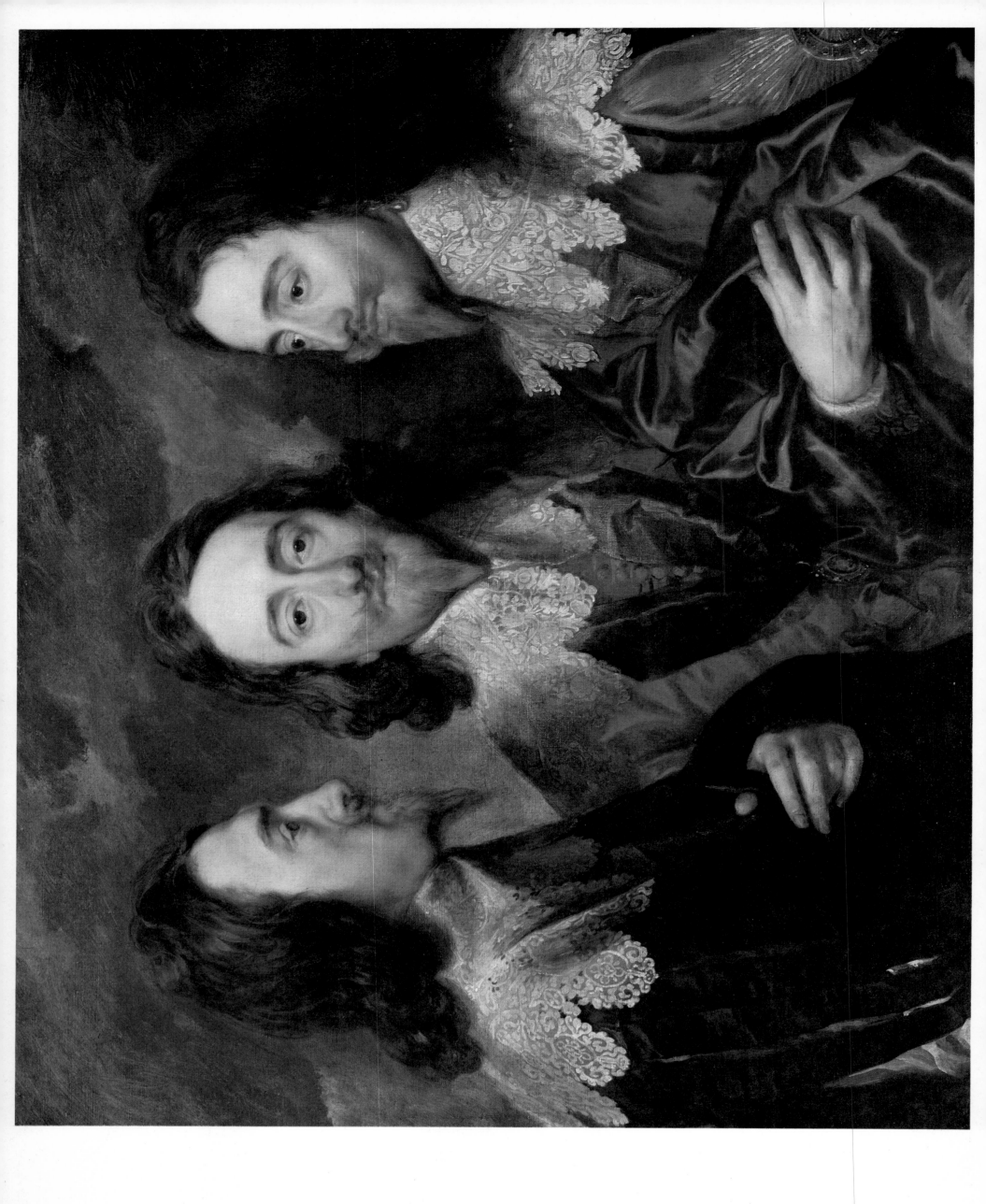

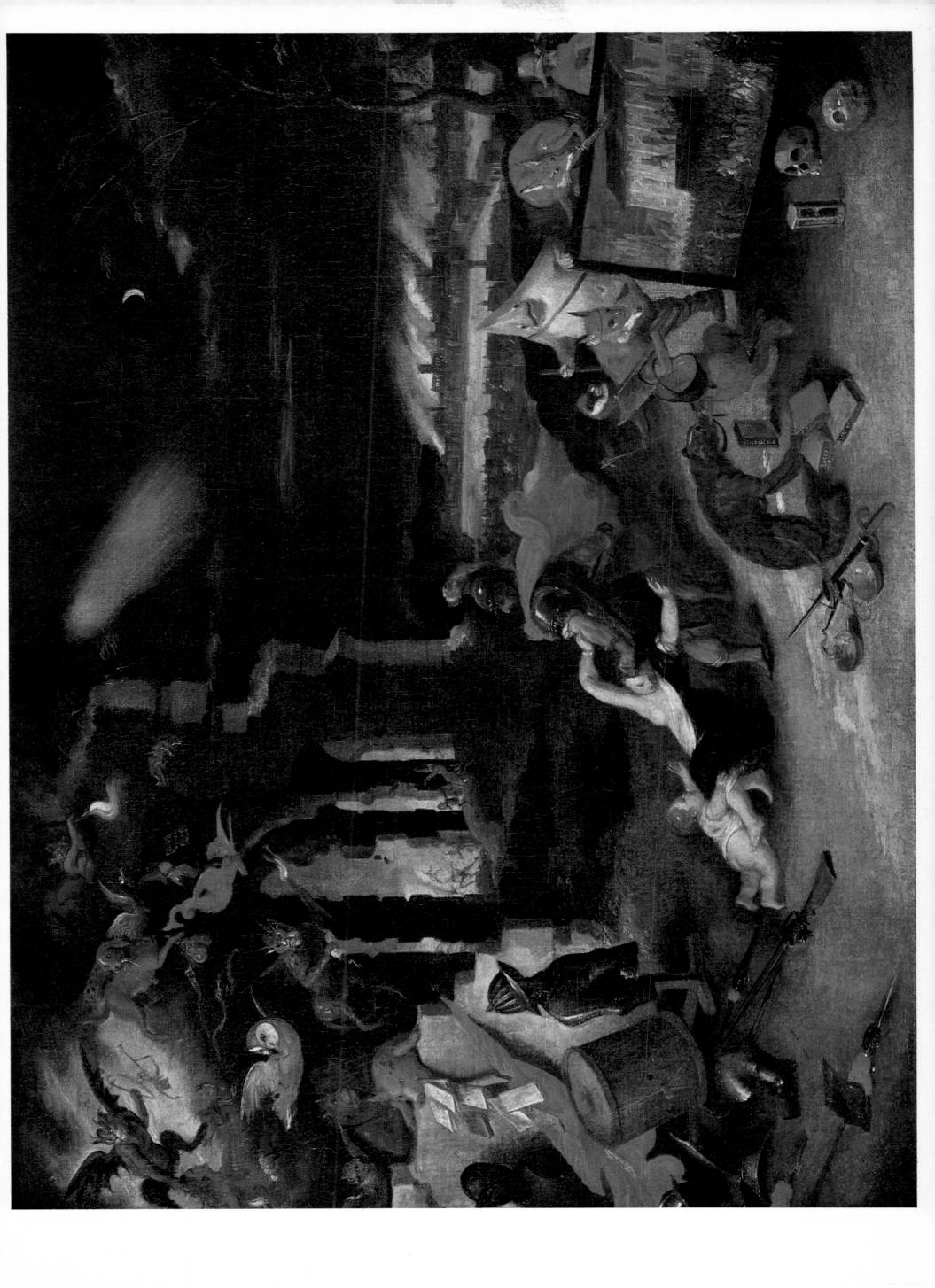

63

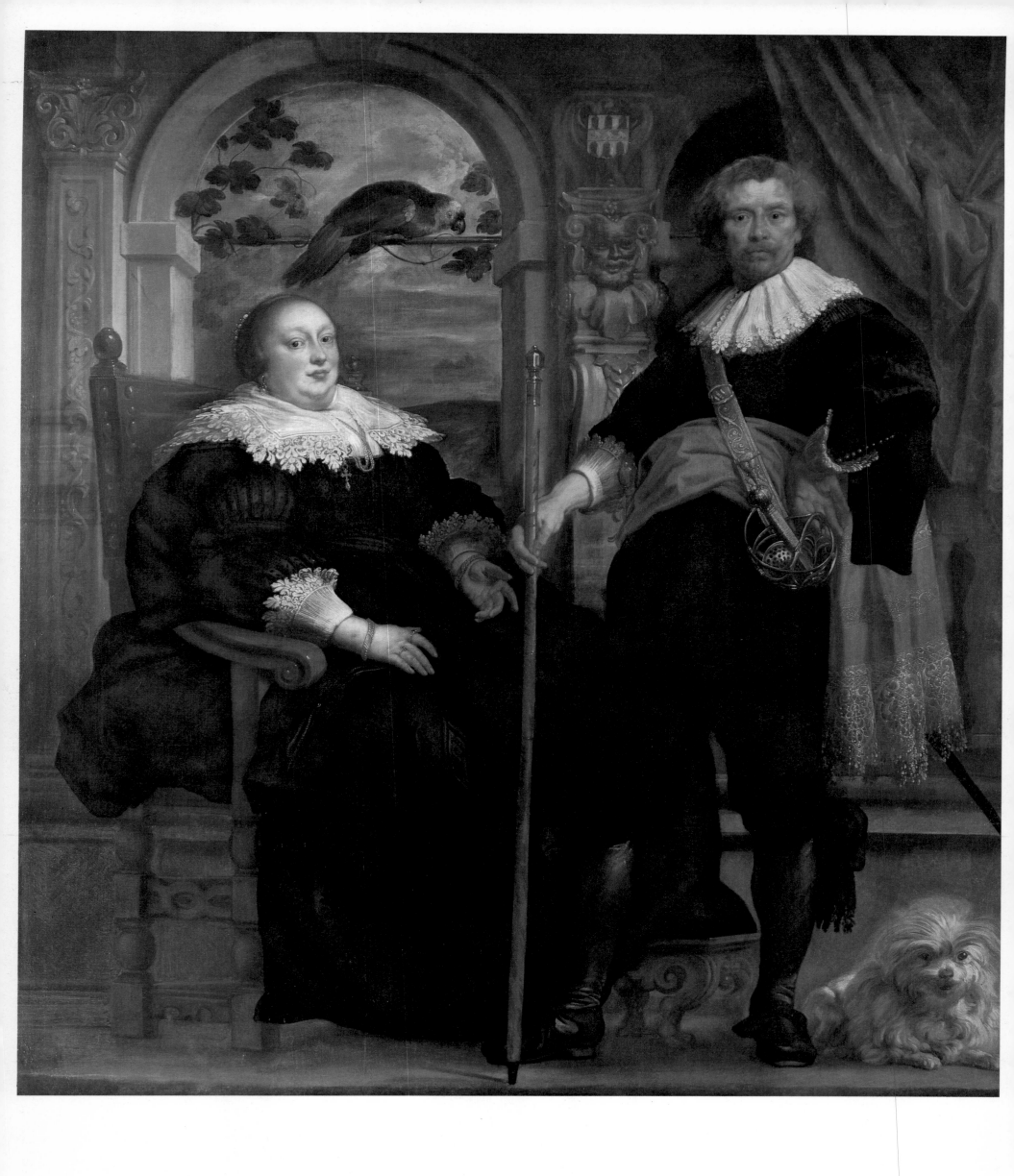

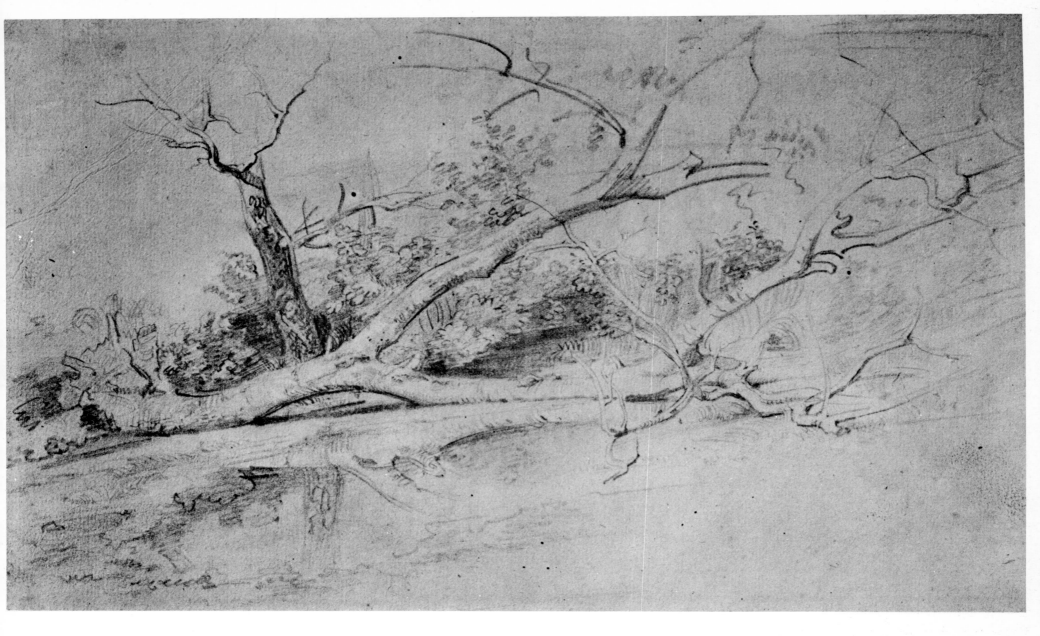

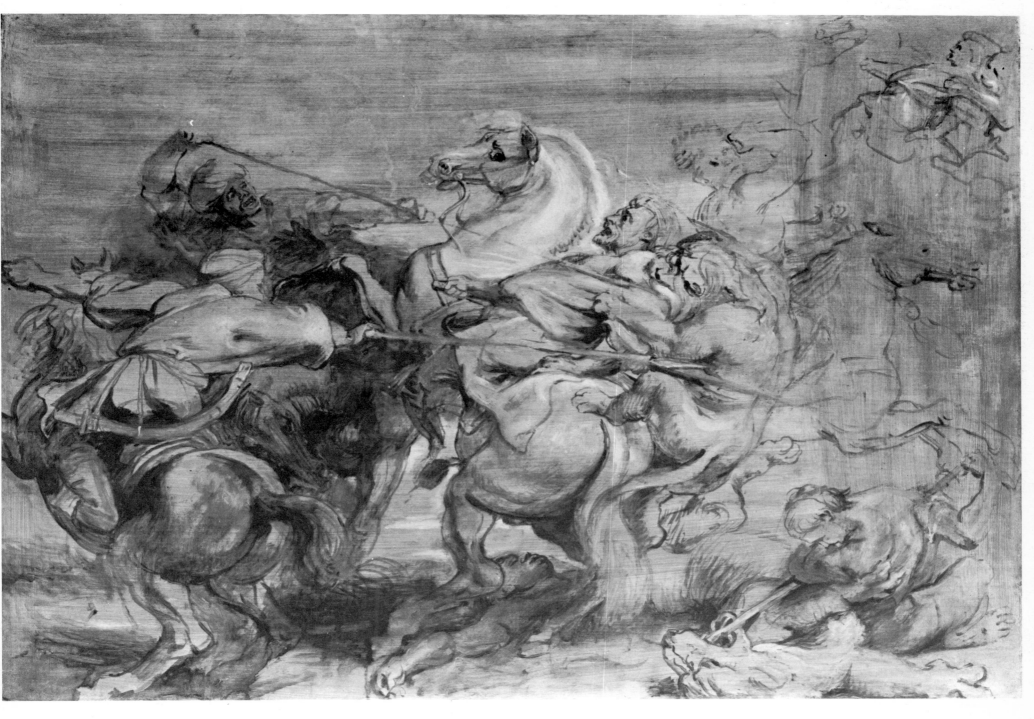

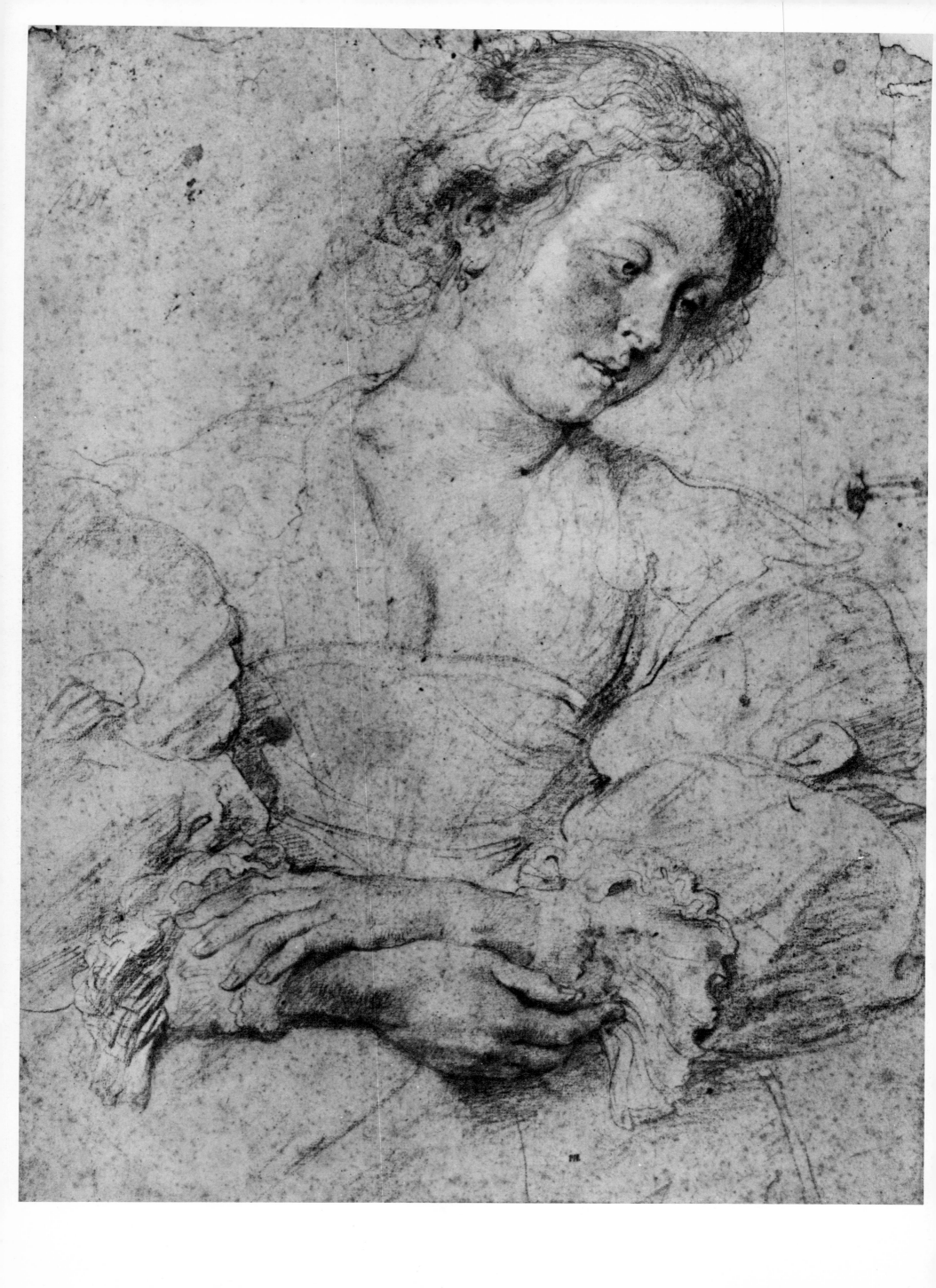

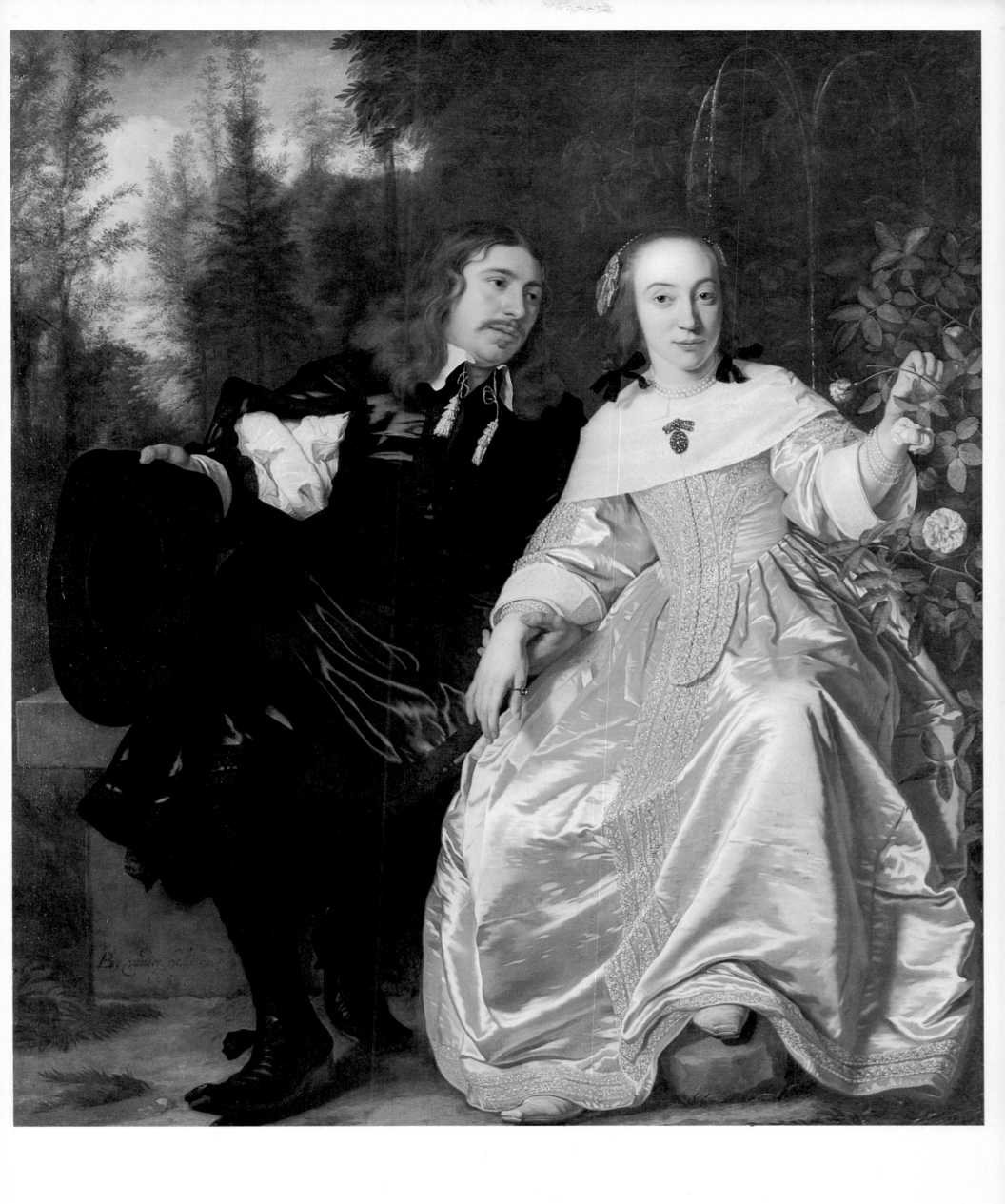

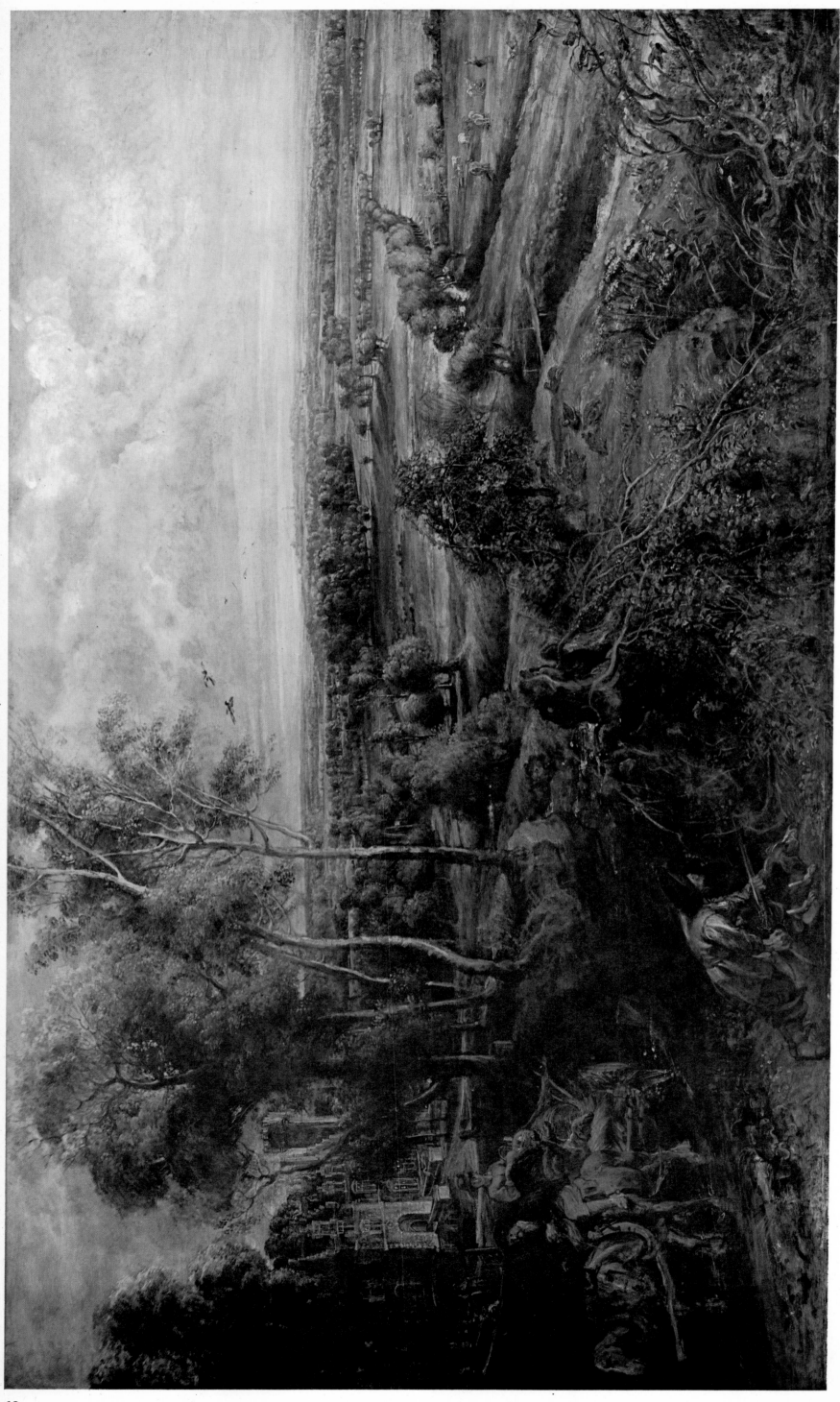

68

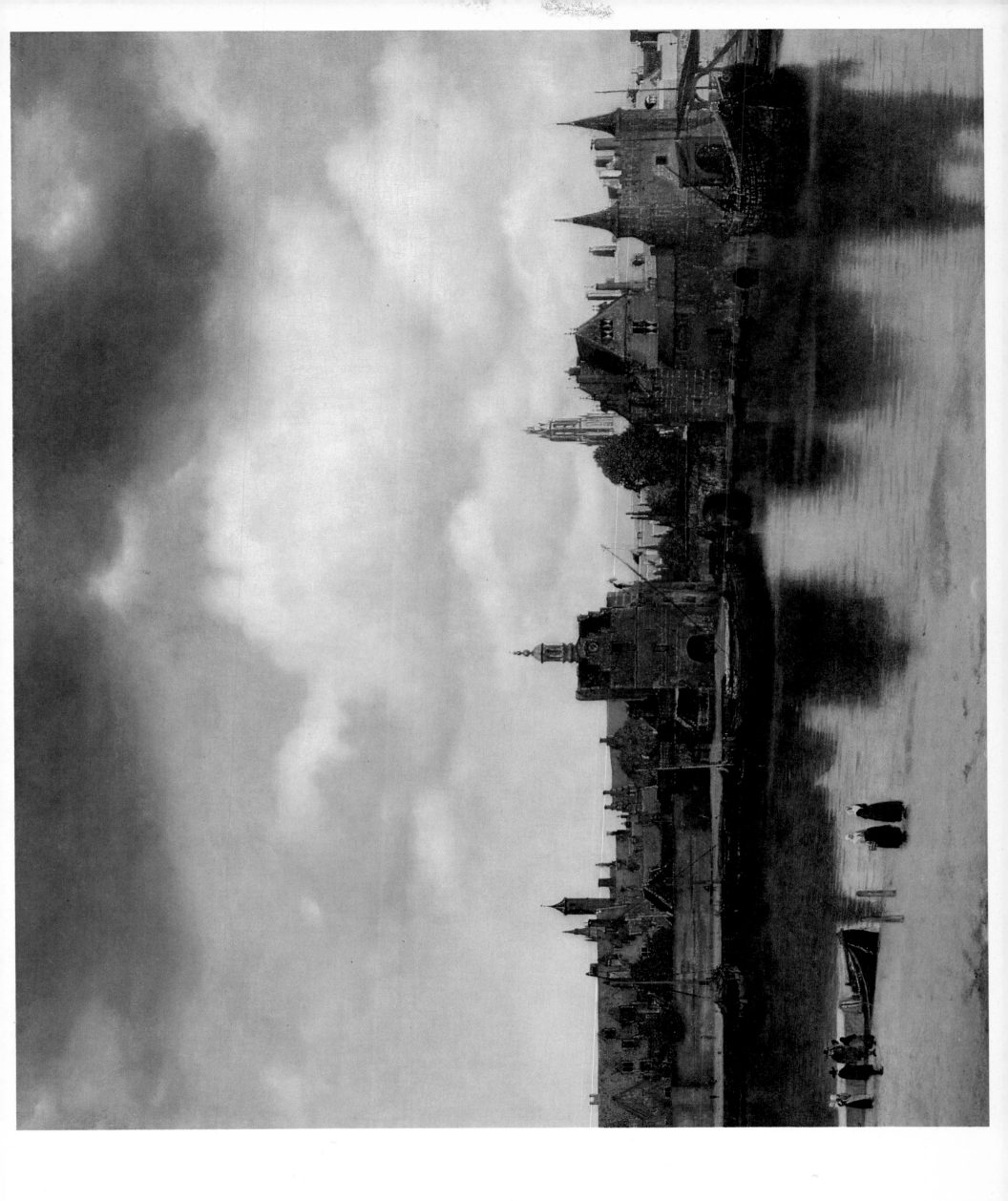

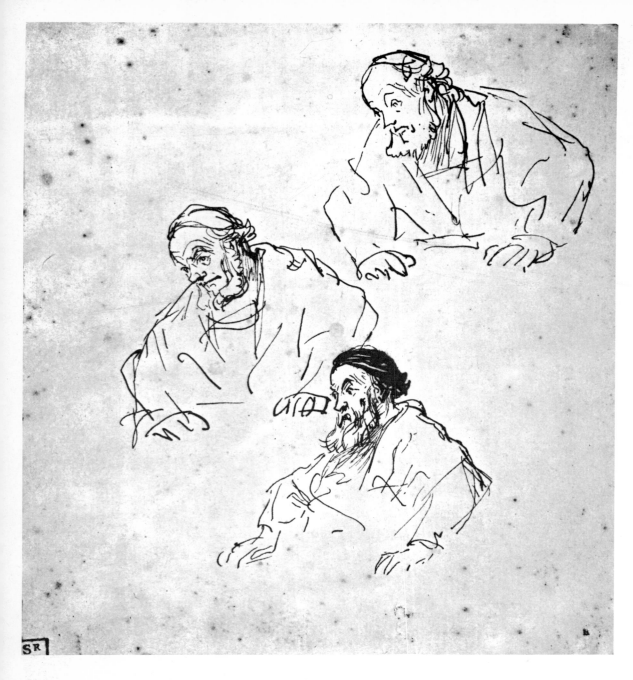

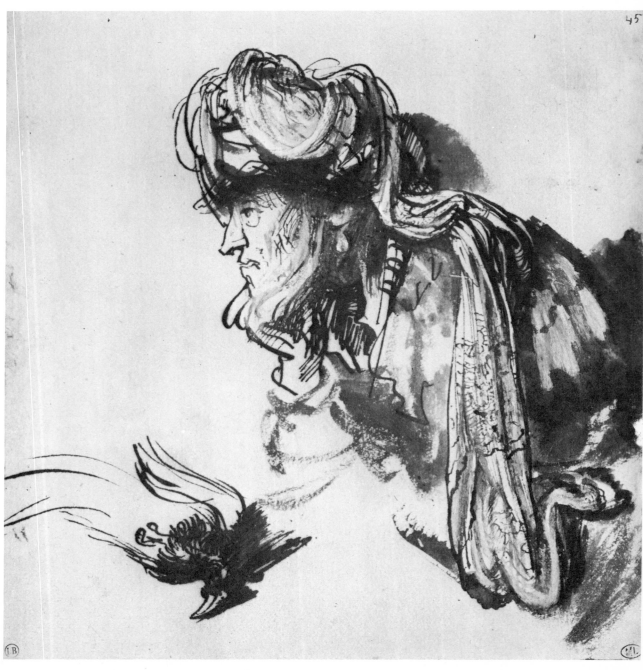

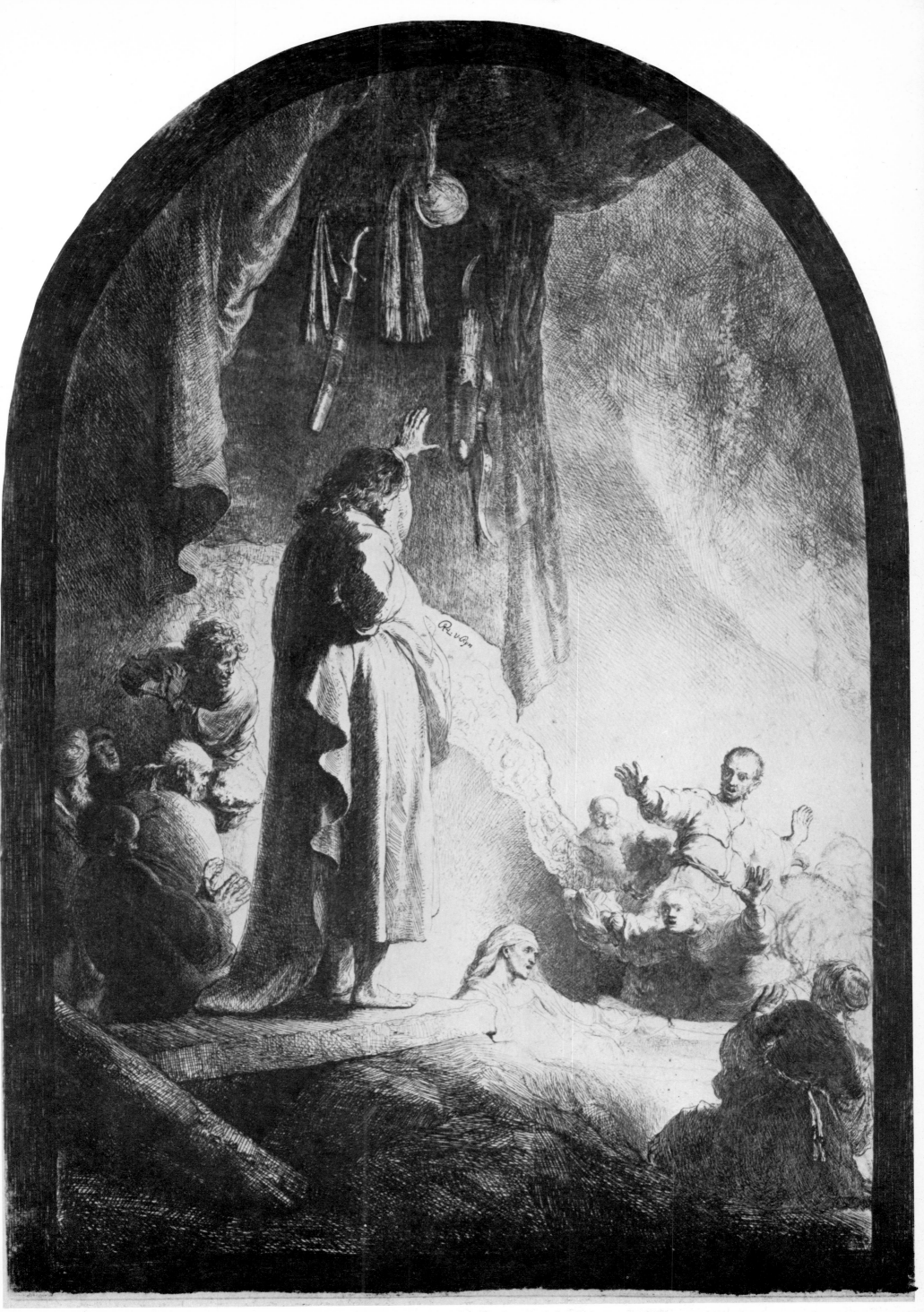

73

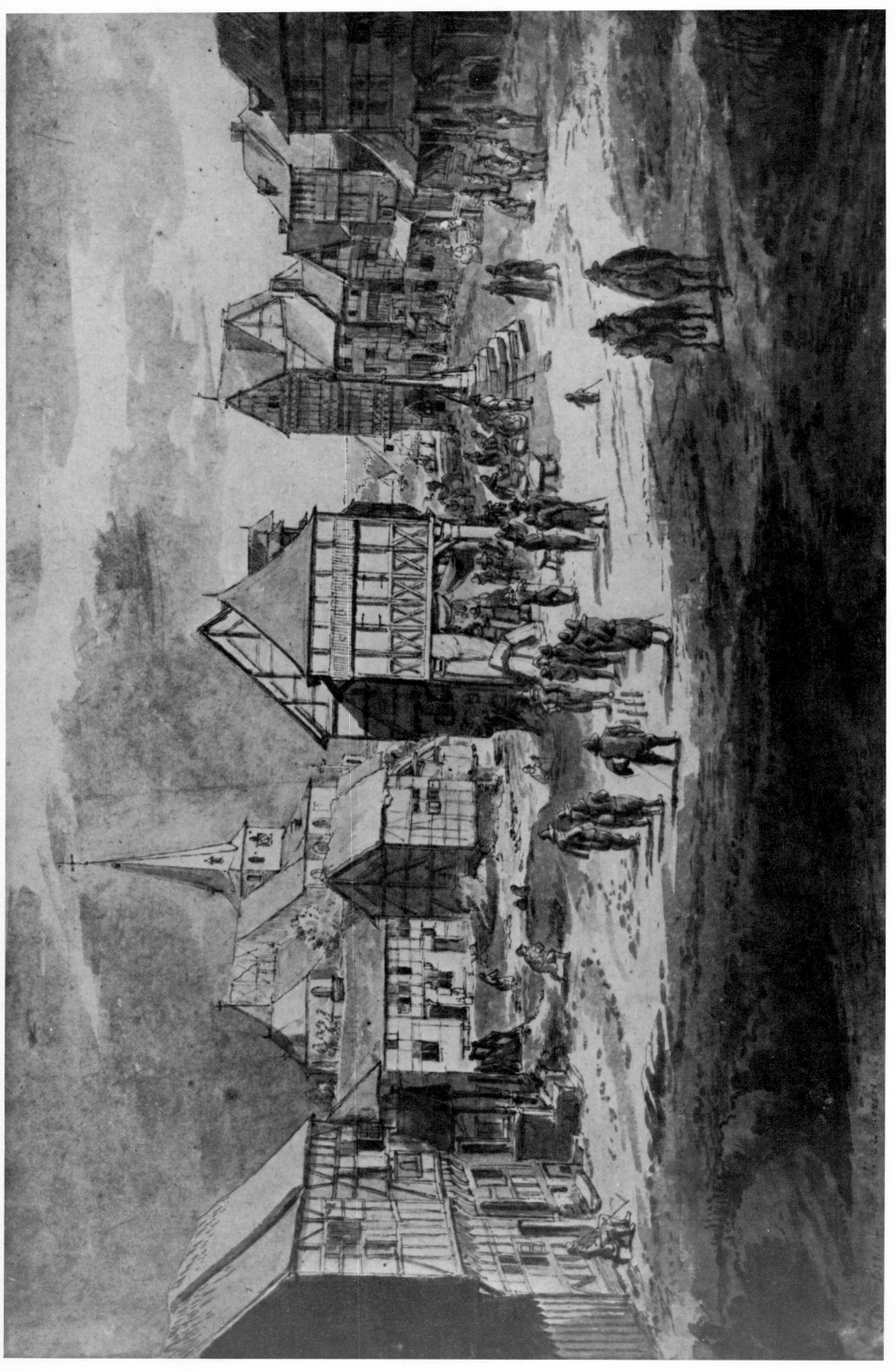

74

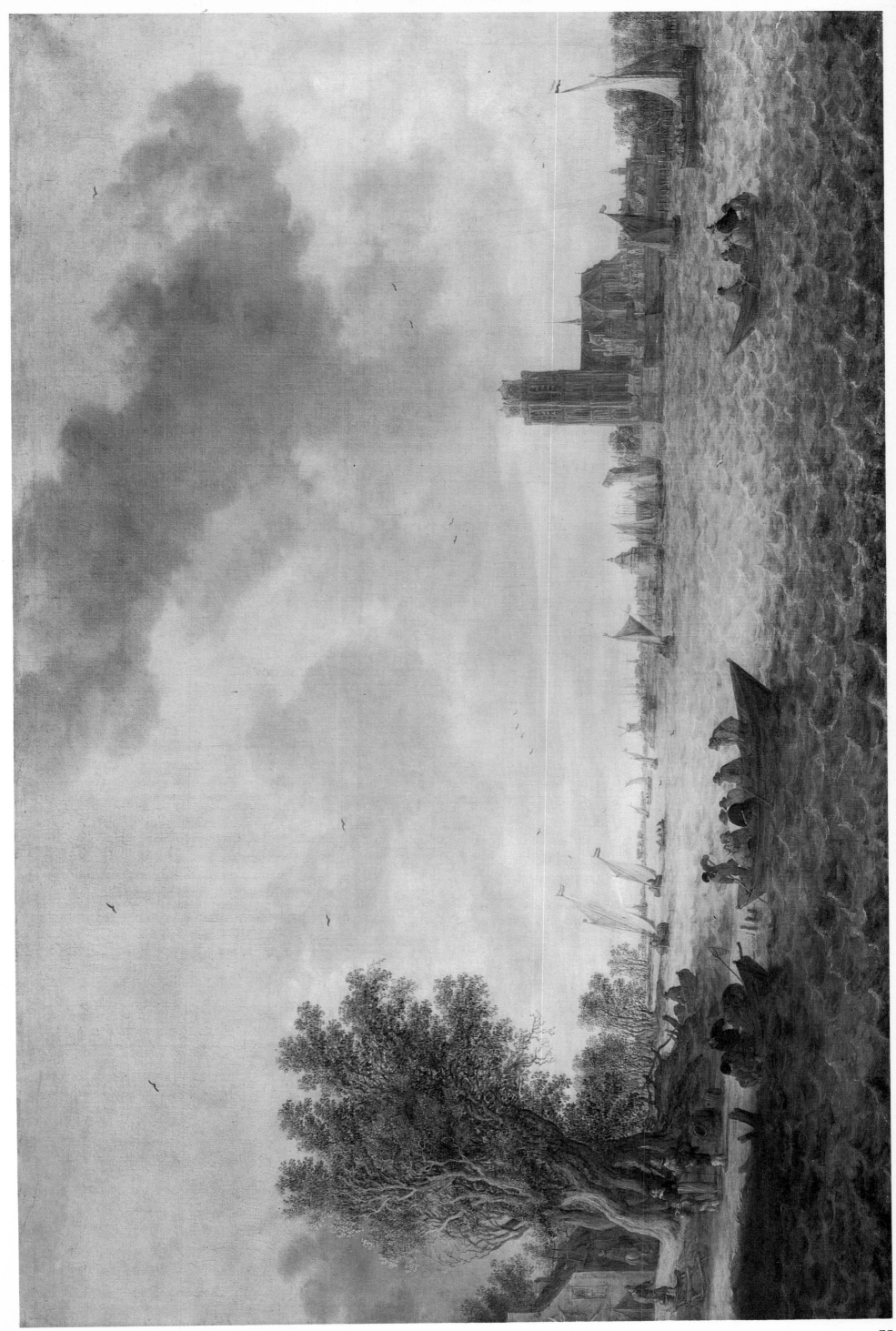

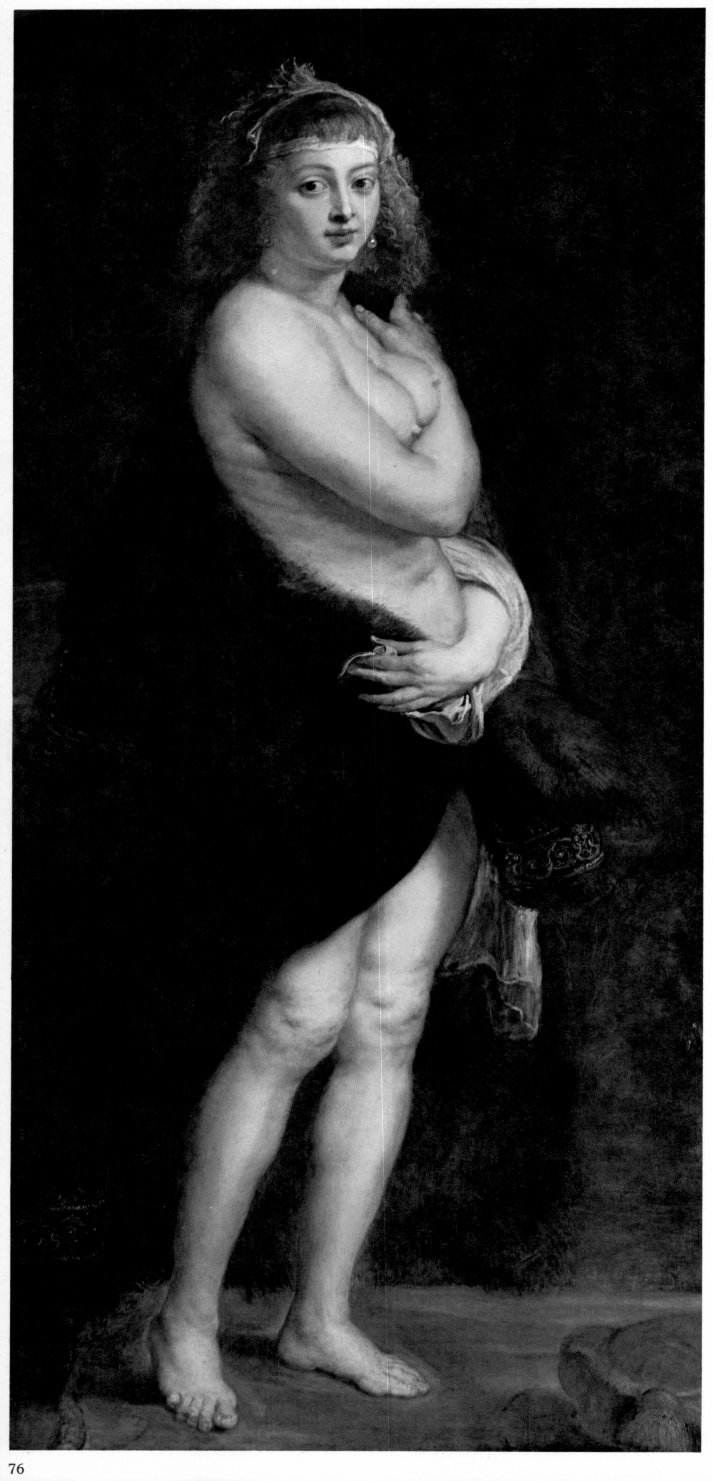

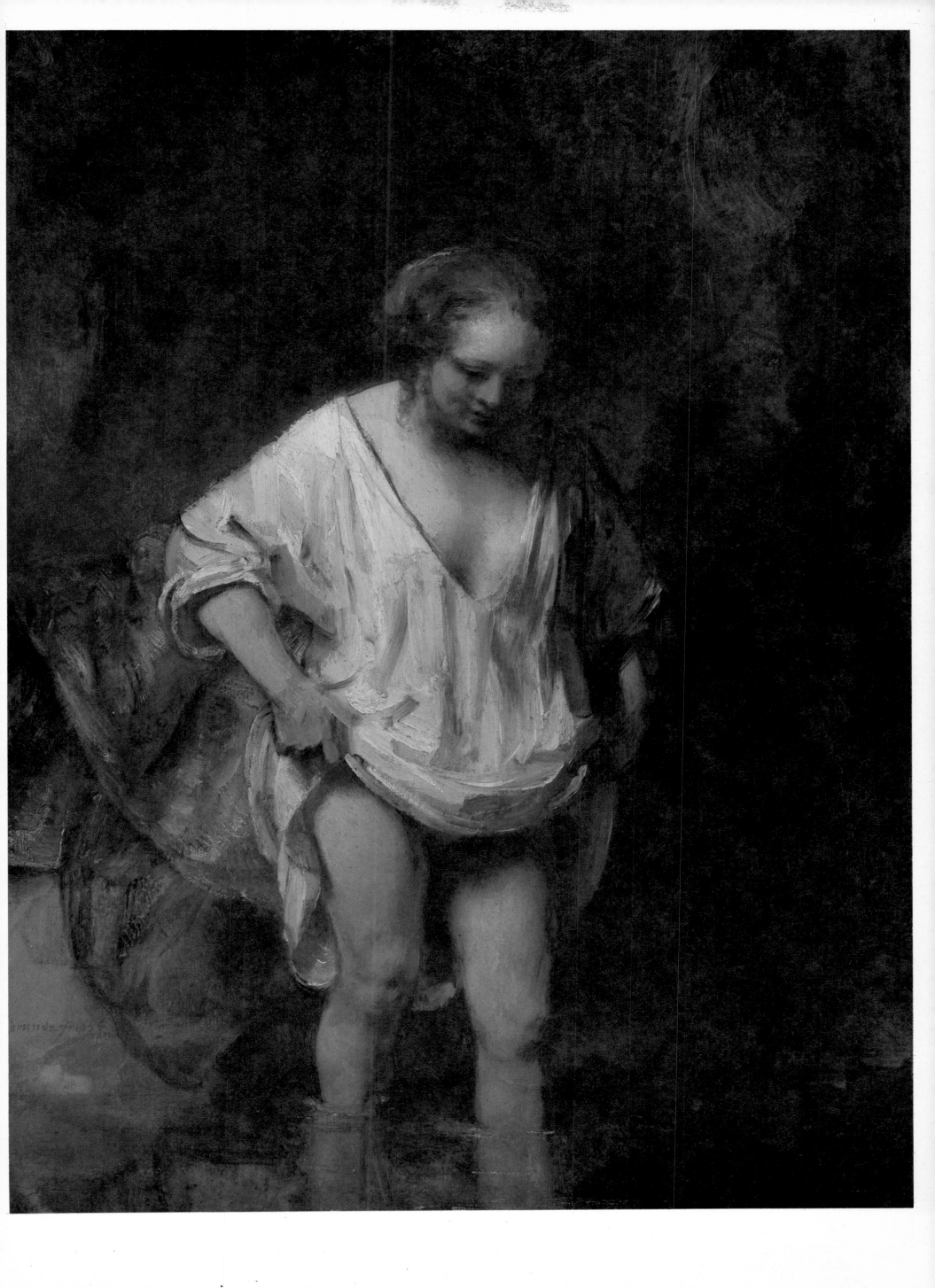

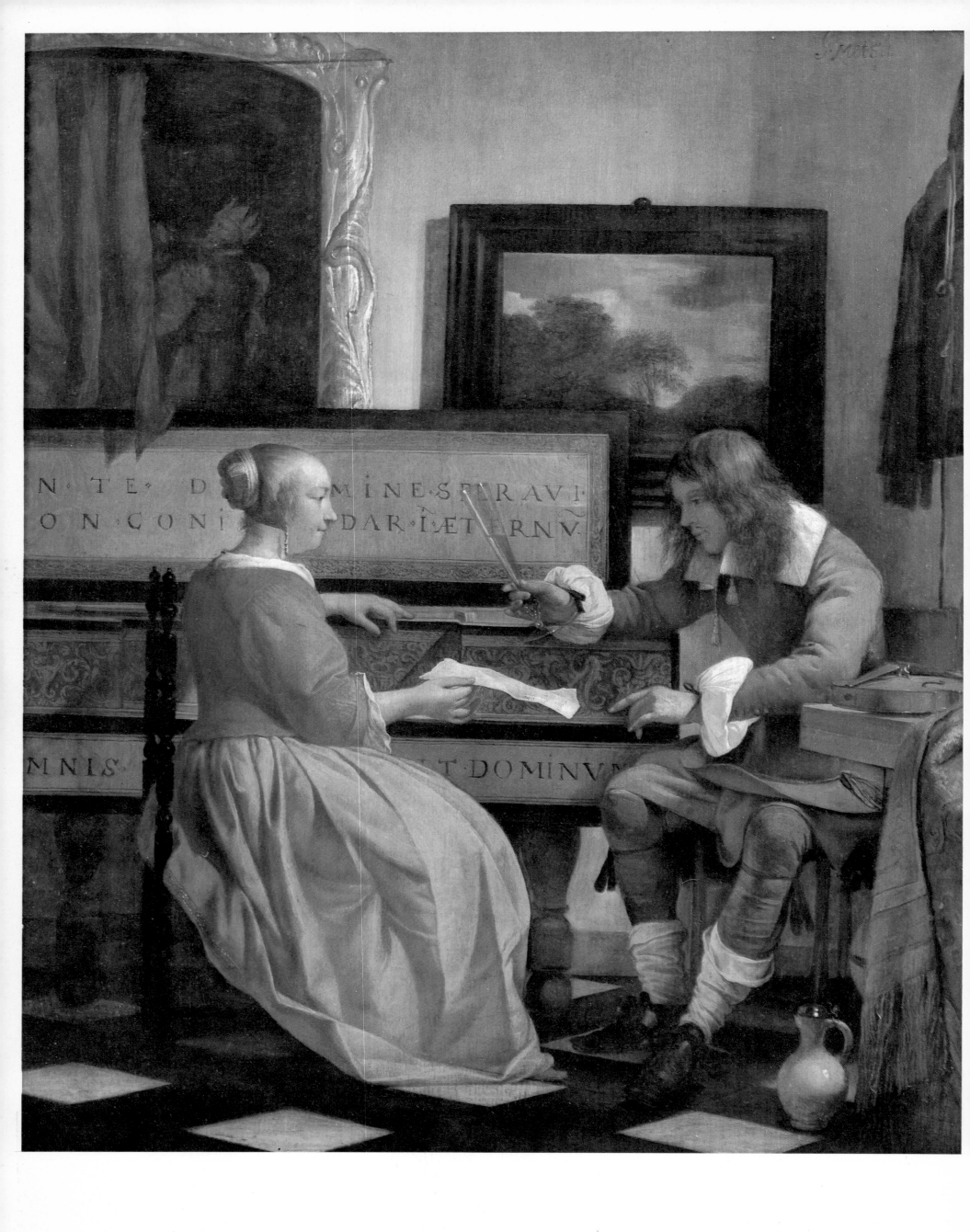

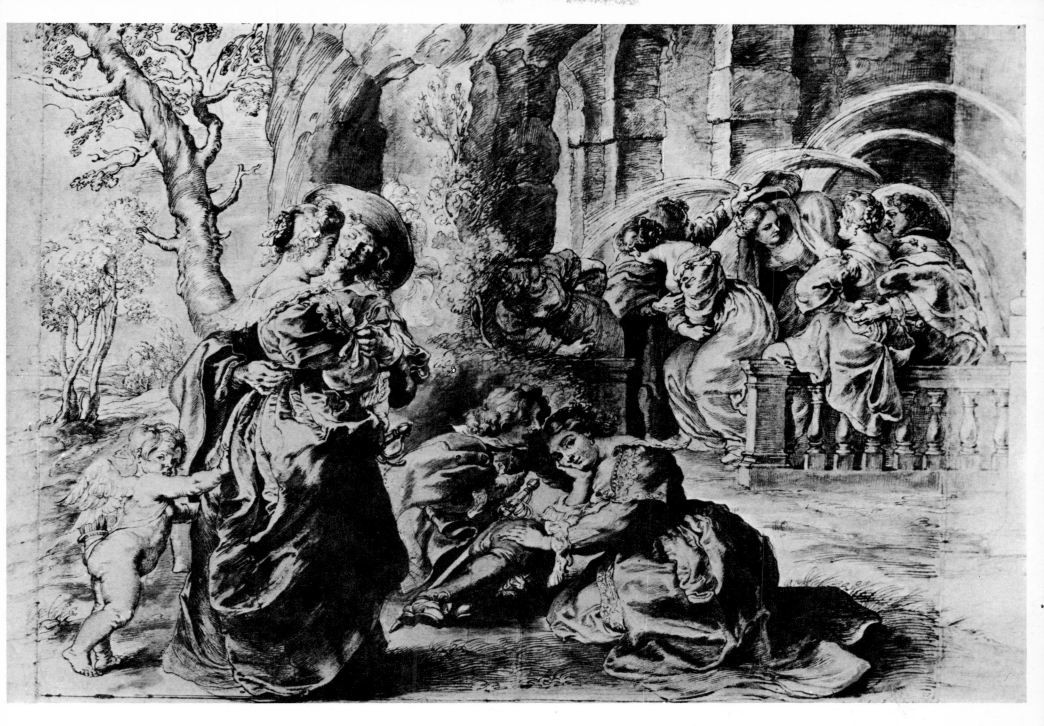

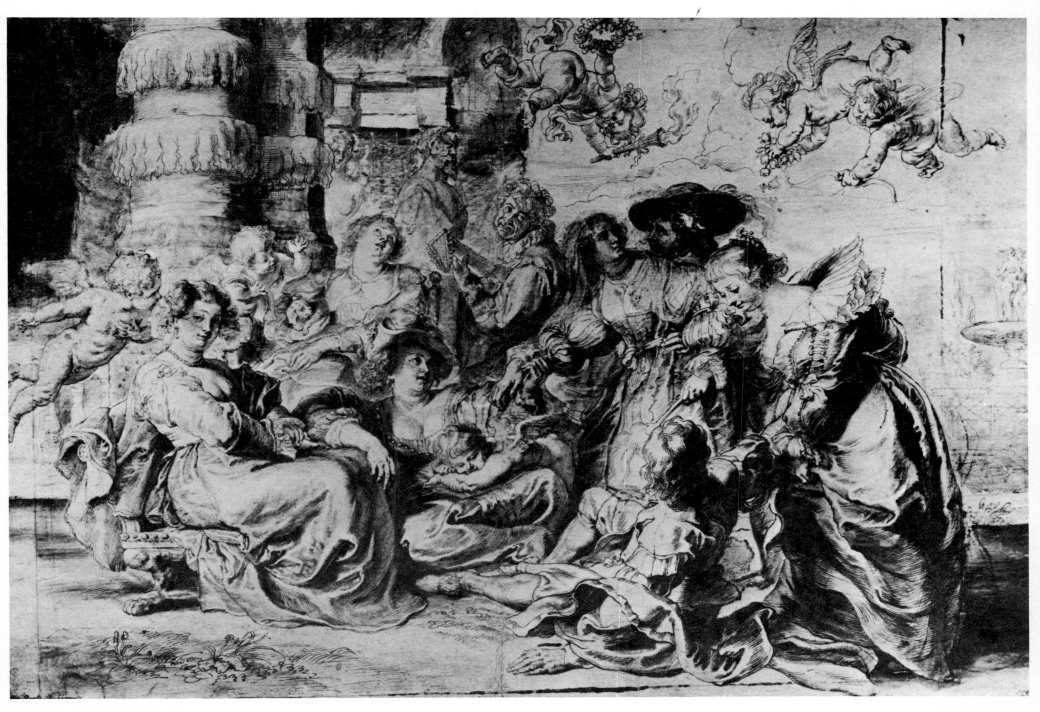

79

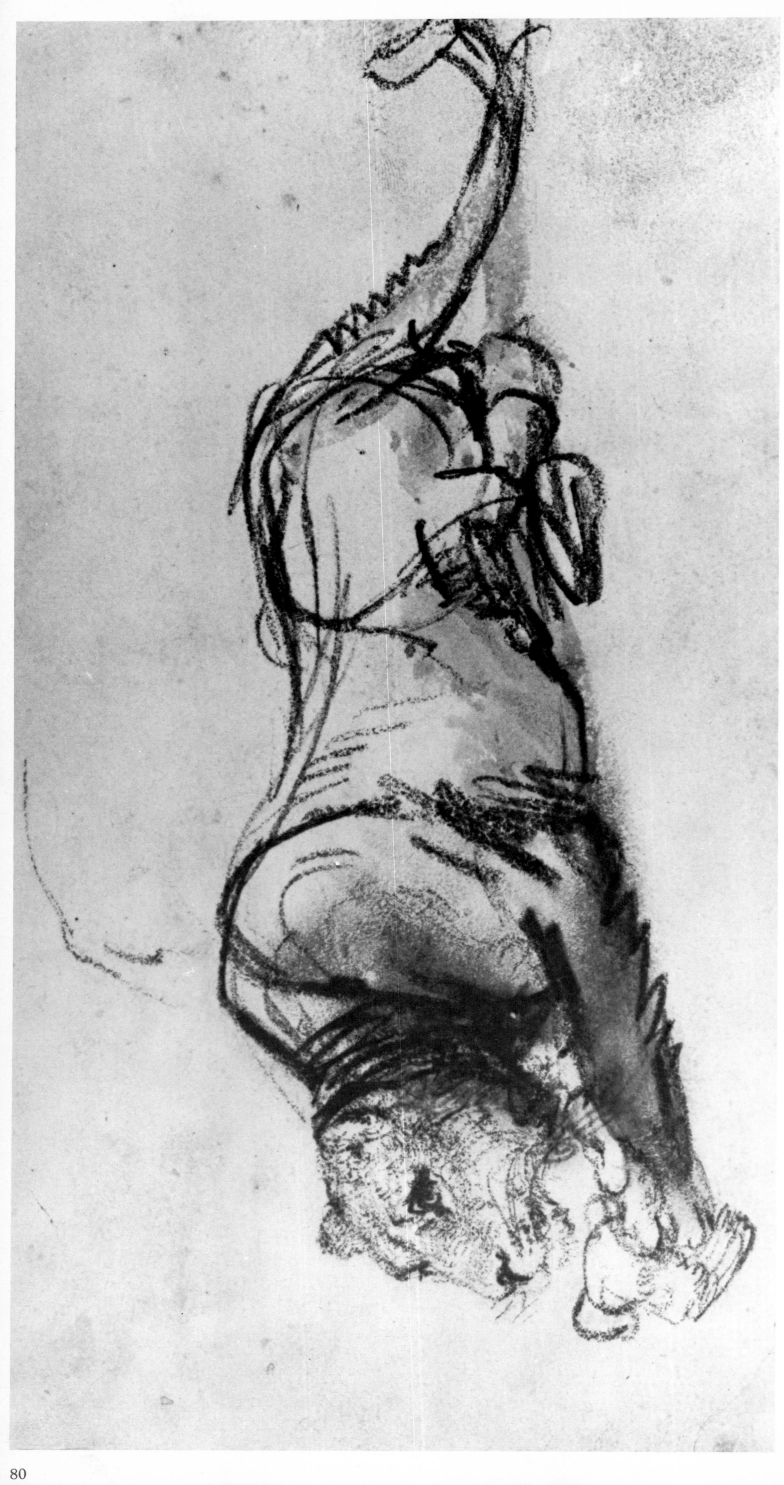

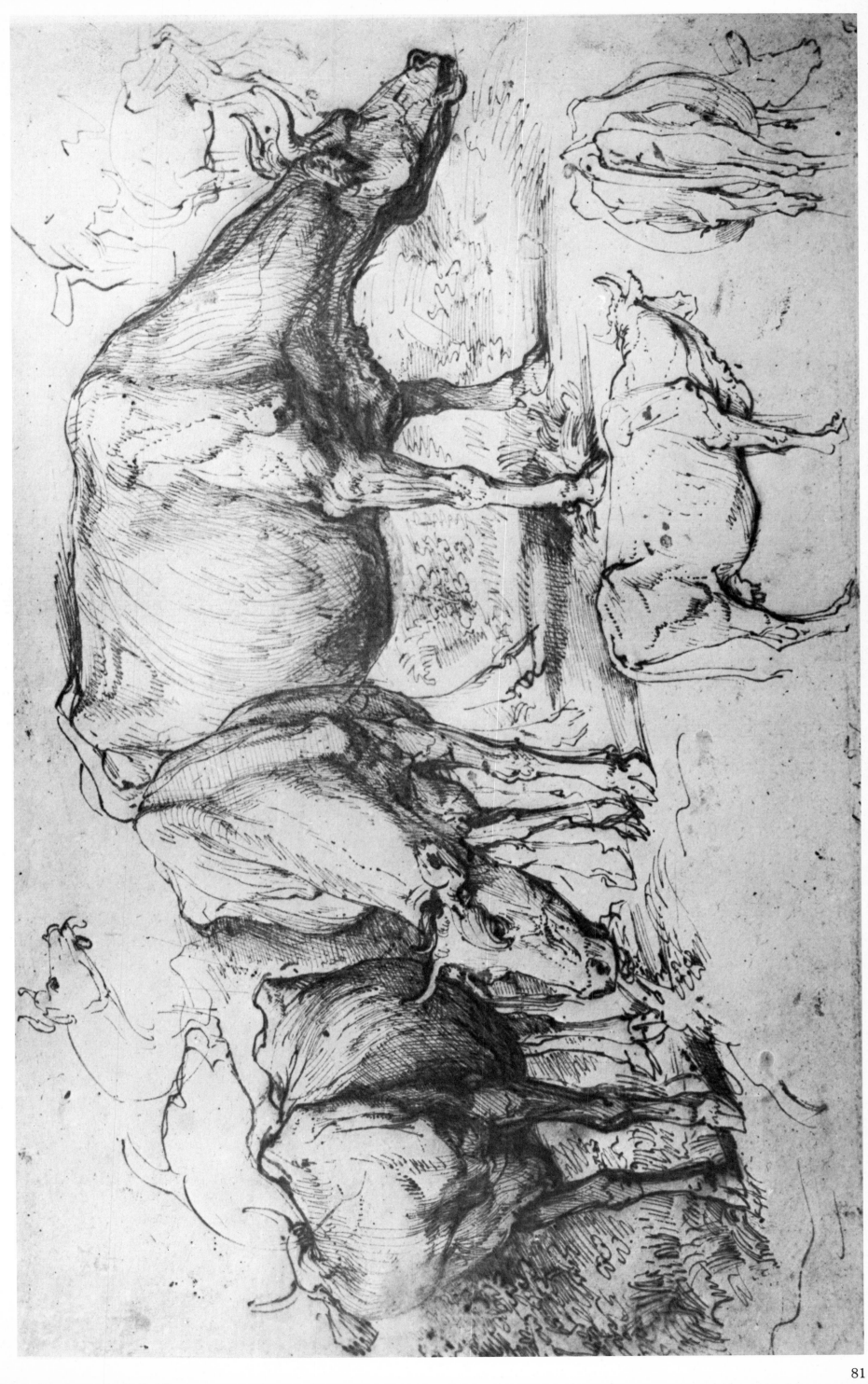

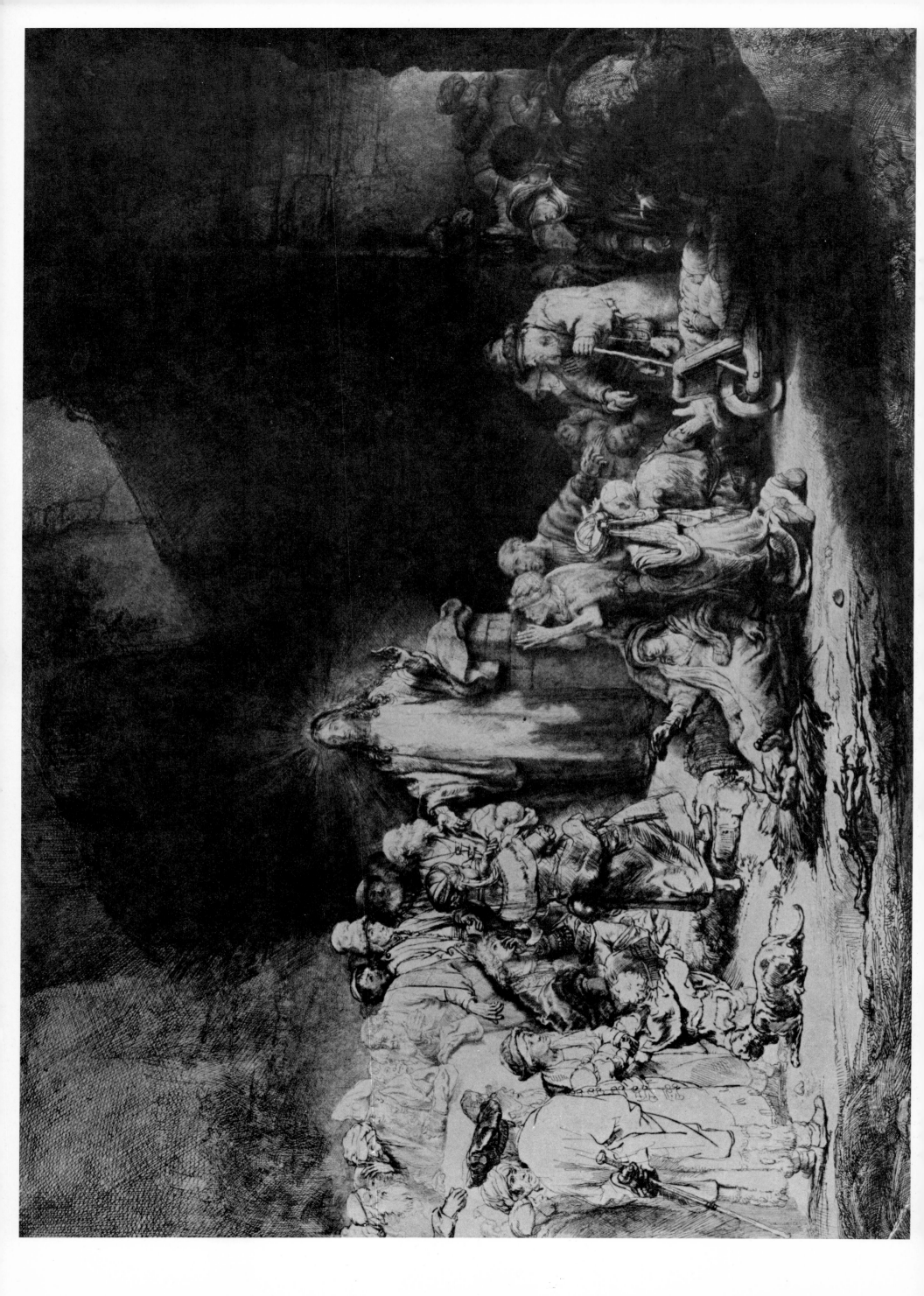

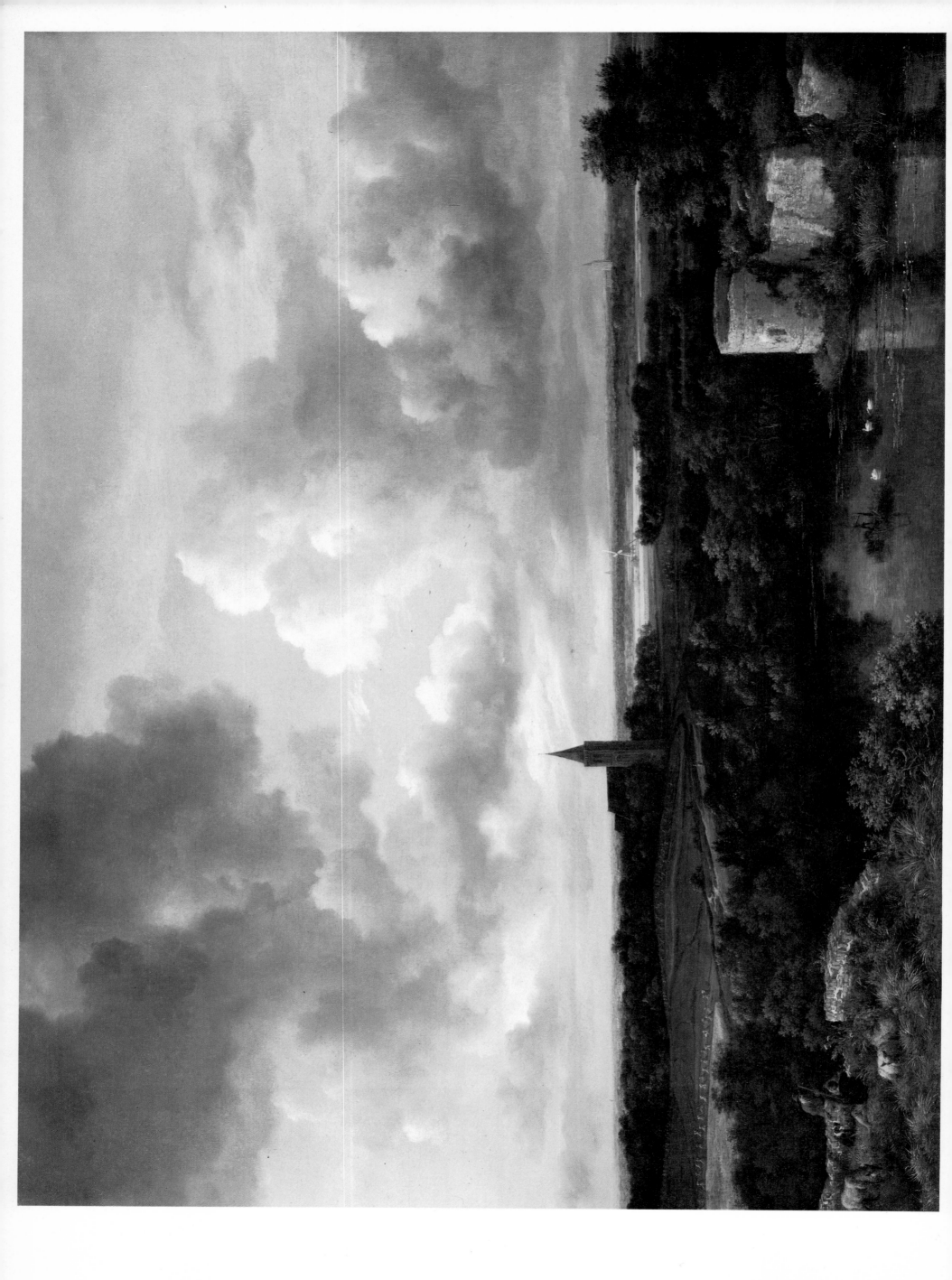

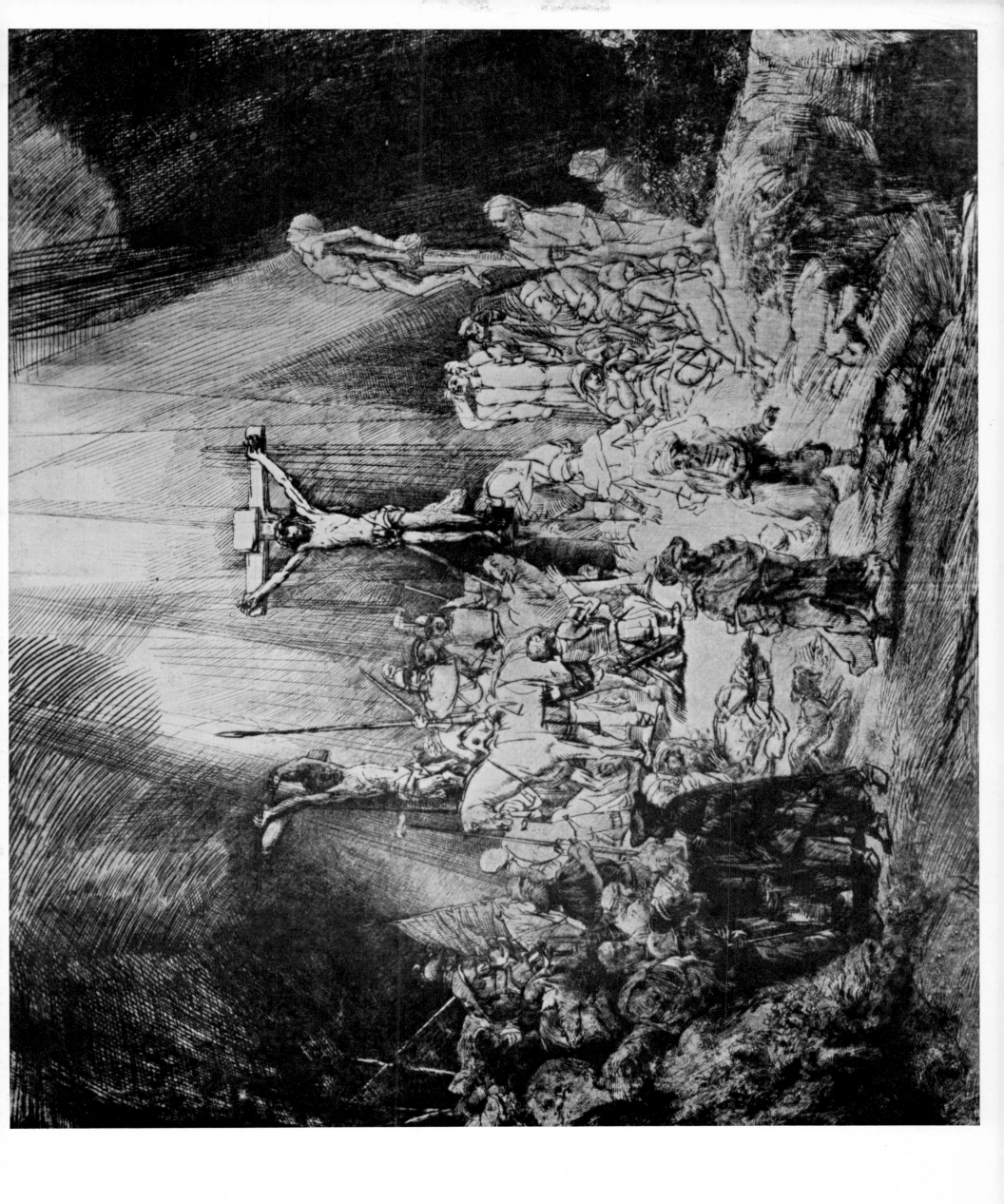

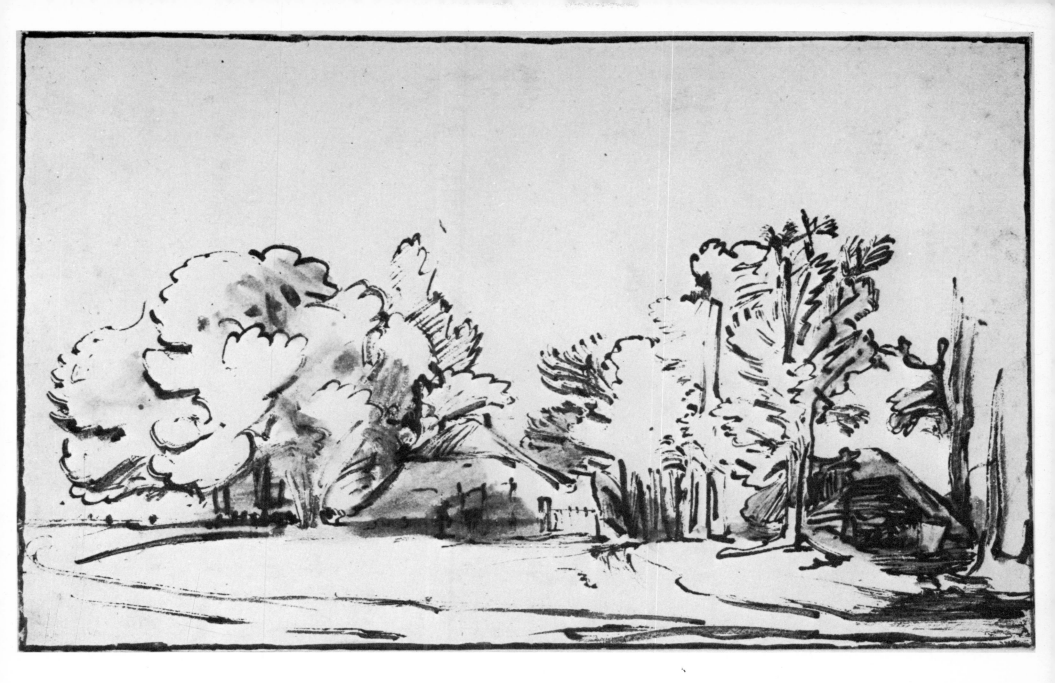

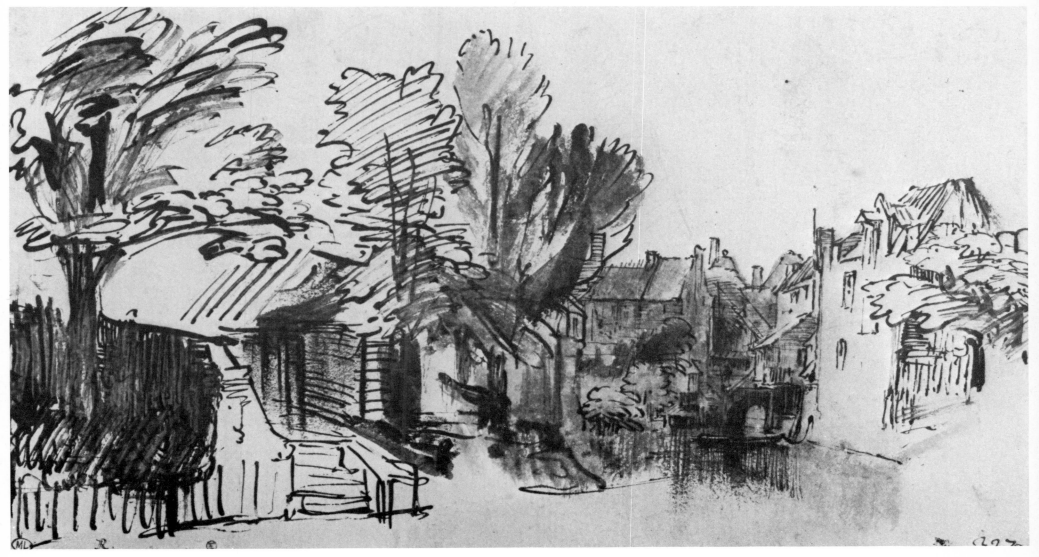

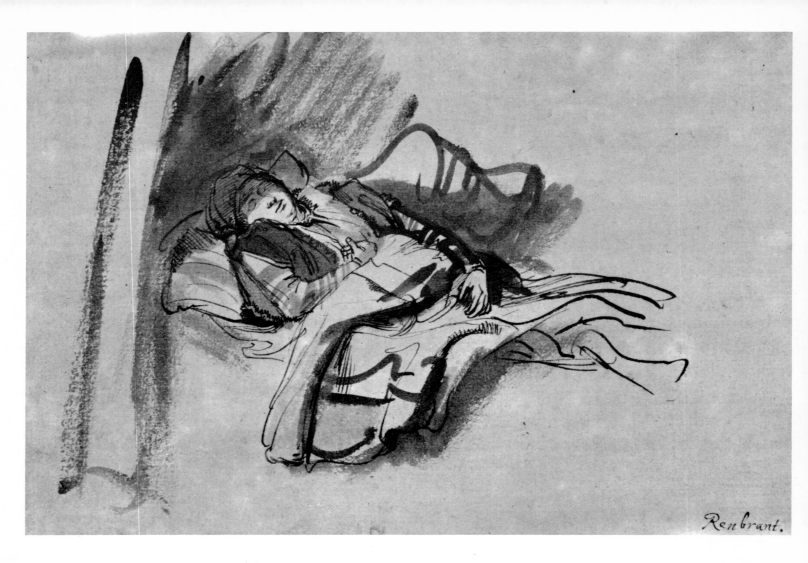

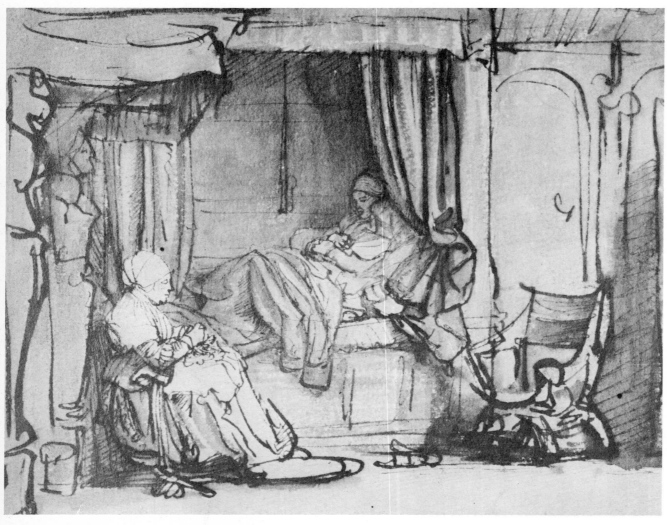

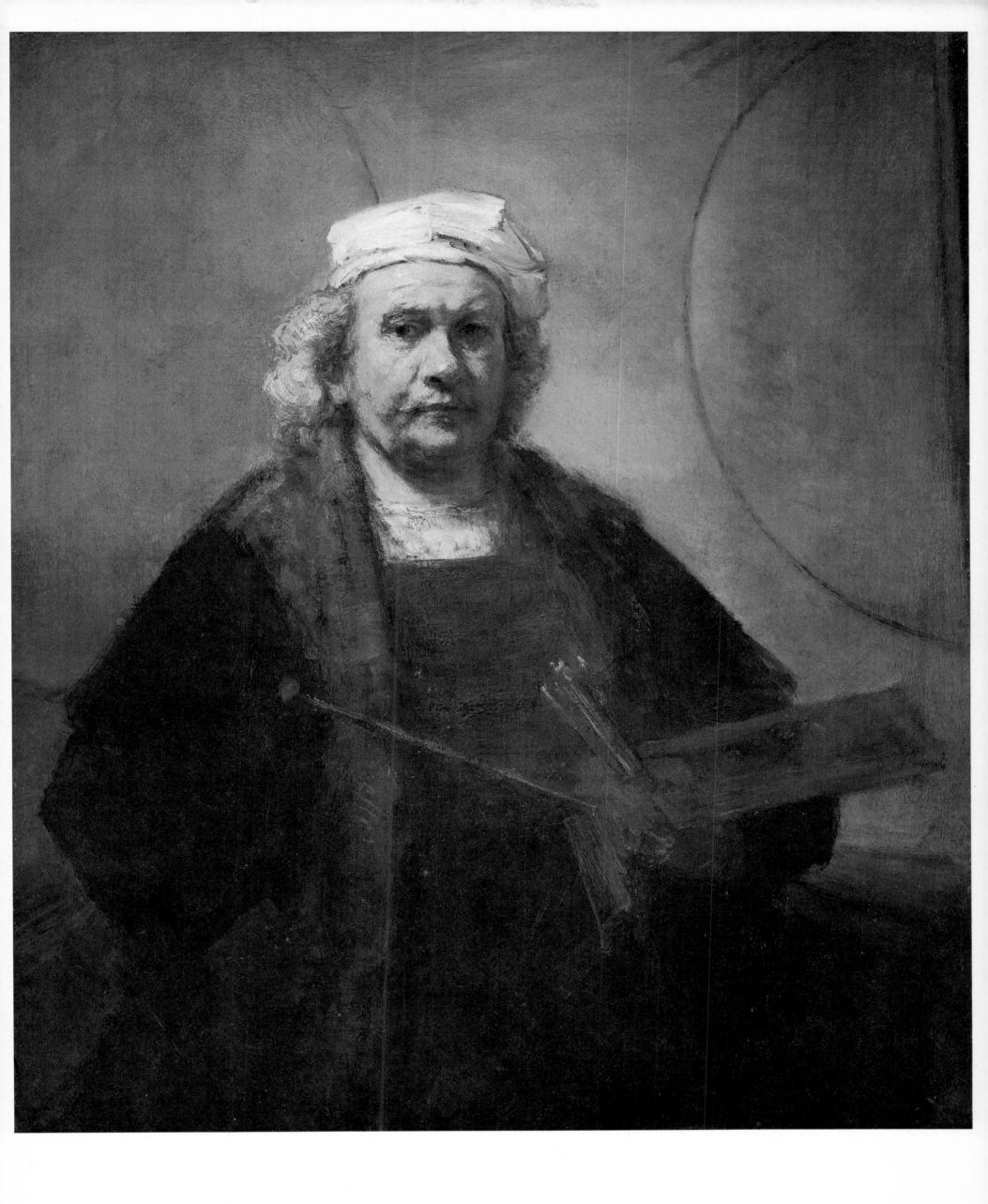

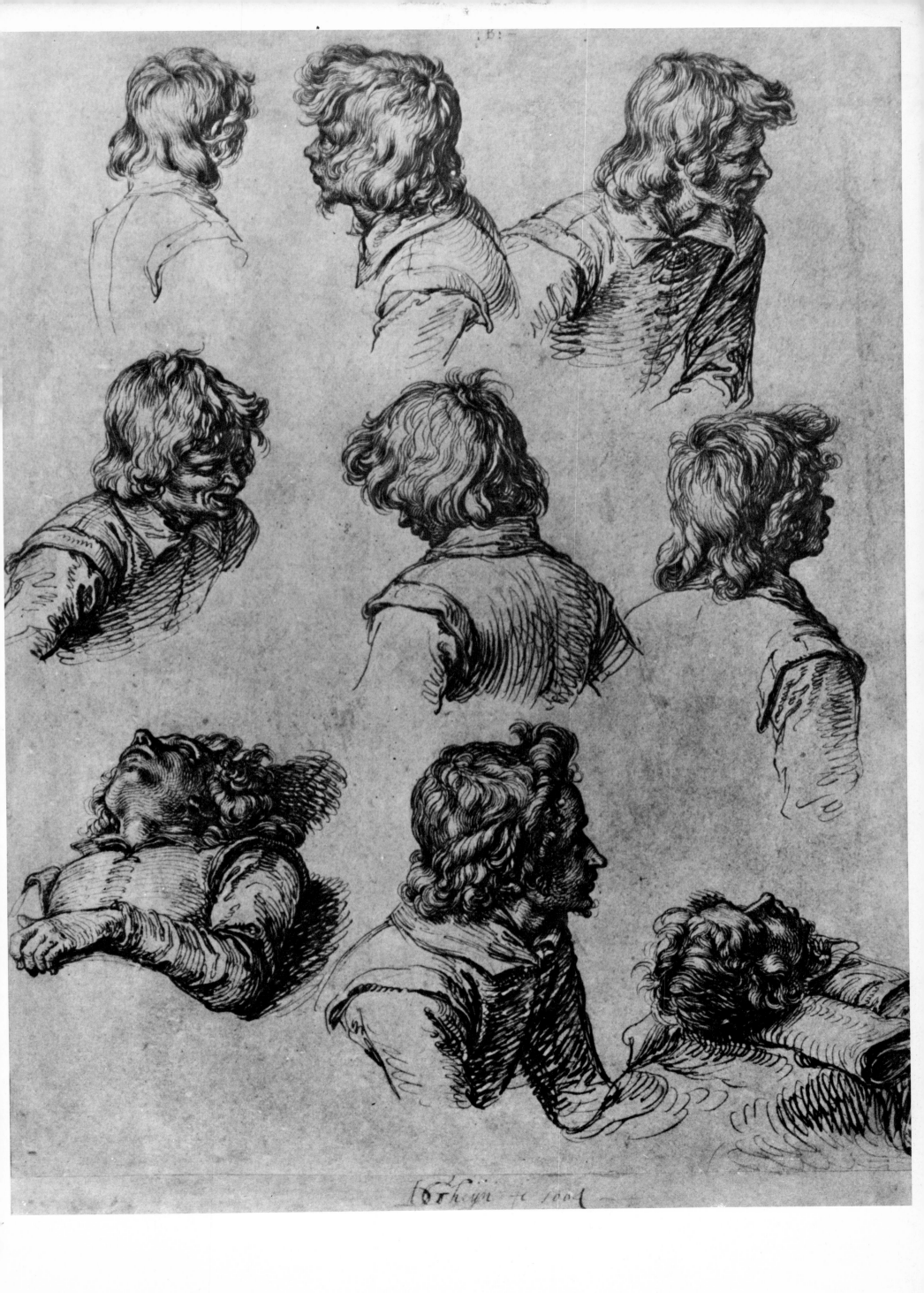

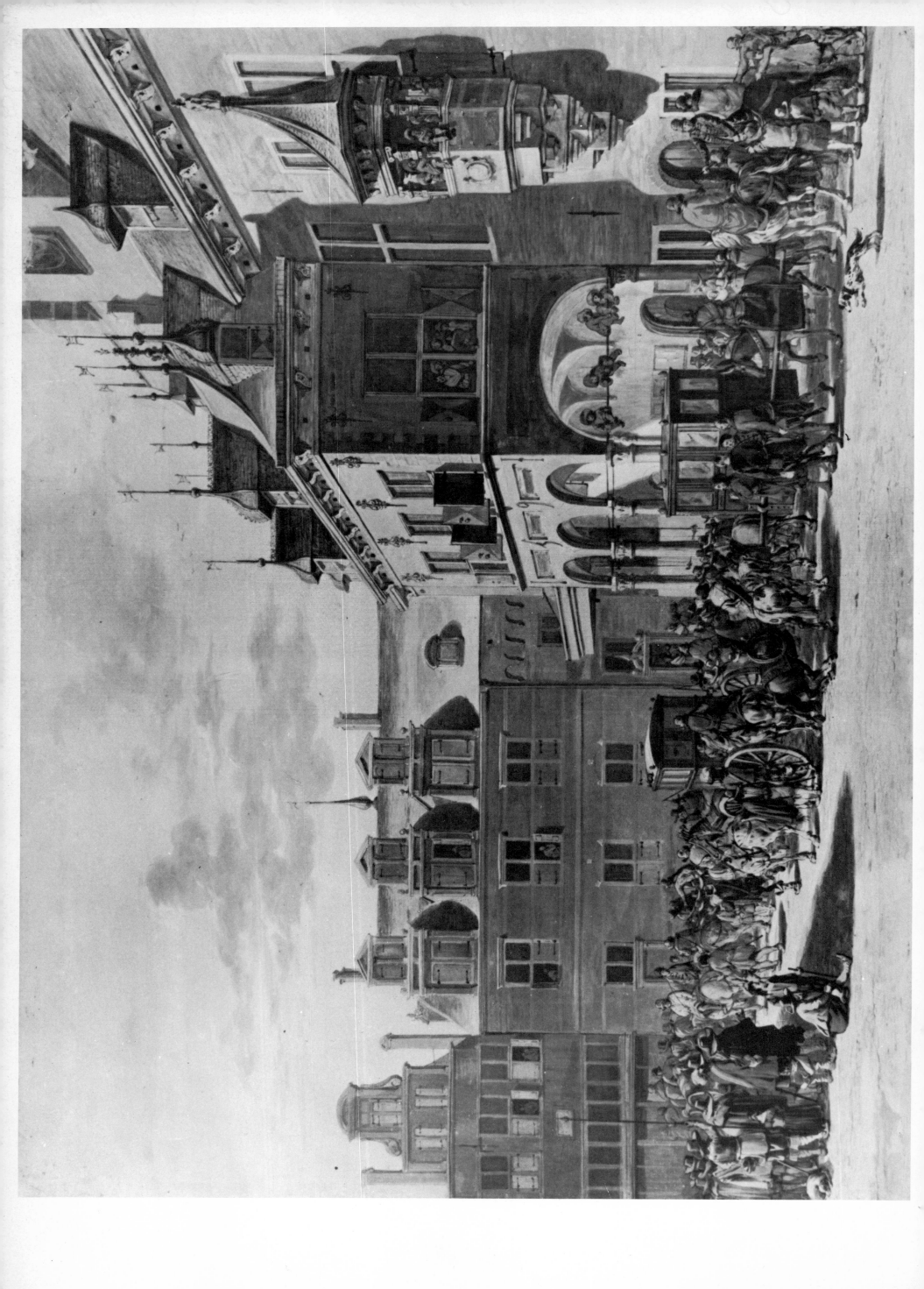